Alois Riegl

Alois Riegl: Art History and Theory

Margaret Iversen

The MIT Press
Cambridge, Massachusetts
London, England

This book was set in Bembo by DEKR Corporation
and was printed and bound in the United States of America.

Library of Congress Cataloging-in-Publication Data

Iversen, Margaret.
 Alois Riegl : art history and theory / Margaret Iversen.
 p. cm.
 Based on author's thesis (doctoral).
 Includes bibliographical references and index.
 ISBN 0-262-09030-9
 1. Riegl, Alois, 1858–1905—Criticism and interpretation. 2. Art—
Historiography. I. Title.
N7483.R54I83 1993
 709′.2—dc20 92-26922
 CIP

In memory of my father, Erling Iversen

Contents

Preface

This book has had an unusually long period of gestation. It began as research for a doctoral dissertation undertaken at the University of Essex between the years 1973 and 1980. Toward the end of the seventies, I became interested in the latest feminist, psychoanalytic, and poststructuralist theories. So when, some four years ago, I was prompted by publishers to return to my dissertation on Riegl, it became necessary to rethink his importance for me and for the concerns of contemporary art historians. I like to think that the resulting book has a certain depth of field made possible by this time-lapsed shift of focus.

The list of those to whom I owe a debt of gratitude is also long. I would particularly like to thank Jules Lubbock, Thomas Puttfarken, and Peter Vergo, all of the Department of Art History and Theory at Essex. Yve-Alain Bois's careful, critical reading of the final manuscript was invaluable. Maureen Reid helped at many stages with preparing the typescript. I am grateful to members of staff at the University of Essex Library and at the Warburg Institute. The book would not have been possible without the inspiration and encouragement so generously given over twenty years by Michael Podro.

Alois Riegl

Introduction: The Concept of the *Kunstwollen*

Over the past few decades there has been a slow crescendo of interest outside German-speaking countries in the work of the Austrian art historian Alois Riegl (1858–1905), despite the dearth of translations into English or any other language (with the exception of Italian). A few key publications mark the progress of this reevaluation in the United States and in Britain. In the early 1960s, the *Burlington Magazine* ran a series of articles on important art historians and critics who have shaped the discipline, including one on Riegl by Otto Pächt, an art historian trained by Riegl's successors at the University of Vienna, Max Dvořák and Julius von Schlosser. In 1976, the U.S. academic journal *Daedalus* published an issue that contained an article by Henri Zerner on Riegl as well as pieces on Aby Warburg and Sigfried Giedion. A barely passable English translation of Riegl's best-known book *Late Roman Art Industry* (*Spätrömische Kunstindustrie,* 1901) was published in 1985, but at a price so exorbitant that its currency was hardly increased.[1] All this has taken place in the context of a general reopening of debate concerning the fundamental methodological procedures and purposes of art history. Michael Podro's *The Critical Historians of Art* (1982), the first history in English of the work that formed the foundations of art history as a discipline, was an important contribution to the general reassessment.

Yet the delayed reception of Riegl's work in the English-speaking world cannot be attributed solely to the unavailability of his work in translation. The twentieth century began with a retrenchment in many academic disciplines into "hard" empirical research and a deep distrust of more speculative or even systematic approaches such as Riegl's. Later, the atrocities of Nazi Germany and the Stalinist Soviet Union no doubt contributed to the rejection of a tradition of art history that could be linked to Hegelian or Marxist historicism. To cite just one case in a complex history, Karl Popper, associated with the Vienna school of logical positivists, made virulent attacks on historicism, which he regarded as the philosophical ground of modern totalitarian political systems. *The Poverty of Historicism* (written 1936, published as articles in 1944 and as a book in 1957) and *The Open*

Society and Its Enemies (1945) were polemics aimed at historicist explanations in sociology and history that rejected the view that the methods of the physical sciences could be just as successfully applied to the social sciences. *The Poverty of Historicism* bears a dedication "In memory of the countless men and women of all creeds or nations or races who fell victims to the fascist and communist belief in Inexorable Laws of Historical Destiny." Popper's position and his scientific methodology fed into art history via Ernst Gombrich, also a refugee from Vienna. *Art and Illusion* (1960) opens with an attack on Riegl, among others, for holding a view that style is the expression of a collectivity. This sort of art history is dangerous because "by inculcating the habit of talking in terms of collectives, of 'mankind,' 'races,' or 'ages,' it weakens resistance to totalitarian habits of mind" (p. 16). The forcefulness of Gombrich's critique probably ensured that the next generation would begin the process of reevaluation. Gombrich's alternative to the concept of style, a history of "making and matching," is a history based on individual efforts to criticize and to improve on predecessors' achievements. In short, it brings ideas forged in the natural sciences to art history.

Now that the technologies associated with the natural sciences have been seen to leave a great deal of human misery and environmental havoc in their wake, a "postmodern" consciousness has become more receptive to thinkers who early repudiated positivistic scientism.[2] It is within this broad context that art historians are reassessing the history of their discipline. Riegl appears now as a more sympathetic figure because he too found himself protesting against a narrowly empiricist approach to the study of art. He complained bitterly of the "cult of individual facts" in art historical methodology (Riegl 1929, p. 63). In a posthumously published draft for a book, Riegl reflected on the history of art historical methodology. He discerned three phases in art history's growth as a discipline, beginning with Winckelmann in the mid-eighteenth century. Couching his analysis in the form of an extended analogy, he proposed that at first aesthetics was in the position of an architect drawing up plans for art historians to follow. The

discipline was founded on a priori principles. In time the unwieldy structure, which included all the different art forms under one roof, was found to be structurally weak and the basic materials of poor quality. In order to correct this weakness, a period of specialization followed, establishing solid partial structures without heed to any overall plan. Individual works of art were closely studied, carefully attributed, and linked in causal chains. Riegl did not deny the value of this archaeological or positivistic study, yet he hoped to discover "higher, universal laws that all works of art uniformly obey without exception" (Riegl 1966, p. 210). His procedure, and that of the third phase generally, is to isolate those features that all works of art have in common and to find the laws of combination and development of those features: "We must no longer concentrate on individual works of art or on individual species of art, but on the elements with whose clearer analysis and understanding a true unifying copingstone of the theoretical structure of art history will be built" (p. 210).[3]

This elegant and seemingly frictionless trajectory of art historical methodology is belied by Riegl's often polemical or bitterly satirical attacks on the fact collectors. Riegl was in quite another mood when he wrote the essay "Late Roman or Oriental?" ("Spätrömisch oder orientalisch?," 1902):

> I do not share the view that a knowledge of monuments alone already constitutes the alpha and omega of art-historical knowledge. The well-known, dubious, and loud-mouthed argument, 'What, you don't know that? Then you don't know anything at all!' may have had a certain validity in the period of materialistic reaction to Hegelian over-estimation of conceptual categories. In the future we will have to ask ourselves in regard to every single reported fact, what the knowledge of this fact is actually worth. Even the historical is not an absolute category, and for the scholar, not only knowing per se, but also the knowing-how-to-ignore certain facts at the right moment may well have its advantage. (Riegl 1988, p. 190)

Riegl's celebrated but much misunderstood concept of a *Kunstwollen*, an artistic will or urge or intent informing different period styles, was designed primarily to counter narrowly empiricist, determinist, functionalist, materialist tendencies in art history and theory. Its emphasis on will was meant to retrieve agency in artistic production from the domain of causal explanation.

Another feature of Riegl's work that makes him newly relevant is his promotion of what might be called cultural pluralism, that is, of an approach to the arts of the past that does not assume a monolithic aesthetic ideal. He opened up the art of late antiquity, formerly regarded as of archaeological interest only, as a serious object of enquiry for art historians. By recognizing alien aims and values, different aesthetic ideals, he hoped to avoid "subjective criticism." The concept of the *Kunstwollen* in Riegl's mature work serves this purpose. In *Late Roman Art Industry* he declares that "everything depends on understanding that the aim of the fine arts is not completely exhausted with what we call beauty or with what we call liveliness, but that the *Kunstwollen* may also be directed towards the perception of other forms of objects (according to modern terminology neither beautiful nor lively)" (Riegl 1927, p. 11).[4] His insistence on recognizing the historical character of aesthetic judgment was a pioneering effort and is now being extended to the art of peoples out of the mainstream of western civilization that had formerly been of interest only to archaeologists and anthropologists. Now even within the precincts of European art history there is a move toward greater differentiation of the artistic intents of various moments and regions. For example, scholars such as Michael Baxandall in *The Limewood Sculptors of Renaissance Germany* (1980) and Svetlana Alpers in *The Art of Describing* (1983) have made efforts to extricate themselves from the problematics of a discipline formed for the study of Italian art in order to discover criteria and discourses appropriate to a critical appraisal of the art of northern Europe. Cultural pluralism now seems like an escape from monolithic paradigms of art and restrictive aesthetic norms, rather than a descent into irrationalism.

Yet Riegl's insight was more complex than this suggests. As the quotation above from "Late Roman or Oriental?" testifies, he had an acute sense of the historicity of the art historians' own discourse and of the limits of what in the past could be appreciated by the present. Yve-Alain Bois has argued that this was Riegl's greatest insight.[5] In the introduction to *Late Roman Art Industry* Riegl observed how underresearched late Roman art was, a virtual "dark continent," and concluded:

> This reveals a fact which can no longer be overlooked: in spite of its apparent independence and objectivity, scholarship takes its direction in the last analysis from the contemporary intellectual inclination, and so too the art historian cannot significantly deviate from the character of the artistic taste of his contemporaries. (Riegl 1927, p. 3)[6]

Riegl underscores this point in a late essay on the preservation of monuments: "At the beginning of the twentieth century, most of us have come to the conclusion that there is no such absolute art-value, and that it is a pure fiction to consider ourselves wiser arbiters than were the contemporaries of misunderstood masters in the past" (Riegl 1929, pp. 187–188; trans. 1982, p. 47). I shall argue in the closing chapter that Panofsky's use of Riegl's concept of the *Kunstwollen* to secure an historically unconditioned, fixed point of departure for art historical enquiry was against the spirit of Riegl's work. There is no Archimedean point, and the *Kunstwollen,* far from proposing one, was intended as its undoing.

Riegl was also an early advocate of broadening the range of objects properly studied by art historians. The applied arts and ornament should, he thought, be treated alongside painting, sculpture, and architecture as equally valid expressions of the *Kunstwollen*. In fact, he tended to regard architecture and the so-called minor arts as particularly revealing since one was not distracted by iconographical motifs. Riegl's formalism led him to take ornament and craft seriously. At the

same time, movements such as the arts and crafts in England and the Secession in Vienna created a climate favorable to a more serious treatment of the applied arts and ornament. Riegl's first two books were on oriental carpets and on 5,000 years of the history of ornamental plant motifs, from their ancient Egyptian origins through to late antiquity and on to Byzantine variations and the Moorish arabesque.

Other valuable components of Riegl's work are more difficult to explain in summary. One was his profound sense, bound up with the concept of the *Kunstwollen,* of artistic form or style. This aspect of his work is only conceivable given those developments in eighteenth- and nineteenth-century epistemology and psychology that emphasized the formative activity of mind in shaping our experience.[7] If everyday experience is taken to be mind-formulated, then the same must be true of art only to a greater extent, for we do not look to works of art to replicate our experience of the world. For Riegl, different stylistic types, understood as expressions of a varying *Kunstwollen,* are read as different ideals of perception or as different ways of regarding the mind's relationship to its objects and of organizing the material of perception. Art displays people's reflexive awareness of the mind/world or subject/object relationship. To put it in terms Riegl would not have used, art makes explicit the implicit values and presuppositions that structure people's experience of the world.

Riegl's concept of form implies that it is not the object represented but the manner in which it is represented that is strictly the mind's contribution. It therefore encourages a critical procedure that centers on formal values. Riegl frequently reiterated his definition of the critically relevant features of the work of art: "outline and color in the plane or in space." This formula already indicates the difficulty of separating form from content, for the manner in which virtual space is represented is regarded as a formal element. In his late work *The Dutch Group Portrait* (*Das holländische Gruppenporträt,* 1902), the sense of form is further extended to include the arrangement of the figures, their postures, the directions of

their gazes, and their peculiar quality of attentiveness. In other words, matters of content come to be explicitly seen as expressions of the Dutch *Kunstwollen*.

The actual categories that Riegl developed to differentiate varying relations of the mind to its objects are complex and subtle. They derive partly from the influential essay written by the sculptor Adolf von Hildebrand, *The Problem of Form in the Visual Arts* (1961; first published 1893). Riegl's terms "haptic" and "optic" are closely related to what Hildebrand called the "near" and "distant" views. One mode of vision, the near or haptic, is analogous to the sense of touch in the way that it must synthesize mentally a number of discontinuous sensory inputs.[8] The distant or optic view, on the contrary, takes in a synoptic survey of objects in space. Wölfflin's famous categories of linear and painterly in *The Principles of Art History* (1950; first published 1915) also derive from Hildebrand, but he makes them the basis for a theory of cyclical artistic change.

These modes of visual apperception are employed in Riegl's analysis of the development of art, architecture, and art industry in antiquity. When he comes to the study of Dutch group portraiture, however, he replaces them with the terms "objective" and "subjective" and integrates into his theory many insights from Hegel's *Aesthetics,* especially Hegel's sense of the way painting exists for an observer, as a mere appearance rather than as an externally existing self-sufficient entity. Riegl's important distinction between "internal" and "external" coherence builds on this fundamental idea. He pioneered a theory of the role of the spectator that enquired into the way works of art exclude or call upon the spectator's imaginative participation. The penultimate chapter of the present book explores Riegl's theory of spectator-depiction relationships and compares it with more recent writing on the subject.

All of these valuable components of the capacious concept of the *Kunstwollen* will be enlarged upon in the course of this book. My aim is to demonstrate the continuing pertinence of Riegl's work. However, one cannot on that account

ignore the very prominent feature of his historiography that is undoubtedly an impediment to art historical understanding. This is Riegl's bold historical scheme that sees the history of art as a continuous process of development leading from an extremely "haptic" or objective view of things in the world to an extremely "optic" or subjective conception of things. Egyptian art and impressionism are usually proffered as examples of these poles. Such a history can certainly be constructed, but in the process some historical periods and geographical areas are arbitrarily isolated as part of the process and others excluded from it. The demonstration of historical continuity was extremely important to Riegl: in the early book on ornament, *Questions of Style* (*Stilfragen,* 1893), it was his major argument against the view that ornamental motifs were "spontaneously generated" in local regions and determined by a set of contingent material circumstances. Continuity and autonomy remained inextricably linked in his mind.

If art's history is both continuous and autonomous, then it must develop according to an internal dynamic. The idea of an internal dynamic driving stylistic change is constant in Riegl's work, but it undergoes quite radical revision. In *Questions of Style,* for example, motifs are progressively modified in accordance with fixed laws of design so that gradually the elements of a composition become more and more highly articulated. In the later works, however, the dynamic of historical development is governed by a dialectical tension between subject and object that produces instabilities and demands adjustments. His historical schemes often involve the confrontation of opposites. This later theory is clearly derived from Hegel's philosophy, particularly his *Aesthetics,* although Riegl is certainly not a doctrinaire Hegelian. Like other late nineteenth-century cultural historians, he tends to reject Hegel's metaphysics, while retaining his many insights by psychologizing them. In fact, he regards the ultimate goal of history in Hegel's philosophy, the elimination of contradiction or antagonism, as an undesirable state of affairs.

> The modern artistic problem is just as much a problem of space as every
> preceding one: an antagonistic relationship between the subject on the
> one hand and things (i.e., extension, space) on the other, not complete
> absorption of the object in the subject which would mean the end of art
> altogether. (Riegl 1931, p. 189)[9]

Nevertheless, many of the difficulties associated with Hegel's philosophy of history recur in Riegl. The elegant architectonic is built on the assumption that history began in the Orient and moved to the Occident, or more precisely, to northern Europe. Just as Mercator's projection gives a map of the world that exaggerates the size of countries furthest from the Equator, so a northern European perspective has constructed a history that leads up to its own achievements. Although Riegl is circumspect about regarding history as progress, his developmental history involves him in some of the familiar tropes of orientalist discourse.[10]

Another serious problem arising from the Hegelian inheritance is Riegl's sense of artistic development as running parallel to, and in harmony with, changes in other domains of culture, philosophy, science, and social life. In the 1901 essay "Naturwerk und Kunstwerk. I" he laid down the principle that "visual art is not determined by the contemporary *Weltanschauung,* but simply runs parallel to it" (Riegl 1929, p. 63). In the book draft referred to earlier he isolated three major *Weltanschauungen* in the history of western civilization: first, antiquity is dominated by a polytheistic vision of the world, then the Middle Ages by their monotheism, and finally the modern age by a scientific world view (Riegl 1966, pp. 24–56). Although he adhered to this broad schema he invented a new concept, the *Kunstwollen,* to describe specifically visual ways of grasping one's surroundings. A passage in the last chapter of *Late Roman Art Industry* suggests a reason for this: "Yet man is not only a (passive) being who perceives with the senses, but also an (active) desiring one who, therefore, wants to interpret the world as smoothly as

possible in accordance with his desire (which changes according to nation, location and time)" (Riegl 1927, p. 401).[11] He goes on to say, apparently contradicting the thesis of parallel development, that the *Weltanschauung* in the broadest sense determines this active, striving, desiring *Wollen* "not only in religion, philosophy, science, but also in government and law, where one or the other form of expression mentioned above usually dominates." The *Kunstwollen* is then one of these interpretative forms of expression.

Riegl's procedure obviously involves a selection of material to fit an a priori scheme. Ernst Heidrich, a student of Wölfflin, noted this weakness of linear histories, making specific reference to the mid-nineteenth-century art historian Karl Schnaase's *Niederländische Briefe* (1834). Heidrich complained that Schnaase first defines, with Hegel, the culminating ideal of Dutch landscape painting as a recognition of the ephemeral, inessential nature of the material world, and then proceeds to discuss only those picturesque landscapes that seem to fulfill the ideal. Accordingly, Jan Both and Ruysdael are highly praised, while "the name of Jan van Goyen is not mentioned" (Heidrich 1917, p. 67). He also complains that Schnaase took "only an indirect interest in the individual works of art, which can only be for him parts of a great integrated complex of value" (p. 62). These criticisms bear to some degree on Riegl. Heidrich directly criticized Riegl's abstract system of historical processes, which he said resembled "a fine and delicate veil over the hard, often brutal realities of history" (p. 59). More recently, Lorenz Dittmann brought similar charges against Riegl. In his *Stil, Symbol, Struktur: Studien zu Kategorien der Kunstgeschichte,* he speaks of Riegl's history as a "triumph of science over art" that leaves us with an empty conceptual husk instead of the works themselves, and abstract laws instead of human accomplishments (Dittmann 1967, p. 26). This critique is belied by Riegl's extremely sensitive readings of individual works of art.

Certainly Heidrich was justified in his rejection of any restrictive, unilinear pattern of development, but with his call for closer attention to the "sensuous impression"

of individual works of art he risked an equal and opposite danger. What both Schnaase and Riegl recognized was that in order for a particular work of art to have meaning, it must be couched in something comparable to a public language. The intelligibility of a particular work of art requires some systematic framework in the same way that an utterance depends for its intelligibility on its being formulated in a public language. Riegl mistakenly thought that this condition of intelligibility required a conception of art's history as a linear history or as an ongoing project fulfilling fundamentally the same purpose. As a result his model of historical development is simplistic. Yet at the same time, the context of intelligibility he elaborated is conceptually very rich, enabling illuminating analyses of art and architecture.

This richness accounts for the enthusiasm with which his work was received in German-speaking countries in the early part of this century. It may also help to account for the amazing diversity of appropriations. For example, Riegl is the crucial intellectual foundation for the work of such strikingly dissimilar, though contemporary, scholars as Erwin Panofsky (1892–1968) and Wilhelm Worringer (1881–1965). I will return to the question of Panofsky's relation to Riegl at the end of this book. As I have noted, the young Panofsky hoped to fuse the concept of the *Kunstwollen* with a neo-Kantian, a priori principle in relation to which all the products of art could be plotted and understood. For him, this meant a perfect poise between objectivity and subjectivity, which he saw realized in the art of the Italian Renaissance. In his 1921 essay on theories of proportion, he wrote disparagingly of "the victory of the subjective principle" in his own time, making explicit reference to expressionism:

> The styles that may be grouped under the heading of "nonpictorial" subjectivism—pre-Baroque mannerism and modern "expressionism"— could do nothing with a theory of human proportions, because for them the solid objects in general, and the human figure in particular, meant something only in so far as they could be arbitrarily shortened and lengthened, twisted, and, finally, disintegrated. (Panofsky 1970, p. 137)[12]

Nevertheless, Worringer, one of the most prominent exponents of what might be called expressionist art history (Kandinsky and Marc published excerpts of his work in the *Blaue Reiter Almanach*), was just as much indebted to Riegl as was Panofsky. His *Abstraction and Empathy* (a doctoral thesis completed 1906, published 1908) is a popularizing and reductive reworking of Riegl's sense of the different perceptual relations to the world realized in art. Worringer fully acknowledges his debt, saying "it is to Riegl that the greatest incentives to the work are due" (Worringer 1953, p. 137). Riegl's historical filiation of varying aesthetic ideals turns up in Worringer as a bipolar swing between cultures dominated by an urge either to abstraction or to empathy. More worrying is Worringer's straining toward a new transcendentalism that would reawaken the lost oriental sense of "the unfathomableness of things" (p. 130). Worse still is his adaptation of Riegl's historical architectonic in *Formprobleme der Gotik* (1911), where Worringer postulates three basic types of mankind, "die Grundtypen der Menschheit": primitive, classical, and oriental.

This contrast of appropriations of Riegl is certainly striking, but not as tragic as that between those of Hans Sedlmayr (1896–1984) and Walter Benjamin (1892–1940). Sedlmayr succeeded Julius von Schlosser to the chair in art history at the University of Vienna, held it between the years 1936 and 1945, throughout the Nazi period, and was an ardent supporter of the regime. In 1927 he wrote the introduction to a collection of Riegl's essays in which he claimed that Riegl had anticipated by twenty years the ideas of Oswald Spengler (Riegl 1929, p. xxx). Sedlmayr produced a list of ideas that he claimed must finally be given up in modern times, among them the Kantian idea of the unity and immutability of human reason, the idea that only individuals are real and groups or collectives mere names, the belief that art is either an imitation or idealization of nature, and, more alarmingly given subsequent events, the view that history is the result of blind causal determinations rather than a meaningful self-movement of the Spirit (p. xxxi). The rise of German nationalism was no doubt, for him, an inevitable and meaningful movement of history.[13]

Sedlmayr thought he could read his proto-Nazi views in Riegl, and yet the unorthodox Marxist critic Benjamin was an equally great admirer of Riegl's work. Benjamin died by his own hand while fleeing his place of exile when the Nazis invaded France. He particularly acknowledged the great debt he owed to Riegl's *Late Roman Art Industry* for his methodological approach in *The Origin of German Tragic Drama,* his rejected Ph.D. thesis written in the early 1920s. Riegl's book was helpful to him because just as late antiquity was thought to be decadent, so also was German baroque drama. Riegl's sense of the intrinsic value of a period style, its answering a need or following the *Kunstwollen* of the times, was borrowed by Benjamin. Charles Rosen's excellent essay "The Ruins of Walter Benjamin" indicates the influence of Riegl's work at the level of close "textual" reading.

> Where Riegl elucidated the significance of industrial forms (buckles, earrings, spoons, etc.) and the abstract decorative patterns of the late Roman period, Benjamin turned his attention to the structure of figures of speech in German dramatic poetry of the seventeenth century, the use of double titles, the insertion of mottoes into dialogue, and the expressive values in syntactical forms. (Rosen 1988, p. 135)

In fact, Benjamin directly intervened in debates concerning art historical methodology. In 1933, he published a review of a collection of essays written by scholars of the Vienna school, *Kunstwissenschaftliche Forschungen,* edited by Otto Pächt. In the review, Benjamin makes it clear that what he admires in Riegl is his attention to individual objects and detail *together with* his insights into how these connect with broader cultural, spiritual, epistemological concerns.[14]

In Benjamin's celebrated essay "The Work of Art in the Age of Mechanical Reproduction" (first published 1936), he gave a highly original inflection to the categories of haptic and optic perception. His well-known observation of the decay of the "aura" surrounding works of art in modern times announces a new

mode of perception or a new way of appropriating the objects of sense that seeks to overcome distance. He noted the desire of the contemporary masses to bring things "closer" spatially and humanly (Benjamin 1973a, p. 225). While "optical" perception, for Benjamin, respects the aura and involves a form of free-floating contemplation, the modern "tactile" mode of perception involves a challenge to the senses. The reception of film and of dadaist art is like being hit by a bullet; the spectator is assailed by constant and abrupt changes that Benjamin compares to the experience of being jostled in a crowd. In short, modern technology and city dwelling have effected a modification of visual apperception, making it mechanized, automatic. Benjamin's appreciation of Riegl's theory did not prevent him from turning it upside down, that is, by making modern perception tactile or haptic rather than optic. Nor was he slow to recognize its most serious flaw: Riegl "did not attempt to show the social transformations expressed by the changes of perception" (Benjamin 1973a, p. 224). Benjamin's debt to Riegl is currently being repaid. As Benjamin rises to ever greater prominence as a cultural theorist, he carries Riegl with him.[15]

These introductory remarks may help to delineate Riegl's contribution to the historiography of art history and to position his work in relation to broader intellectual cross currents. To place him in his immediate familial and social circumstances is more difficult. He was by all accounts a difficult person to know, one who kept his private life very private and who was reserved in public. This remoteness was accentuated in later years by deafness and illness. He died of cancer in 1905 at the age of 47. All we know of him, then, are the bare outlines of his life and career. He was born in Linz in 1858, the son of an official in a tobacco manufacturing business who moved to a remote corner of the empire—Zablotow, Galicia—when Riegl was a young boy. His childhood was apparently not very happy, according to Dvořák, who relates that the boy was denied toys and made to study so that he was able to read and write by the age of four (Dvořák 1929). When his father died in 1873, he and his mother returned to Linz to live on a small pension.

Riegl's academic career at the University of Vienna was supposed to lead to a degree in law on the strict instructions of his legal guardian, but he took courses in philosophy, history, and art history. He had an interesting range of professors, among them the Herbartian philosopher Robert Zimmermann who wrote on psychology and aesthetics and Max Büdiger, a very speculative "universal historian." He also took courses offered by Franz Brentano and, later, Alexius Meinong. In 1881 he was accepted as a fellow at the Austrian Institute for Historical Research, run by Theodor van Sickel, where he was taught art history by Moritz Thausing, the author of an exacting monograph on Dürer (1875, 1884). The Institute trained its students in the skills required for reading historical documents and involved courses in the auxiliary sciences, that is, the technical disciplines of historical research such as paleography and diplomatics. In 1883 he passed the exams for his diploma and was also awarded a doctorate of philosophy.

After spending six months in Rome on a fellowship, he returned to Vienna where in 1886 he became an apprentice at the new Museum of Art and Industry, an institution modeled after what is now the Victoria and Albert Museum in London. By 1887 he had been made keeper of the textile collection. However, soon after this he took steps, apparently with some reluctance, to embark on an academic career instead. He earned his *Habilitation* in 1889, becoming a lecturer or *Privatdozent*. He was made *Professor Extraordinarius* in 1895 and was promoted to *Ordinarius ad personam* two years later. He was appointed head of the Art Conservation Commission in 1901 where he was responsible for halting the demolition of several baroque buildings. He also began a monumental task of documentation, the Österreichische Kunst-Topographie, which was interrupted by his untimely death.[16]

Although the picture we have of him is shadowy, the overall impression one receives from the accounts of those who knew him is of a man both formidably intelligent and painfully shy. Dvořák called him "quiet and solitary" (Dvořák

1929, p. 297). I am quite sure that his fairly humble background and social awkwardness inform the range of his art historical sympathies: the so-called minor arts, ornament, late Roman and Dutch art. Riegl turned from what were regarded as the pinnacles of artistic accomplishment, the art of classical antiquity and of the Renaissance, in order to champion these "others" of art history.

II

Modernity in the Making

The attraction of the myth of Vienna at the turn of the century can perhaps be understood as our sense of affinity with a generation that stood on a threshold. It was a flowering at the end of an old regime: by 1918 the venerable Habsburg monarchy came to an end and Austria-Hungary no longer existed. Modernity was then in the making. Now we stand at the other end of the corridor, hesitate on the opposite threshold. From what is called a postmodern position, *fin-de-siècle* Vienna looks uncannily familiar: one is struck by the hybridity, the clashing of old and new, the mix of cultures and the demand of ethnic minorities for self-determination, the disintegration of a great empire, the rise to power of a new right, the crisis of rationalism and general millennial paranoia.

Riegl does not have a very conspicuous place in the vast literature that has recently appeared on the history of that time and place.[1] He is sometimes mentioned as the cofounder, along with Franz Wickhoff, of the Vienna school of art history. But his relation to the turbulent cultural cross currents of the time remains obscure. It has been suggested that his interest in ornament and his antinaturalist aesthetic were in accord with the views of the Secession and that, further, his concept of the *Kunstwollen* can be glossed as a commitment to an aesthetic principle consistent with the Secession slogan—"To the age its art; to art its freedom." In an essay of 1903, he in fact confirmed that "in our day" the motto "to every age its art" prevails, although he went on to remark with some irony that "an era seeking aesthetic redemption through the arts cannot do without earlier monuments" (Riegl 1929, p. 188). His name is also mentioned in connection with the debacle over Klimt's designs for the ceiling of the Great Hall at the University of Vienna, although it was Wickhoff who took an active role in defending Klimt.

In fact, Riegl was discreet about his views of the new art. His only mention of an artist in the orbit of the Secession is of Jan Toorop, a Javanese-Dutch artist who exhibited at the Seventh Secession exhibition in 1900 and evidently influenced Klimt, particularly in the latter's design for *Jurisprudence* and the Beethoven frieze, both of 1903. Toorop's skinny, silhouetted women, perhaps related to Javanese

shadow puppets, are thought by Riegl to be an indication that the contemporary aesthetic of dissolving lights and shades had gone so far as to need a counterbalance. In the same context he mentions the vogue for linear styles of ornamentation (Riegl 1929, pp. 205–206).

There is, then, slight evidence to suggest that Riegl was sympathetic with the aims of the Secession. It is much easier to pin down his antipathies. A recurrent polemic in Riegl's work was aimed at the great German architect and theoretician Gottfried Semper, who had died in 1879. Semper had been professor at the Academy of Fine Arts in Dresden until his participation in the failed republican uprising of 1849 forced him into exile. Some of his biggest projects were built in Vienna, including the imperial Baurat (1873–1888) and, with Karl Hasenauer, the museum complex and Burgtheater (1873–1888). Although only Semper's name is mentioned, Riegl always prefaced his jibes by insisting that his target was not Semper himself. He addressed his criticisms to certain "sub-Semperians": "If Semper said: in the genesis of an artistic form material and technique also came into play, then immediately the Semperians surmised: artistic form was a product of material and technique" (Riegl 1893, p. vii).[2] Riegl invoked Semper's name as the intellectual figurehead of a growing tendency in the theory and practice of the visual arts, particularly architecture and design. He saw the modern interest in technique and technology insinuating itself in the place of art. "'Technique' gradually became a favorite catchphrase; its usage was soon equivalent to 'art' and eventually one even heard it more than the word 'art.' The naive, the layman, spoke of 'art'; it sounded more expert and authoritative to speak about 'technique'" (Riegl 1893, p. vii).[3] Riegl's indirect attack on certain of his own immediate contemporaries had the unfortunate side effect of distorting subsequent scholarship on Semper, which tended to neglect Riegl's distinction between Semper and sub-Semperians.

In fact, Semper and Riegl had a great deal in common. Both addressed the vexing problem of style in the nineteenth century.[4] They were equally concerned about apparent arbitrariness of style, especially in the fields of architecture and design.

Michael Podro has succinctly summed up the particular circumstances in the mid-nineteenth century that prompted this concern: "the easy availability of styles, the facility of new technologies which can cut granite like cheese, and the separation of designers from craftsmen in industry" (Podro 1972, p. 54). Riegl's characteristic approach to this situation was to formulate an aesthetic appropriate to the age within the context of a systematically elaborated historical schema. Semper's solution was to refer to early prototypes and their evolution, in the same way that one would evaluate the appropriateness of a particular usage of a word by referring to its etymology. From a limited number of original motifs or *Urmotive* the whole family of motifs and forms could be seen to unfold.

These ur-motifs are actually certain basic methods of making and the material associated with them, that is, the traditional crafts. In his pamphlet "The Four Elements of Architecture" (*Die vier Elemente der Baukunst,* 1851), Semper argued that architecture is a synthesis of these crafts: ceramics for the hearth, weaving or basketry for the walls, woodwork for the roof, and stone construction for the foundation. Modern architecture and design were in disarray, according to him, because all trace of these ancient ways of making had been effaced by industrial production. (This argument is made especially clear in his critique of London's Great Exhibition of 1851, "Science, Industry and Art," in Semper 1989, p. 134). Semper did not, however, advocate a return to preindustrial manufacture; rather, he suggested that by making reference to appropriate crafts and to the history of motifs derived from them, architects or designers could introduce some order and direction into their work. For example, a nonarbitrary masonry wall decoration might subtly refer to the pattern of the carpet or wickerwork that once served as room dividers (Semper 1989, p. 127). Or, again, structural or functional elements of a building or object might be underscored by the design. One can easily see how Semper's ideas might get reduced to a functionalist aesthetic. While Semper advocated *grounding* design in original forms or functional elements, some followers favored architecture or household objects that accented modern materials,

23

functions, and structure. It was thought that an architecture of the age would be more or less dictated by these conditions. Clearly Riegl did not adequately represent Semper's views (nor have I done so here); by focusing on Riegl's polemic, one runs the risk of deepening misunderstandings of Semper's thought. By doing so, however, one is able to bring out certain crucially important issues at stake. The so-called Riegl-Semper debate is in effect Riegl's intervention in the struggle over the shape of the future of modernity. This negative thrust of Riegl's project helps to anchor his notoriously abstract concept of the *Kunstwollen* in its historical context.

In the introduction to *Late Roman Art Industry,* Semper is criticized for holding the view that "art is a mechanistic product of practical utility, raw material, and technique" (Riegl 1927, p. 8). This misleading characterization of Semper's theory Riegl puts to polemical use, denouncing it as mechanistic and the dogma of a materialist metaphysics. He makes the radical claim that these factors have only a restrictive, negative function (p. 9). Riegl argued strenuously against reducing the sense of human purposes to the necessities imposed by need or by materials. By undermining the foundation of subsequent reductive uses of Semper, he seems to have thought he might be able to rescue the very idea of art for modernity. Riegl's concept of the *Kunstwollen* was first formulated in *Questions of Style* as a counter to the Semperian theory that the genesis of ornamental motifs, like the zigzag geometric pattern, is an accidental interplay of materials and technique: "a happy combination of colored reeds brought into being the zigzag pattern" (Riegl 1893, p. 5). Riegl argued, on the contrary, that geometric design is part of a whole aesthetic feeling about one's relationship to nature. It tells us something profound about the people who favored it. This debate about the genesis of the zigzag pattern, examined in detail in chapter 4, may look like a storm in a Grecian urn if it is abstracted from artistic and architectural developments in turn-of-the-century Vienna. It implies a definite position vis-à-vis the very heated debates of the day.

I want to argue that Otto Wagner must have been one of the people Riegl disparagingly referred to as the "sub-Semperians," or at the very least he represented the latest and most prominent exponent of a theoretical position to which Riegl was implacably opposed. Wagner is nowhere mentioned by Riegl, but the attack on Semper is insistent and couched in an uncharacteristically vehement language. Wagner was given to repeating Semper's dictum "Necessity is art's only mistress." In his manifesto *Moderne Architektur,* he praises Semper but also criticizes him for not being thoroughgoing enough:

> Need, purpose, construction and idealism are therefore the primitive germs of artistic life. United in a single idea, they produce a kind of "necessity" in the origin and existence of every work of art, and this is the meaning of the words "ARTIS SOLA DOMINA NECESSITAS."

> No less a person than Gottfried Semper first directed our attention to this truth (even if he unfortunately later deviated from it), and by that alone he quite clearly indicated the path that we must take. (Wagner 1988, pp. 91–92)

In this passage Wagner implies that only Semper's early position supports his own, and indeed Semper did make some startling statements in the foreword to his early pamphlet on polychromy in antiquity (1834): "Art knows only one master—the need. It degenerates when it follows the whim of artists, even more so when it obeys powerful patrons of art" (Semper 1884, p. 217; trans. 1989, p. 47).[5] Even here, however, "need" is immediately glossed as religion and a system of government, hardly what one would call material needs. Because he stressed the importance of construction in generating architectural forms, he was from the first misinterpreted as a materialist, even though in his major treatise *Der Stil* (1878) he wrote: "Annihilation of reality, of material matters, is necessary if form is intended to appear as a significant symbol, as an autonomous creation of man" (Semper 1878, 2:347).

Exactly what was at stake becomes clear upon examining Otto Wagner's career. He was a prominent architect in Vienna at the time when Riegl was writing. He was appointed professor of architecture at the Academy of Fine Arts in 1894, at which time he was chief architect in charge of the construction of the Vienna city railway system and a system for regulating the flow of the river Wien and the Danube Canal. This rapid move from an historicist Beaux-Arts training to very practical engineering problems perhaps accounts for the unresolved contradictions in his views. In 1896 he published his theoretical work *Moderne Architektur,* which was reprinted several times and translated into many foreign languages. In it he argues that functional requirements, material, and structure are the initial conditions out of which architecture should evolve. Although his major early projects were feats of civil engineering that demanded rational functionalism, they also display a lively interest in sinuous ornamentation. This other side of Wagner's personality made him sympathetic to the work of his assistant Joseph Maria Olbrich and his student Josef Hoffmann, both founding members of the Secession. Wagner himself became a member in 1899.

Although many of his buildings happily marry functionalism with ornament, Wagner's writing is ambivalent, oscillating wildly between extreme forms of idealism and materialism. At one moment he elevates the architect to a godlike creator of new forms and next moment promotes a reductive functionalism. One can see this incoherence in a nutshell in the passage cited above where he lists the material conditions "need, purpose, construction" and then adds "idealism." It is difficult to understand how Wagner held these two sides of his thought together: in fact, Adolf Loos was quick to drive a wedge between them, praising Wagner while damning the Secession (see Loos 1982, p. 27).

The vegetal forms of the Secession were a kind of resistance to technology's encroachment in every sphere of life, including the arts. In "Paris: Capital of the Nineteenth Century," Walter Benjamin describes *art nouveau* as precisely a last-ditch defense against technology. "They found their expression in the mediumistic language of line, in the flower as symbol of the naked, vegetable nature that

confronted the technologically armed environment. The new elements of construction in iron—girder-forms—obsessed *art nouveau*. Through ornament it strove to win back these forms for Art" (Benjamin 1973b, p. 168). Yet the dominant ethos of Wagner's texts is an embrace of the technological age; the emphasis is on revealing structure, being true to materials, and utilizing the new technology. "All modern creations must correspond to the new materials and demands of the present if they are to suit modern man" (Wagner 1988, p. 78). He castigated his mentor, Semper, for not consistently following through the implications of his principle that "every architectural form has arisen in construction and has successively become an art form" (p. 92):

> It is Semper's undisputed merit to have referred us to this postulate, to be sure in a somewhat exotic way, in his book *Der Stil*. Unlike Darwin, he lacked the courage to complete his theories from above and below, and had to make do with a symbolism of construction, instead of naming construction itself as the primitive cell of architecture. (p. 93)

Indeed, Semper explicitly rejected the application of Darwinian theory to cultural history (Semper 1989, p. 268). Similarly, Riegl declared the sub-Semperian method to be a misplaced application of *Darwinismus* to artistic life and went on to compare the difference between Darwin and vulgarized uses of Darwin's theories in other disciplines with that between Semper and the sub-Semperians (Riegl 1893, p. vii). For Riegl, it was precisely Semper's "symbolism of construction," the idea of architecture making use of an historically generated repository of meaning-laden forms, that was his saving grace (see Sauerländer 1983, p. 265).[6]

In his architecture, Wagner frequently found a way to make his principles work to produce very pleasing decorative effects—for example, in the beautiful Post Office Savings Bank (1904–1906), where thin polished sheets of white marble are

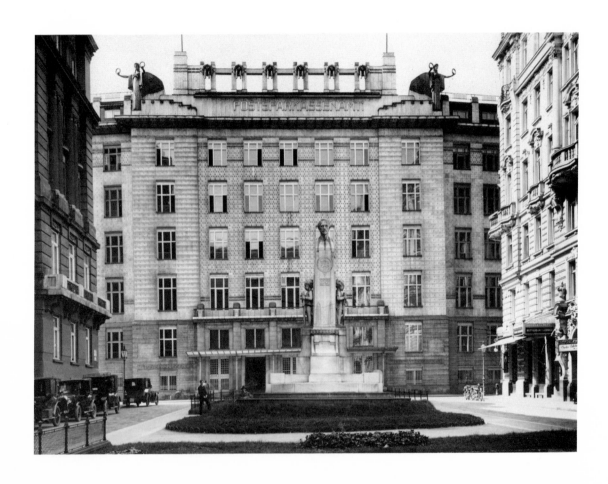

I
Otto Wagner
Post Office Savings Bank, main facade
1904–1906
Georg Koch Platz, Vienna
Courtesy Österreichische Nationalbibliothek
photo: Lichtbildwerkstätte Alpenland

anchored to the facade with countersunk aluminum rivets (fig. 1). The theoretical work, however, fails to achieve this integration. In the name of modern life he forcefully repudiates the tradition of historicism that governed the building of the Ringstrasse. But just what is his idea of "modern life"? One gets some sense of Wagner's conception of it from the following rather chilling quotation: "The number of city dwellers who prefer to vanish in the masses as mere numbers on apartment doors is considerably larger than those who care to hear daily a 'good morning' or 'how are you' from their gossipy neighbors in single houses" (Wagner 1979, p. 109). If modern man has lost his interest in community, Wagner also believed that "the modern eye has lost the sense for a small, intimate scale; it has become accustomed to less varied images, to longer straight lines, to more expansive surfaces, to larger masses, and for this reason a greater moderation and a plainer silhouetting of such buildings certainly seems advisable" (Wagner 1988, p. 109). Modern man, always busy and in a hurry, would be annoyed by the smallest time-consuming detour. "The last decades have carried the banner 'Time is Money'" (p. 110). Wagner's vision of the future is surely one offspring of the dark side of the Enlightenment. This aspect of his thought, his rationalization of the environment, of life, and of work is in lockstep with the needs of capitalism and of totalitarian bureaucracy.

Like the artists of the Secession, Wagner was committed to the regeneration of art and to the rejection of historicism in favor of a style appropriate to the age. Yet, as Schorske points out, there is a world of difference between Wagner's theories and Klimt's inward-looking search for the essence of modern man that involved opening the Pandora's box of instinctual life: "Presenting a Schopenhauerian universe of boundaries liquefied and rational structures undermined, Klimt limned in allegorical and symbolic language the suffering psyche of modern man impotently caught in the flow of fate" (Schorske 1980, p. 85). This is in sharp contrast to Wagner's picture of modern man and his "business-like essence," summed up by Schorske as "an active, efficient, rational, modish bourgeois—an

urban man with little time, lots of money, and a taste for the monumental" (p. 85). While Klimt plumbed the unconscious in the search for a new style, Wagner thought that the materials, techniques, and conditions of modern life would dictate one. This position can indeed be called sub-Semperian. But unfortunately for the historian, the lines are not clearly drawn: Wagner was a member of the Secession and had great admiration for Klimt.[7]

If Riegl's strongly worded condemnation of a "sub-Semperian" aesthetic gives us an historically contextualized basis for understanding the negative thrust of his project, we are on much less solid ground when it comes to appreciating Riegl's own sense of the modern aesthetic or *Kunstwollen*. In order to approach this problem, one must explore his concept of the "optic" or "subjective" ideal of art.

The Aesthetics of Disintegration

In a late essay called "The Modern Cult of Monuments: Its Character and Origin" (1903), Riegl offered an historical explanation of the modern propensity to value monuments, buildings, or artifacts for their age alone. A purely historical value set on monuments as indispensable links in a continuous chain was typical of nineteenth-century scholarship, but this seems to have given way to a more popular appreciation of their simple irrecoverable pastness: "If the nineteenth century was the age of historical value, then the twentieth century appears to be that of age value" (Riegl 1982, p. 29). Riegl connected this change with broader cultural transformations: "The characteristic drive in this change is the desire to transcend an objective physical and psychic perception in favor of a subjective experience" (p. 29).[1] Riegl saw the positive side of this change as well as its possible undesirable side effects. On the positive side, the value set on age had put a stop to the overzealous restorations typical of the nineteenth century when "the aim was to remove every trace of natural decay, to restore every fragment to achieve the appearance of an integral whole" (p. 44). Although it is not spelled out, the implication is that this attitude to restoration coincides with a belief in a suprahistorical objective knowledge of history. On the negative side, Riegl found that the cult of age value lacked interest in particular individual monuments in all their specificity: "These monuments are nothing more than indispensable catalysts which trigger in the beholder a sense of the life cycle, of the emergence of the particular from the general and its gradual but inevitable dissolution back into the general" (p. 24).[2] Despite this qualm, Riegl seems to have recognized a new cultural paradigm that accepts that the new quickly becomes the old, that the present hurtles into the past, that cultures die and that there is no absolute aesthetic value: "An aesthetic axiom of our time based on age value may be formulated as follows: from man we expect accomplished artifacts as symbols of a necessary process of human production; on the other hand, from nature acting over time, we expect their disintegration as the symbol of an equally necessary passing" (p. 32).[3]

Riegl's own taste was in accord with what he saw as the character of his age; he seemed to have valued highly what might be called an aesthetic of disintegration. He used a variety of terms to describe this aesthetic: "tactile disintegration," the "optic" or "subjective" style. His choice of this stylistic type was, so to speak, overdetermined. It has partly to do with his rich inheritance of German idealist philosophy, particularly that of Hegel. The argument of the previous chapter suggests why Riegl would have been drawn toward a tradition that was so reflexive about the mind's contribution to experience. He must also have been influenced by the several defenses of "modern" art as having equal value to the achievement of the ancients: the modern age may not be able to produce classical beauty, but it has a compensating virtue in being more spiritual, authentic, self-conscious, or democratic.[4] There were other theoretical factors in his formulation of a modern aesthetic, including Hildebrand's important *Problem of Form in the Visual Arts* (1893), which will be discussed fully in chapter 5. It is likely that his general sense of the modern world view was partly derived from scientific theory such as Ernst Mach's, who was a professor at the University of Vienna and very influential in cultural circles. Mach promoted an extreme form of empiricism that regarded the world as consisting of our sensations. In a posthumously published book draft, Riegl suggests that modern science obviates the primitive need for tightly coherent art objects as solace amidst unruly nature.

> [Art] does not have to represent the particular that does not exist or, to put it more exactly, exists as molecules too small to be represented, but rather it has to picture the universal coherence of all natural phenomena. Art does not represent the latter as a corporeal individual, but as an aggregate of optical appearances that strike the eye of the beholder at the same time. (Riegl 1966, p. 261)[5]

Modern science no longer concerned itself with individual solid objects but rather with particles, just as modern artists depicted not objects but sensations. Riegl's

aesthetic was also in keeping with the dissolution of substantial being felt by a whole generation of intellectuals permeated with the philosophy of Schopenhauer and Nietzsche. In his discussion of Klimt, Schorske speaks of "that intellectual generation's painful, psychological world-view—a view that at once affirms and suffers the deathly dissolution of the boundaries of the ego and world which desire decrees" (Schorske 1980, p. 230).

Riegl's scholarly work on late Roman and Dutch art can be considered either as disposing him toward a coloristic aesthetic or as a result of his own personal aesthetic preference. And there is also the art of impressionism, postimpressionism, and the Secession, some of which displays a heightened form of coloristic dissolution. If the concept of the *Kunstwollen* was a defense of the artistic imagination against utility and design determined by materials and techniques, it was also a veiled plea for an aesthetic appropriate to the age. The Secession slogan had a special force in the intensely historicist context of Vienna. Riegl's theory of the history of style implies that every age has a characteristic relation or attitude to the world which is realized in its art, design, and architecture. The eclectic historicism of the Ringstrasse was anathema to him.

The reaction to historicism was at the bottom of the scandal that erupted over Klimt's design for *Philosophy* that was to form part of the ceiling decoration of the Great Hall of the University of Vienna (fig. 2). Riegl's friend and elder colleague Franz Wickhoff delivered a lecture defending Klimt in May of 1900 entitled "What Is Ugly," suggesting that Klimt's critics were out of step with the times. The critics complained of the design's lack of clarity, its formlessness, and also of the fact that no classical model was used for the figure of Philosophy. Others seized on these criticisms and turned them into praise: because Klimt copied no one, borrowed no antique models, his work embodied the character of the age (see Vergo 1975, p. 50). Clearly the dispute involves more than aesthetics; each side is pronouncing what the character of the age ought to be. One can well imagine the dismay of the faculty members who commissioned *Philosophy* as a

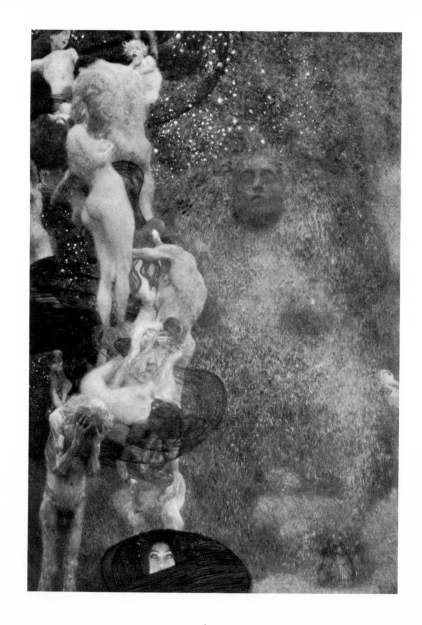

2

Gustav Klimt

Philosophy

oil on canvas, 430 × 300 cm

exhibited at the Seventh Secession exhibition, 1900

ceiling painting for the Great Hall of the University of Vienna

destroyed 1945

Courtesy Galerie Welz, Salzburg

representation of "the triumph of light over darkness." The painting shows ghostly naked bodies spiraling together in a gloomy viscous void while a giant Sphinx figure looms like some ectoplasmic manifestation, "a condensation of atomized space" (Schorske 1980, p. 288). Nothing could be further from the affirmation of Enlightenment ideals proclaimed by the commission. It has all the pessimism of Schopenhauer's meaningless universe. Klimt depicted the crisis, not the triumph, of reason. Neither Riegl nor Wickhoff could be accused of antirationalism, but Wickhoff seized the moment to defend an artist who had rejected classical realism and whose experiment had been castigated as ugly.[6] Wickhoff's major work, *The Vienna Genesis* (1895, 1912), had been written in conjunction with Wilhelm von Hartel, who had since become Minister for Culture and a supporter of the new art. Wickhoff's scholarly interest in early Christian art, which was not aesthetically appreciated, led him to make comparisons between it and recent impressionist works, comparisons intended to dignify both.

Riegl was more guarded about his aesthetic preferences, perhaps because of his proclaimed ideal of art historical neutrality. Yet it is possible to discern two definite sympathies in his writing. He was attracted to styles that fall on either side of the classical—highly stylized oriental design, on the one hand, and the painterly dissolution of late Roman and seventeenth-century Dutch art, on the other. His work on oriental carpets and ornament in antiquity led him to favor nonnaturalistic design. The deplorable design of mass-produced goods in the nineteenth century, such as naturalistic floral patterns on carpets and wallpaper, incited a group of reformers in England that included Owen Jones, Matthew Digby Wyatt, Richard Redgrave, and briefly Semper to insist that industrial design should abstract from natural forms instead of simply imitating them. Riegl refers approvingly to the work of these reformers in the introductory paragraph of his first major study, *Antique Oriental Carpets* (*Altorientalische Teppiche*, 1891).

It was by the arts and crafts reform movement with its call, on the one hand, for renunciation of that aesthetic deformity whose presence in the

European state of art it had made known, and on the other, for a return to simplicity, that one must have been led back to the oriental system of decoration. How Semper, Redgrave, Owen [Jones] wished to praise the merits of the oriental carpet: the unpretentious row of connected blossoms around the border, the neutral pattern of stylized flowers and gracefully animated play of lines in the middle ground. (Riegl 1891, pp. iv–v)[7]

Just as the Semperian emphasis on the causes of design seemed to Riegl to underestimate the productivity of the imagination, so naturalistic art seemed to indicate a slavish sort of imitation. In a draft for a book published posthumously, he bitterly attacked the naturalistic art of his own day, saying that it trivialized the role of art in society: the only advantage a naturalistic painting of the world has over a view of nature framed by thumbs and forefingers is its more effective isolation from surrounding distractions and the opportunity it affords to enjoy "solitude in the woods [*die Waldeinsamkeit*] in a heated room" (Riegl 1966, p. 128). But an excess of nonnaturalistic geometric regimentation in design equally suggested to Riegl a lack of freedom and flexibility. The trouble with both strict geometry and strict mimesis is that they fail to call upon the imagination of artist and beholder alike. Painterly, "optical," or "subjective" styles, on the other hand, call for imaginative adjustments and projections to grasp the form. In this sense they imply a high valuation of spiritual qualities.

This aesthetic of disintegration has a long prehistory. We can better understand Riegl's sense of the optic or subjective style if we return to the eighteenth- and early nineteenth-century philosophical precursors of these notions. Kant's development of the distinction between the beautiful and the sublime is of fundamental importance. Although his *Critique of Judgment* is about the specific kinds of mental functioning involved in aesthetic judgment and not about the objects of that judgment, it is fair to say that Kant understood the beautiful as a form (typically

a natural form) that conforms, seemingly by design, to human perception and intelligence. Kant says that "the object may supply ready-made to the imagination just such a form of the arrangement of the manifold, as the imagination, if it were left to itself, would freely project in harmony with the general conformity to law of the understanding" (Kant 1952, p. 86). The beautiful gestures toward what is outside the limits of possible knowledge; it intimates that our minds and the natural world, or rational ideas and sensuous particulars, are in harmony and that therefore we have an aesthetic assurance that our knowledge is genuine. The judgment of the beautiful is reflexive to the extent that is refers to the felt sense of harmony of the perceptual and conceptual faculties. The sublime, however, is more violently reflexive. Its objects—gigantic mountains or huge waves—overwhelm and defeat our sensory and cognitive apparatus. This temporary humiliation is followed by a triumphant, uplifting sensation as we recognize that we are more than sensuous creatures and capable of thought that transcends mere empirical, conceptual understanding. The sublime serves to remind us that we are not so in harmony with nature that we are tied to it. In other words, we are free rational subjects and may even hope for the life everlasting.

The philosopher-poet Friedrich Schiller borrowed the connotations attaching to the beautiful and the sublime in his effort to persuade his readers that modern poetry should not be unfavorably compared to that of the ancients since they are two radically different kinds of poetry, each having its own value. The "naive" poet of antiquity is in harmony with nature and produces poetry as if by instinct. The "sentimental" poet, on the other hand,

> reflects upon the impression that objects make upon him, and only in that reflection is the emotion grounded which he himself experiences and which he excites in us. The object here is referred to an idea and his poetic power is based solely upon this idea. The sentimental poet is thus always involved with two conflicting representations and perceptions—with actuality as a limit and with his idea as infinitude. (Schiller 1966, p. 116)

Schiller extended these characterizations to embrace the arts generally and in so doing suggested that the ancients and the moderns have strengths in different media. Antiquity's perfect accord with finite nature explains its undoubted superiority in the plastic arts, particularly sculpture. The modern, however, has the advantage in poetry, where ideas and imagination take the lead. So the ancient poets "are victorious too in the simplicity of forms and in whatever is sensuously representable and *corporeal.*" The modern poet "can nonetheless leave them behind in richness of material in whatever is insusceptible of representation and ineffable, in a word, in whatever in the work of art is called *spirit*" (pp. 114–115).

The beautiful and the sublime reappear in a somewhat revised form in Hegel's lectures on aesthetics, modified partly by his reading of Schiller's *Naive and Sentimental Poetry* and *On the Aesthetic Education of Mankind*. There they become the two final stages of art's historical development through the symbolic, classical, and romantic stages. Hegel understands the classical as the product of a consciousness whose idea of the ultimate reality or divinity is consistent with embodiment. Antique sculpture is beautiful because Greek gods were the sort that could be perfectly represented in material form. Beauty is rationality fused with, and happy in, a sensuous medium. For Hegel, Greek sculpture is an unsurpassable pinnacle of artistic achievement, an unchanging aesthetic ideal, even if our taste has now moved on.

In preclassical or symbolic art, such as the ancient Egyptian, mind or spirit has not yet penetrated the obdurate object. These art objects are enigmatic and puzzling, a poor medium for self-reflection, but an eloquent expression of a consciousness that cannot find a way of reconciling abstract thought and particular things. Hegel regards the Sphinx as a symbol of the Egyptian spirit. "It is, as it were, the symbol of the symbolic itself . . . they are recumbent animals out of which the human body struggles . . . the human spirit is trying to force its way forward out of the dumb strength and power of the animal, without coming to a perfect portrayal of its own freedom and animated shape" (Hegel 1975, p. 465). This "perfect portrayal" is the achievement of classical Greek sculpture.

In the postclassical romantic phase, mind withdraws from externality because it has reached a stage of consciousness that recognizes that its ideas, particularly the idea of divinity, are not suitable for expression in material form. The kinds of arts that are typical of this phase are therefore those less tied to physical substances—painting, music, and poetry rather than sculpture or architecture. (This recalls Schiller's judgment about the respective strengths of the ancients and the moderns.) Ideal beauty is doomed to disappear. "The simple solid totality of the ideal is dissolved and it falls apart into the double totality of (a) subjective being in itself and (b) the external appearance" (p. 518). This withdrawal from the external or, as Hegel puts it, this killing of immediate reality, is figured by the crucifixion of Christ. While the Greeks understood death as a negation only, the Christian religion understands it as a negation of a nullity. Romantic art therefore does not try to idealize the body; rather "it turns its back on this summit of beauty; it intertwines its inner being with the contingency of the external world and gives unfettered play to the bold lines of the ugly" (p. 527).

Hegel is in fact somewhat ambivalent about the summit of beauty achieved by the Greeks. He remarks that the sculpture of antiquity leaves us somewhat cold. Painting, unlike sculpture, "reveals its purpose as existing not independently on its own account but for subjective apprehension, for the spectator" (p. 806). In some of Hegel's descriptions of classical art, it is the sculpture itself that is cold: "When the classical ideal figure is at its true zenith, it is complete in itself, independent, reserved, unreceptive, a finished individual which rejects everything else" (p. 523). Similarly, Schiller compared the naive poet to the virginal Diana, shunning intimacy in her forest (Schiller 1966, p. 106). While the Greek gods rebuff us with their aloof perfection, the Christian God makes himself known as a familiar sort of man caught up in the contingencies of everyday life. A devaluation of the body makes imperfection, accident, even ugliness acceptable in art. Whereas in classical art there is a perfect unity of form and content, in romantic art the form/content relation is contingent: an ugly body can be the vessel of spiritual beauty.

It is not difficult to demonstrate that Riegl derives much of his conception of the optic/subjective ideal from Hegel's morphology of the romantic phase of art. There is a gap of eight years between the appearance of *Questions of Style* (1893) and his next major study *Late Roman Art Industry* (1901). During that time Riegl was assembling and synthesizing the elements of his mature historiography. The publication in 1966 of an unpublished book draft and lecture notes, both written between the years 1897 and 1899, makes it possible to see the raw material out of which his mature work is fashioned. In this volume, called *Historical Grammar of the Visual Arts* (*Historische Grammatik der bildenden Künste*), there is a section on the history of art as the history of different *Weltanschauungen*. Riegl's characterization of the early Christian period corresponds to Hegel's conception of the beginnings of a romantic form of art. With the rise of Christianity and its belief in a redeemer made flesh, Riegl thought there was a new tolerance for the imperfections of nature. Deformed, ugly nature could then be a carrier of spiritual beauty. Just as ugliness has a place in this art, so Christian ethics extended value to the weak, suffering, or oppressed. In this new context, the goal of art as idealization of nature gave way to a new conception:

> Hence the ancient Christian submitted to the imperative postulate: down with perfecting the corporeal, that is, with the beautification or the idealization of nature! That which is imperfect in itself should be artistically produced as imperfect, just as it reveals itself in nature, and thus elevated to the precious vessel of art! (Riegl 1966, p. 37)[8]

He remarks on the emergence in late Roman times of representations of the crucified Christ—"that utterly anti-antique glorification of suffering and transience" (p. 38). A more distinctively "Rieglian" observation is made when he attempts to show how the art of this period attempted *formally* to convey spirituality in art. It accomplishes this by giving equal prominence to both figure and ground so that the eye is attracted not to the motif as such, but rather to a

shimmering of light and shade. "The task thus lay in the following: to utilize a motif and yet to suppress its quality as a motif. This was accomplished principally by using every means to give the ground, which should contrast with the motif, an independent meaning" (p. 102).[9] This coloristic surface is the visual correlate of intangible spirituality and also expresses an egalitarian ethic: "For within coloristic harmony there is no stronger that is served by the weaker as a foil: the eye observes only a multiplicitous whole, out of which no dominant figure emerges" (p. 102).[10]

These metaphorical connotations that Riegl reads in late Roman and early Christian art are superseded in *Late Roman Art Industry* by a far more sophisticated sense of the way this art is allied to the spiritual. Tactile disintegration is not just a sign of subjectivity or spirituality, it actually provides an occasion for the exercise of our imaginative faculties. Painterly styles call on the activity of subjective thought to bring the play of light and shadow into a *subjectively* unified plane. In *The Dutch Group Portrait,* this sense of imaginative supplementation is further elaborated to include an engagement with the depicted figures. Here tactile disintegration, spectator involvement, and egalitarian ethics are skillfully interwoven. In Dutch group portraits, the figures are held together not by subordination to a dominant figure but by their rapt attention, and the spectator is encouraged to enter imaginatively into the scene, closing its circle. The binding element is psychological. In Rembrandt's late works, like *The Syndics of the Clothdrapers' Guild,* this imperceptible medium of coherence is amplified by the figures' immersion in a coloristic shallow space.

It seems clear that Riegl learned a great deal from Hegel. Not just the optic or subjective ideal but, as we shall see, the haptic or objective ideal also has a precursor in Hegel's *Aesthetics.* So the whole historical trajectory of Riegl's architectonic runs from Hegel's symbolic to romantic phases. But we must be careful not to import the Hegelian understanding of art's purpose into Riegl's historiography. For Hegel, the purpose of his constructing a systematic philosophy of art

was to demonstrate what role art plays in the mind's project of overcoming its alienation in objects or nature and of its self-recognition as pure spirituality. The artist transforms external nature into an object in which mind can decipher itself: "this purpose he achieves by the modification of external things upon which he impresses the seal of his inner being, and then finds repeated in them his own characteristics" (Hegel 1905, p. 95). The products of past culture are intelligible and valuable to us in so far as they have contributed to that project. The whole history of western art is conceived as a progression of self-transcending stages whose final culmination is the transcendence of art itself in thought. In other words, the ultimate objective of art is to make itself obsolete. Art "has lost for us genuine truth and life, and has rather been transferred into our ideas instead of maintaining its earlier necessity and occupying its higher place" (Hegel 1975, p. 11). Art is just one of the ways mind makes the world its own by giving it a discursive, thoughtlike character.

There is a marked difference between Hegel's conception of art's purpose and the one put forward by Riegl. Riegl does not regard art as a means to the end of its own demise as it is absorbed in and transcended by religion and philosophy. Rather, he believes that fundamental attitudes to the world, perhaps ones not clearly articulated, are given a perceptual embodiment or realization in art. He uses Hegel's multiple morphology as a basis for validating different stylistic types as different attitudes to the world. In other words, Riegl wishes to avoid a teleology like Hegel's that values later forms of art (or consciousness) as higher, or closer to the goal toward which art strives. He also wants to overcome the traditional high aesthetic evaluation of Greek art, still adhered to by Hegel, that makes art history a history of bud, bloom, and decay. Yet there remains a problem in adopting the morphology while trying to avoid the teleology; inevitably some of the latter seeps through. Riegl also overcomes the feature of Hegel's theory that makes art symptomatic of developments in another sphere, the view of mind unfolding through history while art follows after, providing sensuous embodiments. Although, for Hegel, art has the necessary task of reconciling the oppo-

sition between mind and nature by being an expression of mind in a sensuous medium, it is ultimately subservient to the end of self-knowledge. For Riegl, aesthetic ideals imply a whole range of attitudes, values, ideologies, without subserving those ends.

There is another major discrepancy between the general philosophical positions of the two. Hegel thinks that mind is capable of complete and completely lucid knowlege. This comes about by a process of making ever more refined articulations of the world and then discovering that the world is mind's own formulation. Riegl, on the other hand, has a more Kantian perspective: the world remains a stubborn, alien thing-in-itself outside our most complex and internally coherent formulations. This contrast is clearly marked in the following passage from Riegl's *The Dutch Group Portrait:*

> All life is a constant antagonism between the individual ego and the surrounding world, between subject and object. Man in a state of culture finds a purely passive role toward the world of objects impossible, and sets out to regulate his relation to it as one of independence and autonomy. He sets out to do this by seeking a further world outside himself by means of art (in the widest sense of the term) alongside that natural world that was none of his doing. (Riegl 1931, p. 280)[11]

Riegl's position is informed by a critical, post-Kantian view of the limits of knowledge, according to which we can construct coherent worlds but their relation to the external world is ultimately unknowable. This position has important consequences for his historiography. Because there can be no culmination of history, any sense of progressive development within history is weakened and, as a result, the whole range of articulations of the visible, each period style, is granted a measure of epistemological as well as aesthetic validity. A comparison of Riegl's conception of the haptic ideal with Hegel's characterization of the symbolic phase of art will bear this out.

According to Hegel, the art of Chinese, Indian, and Egyptian peoples is aesthetically defective because their ideas are abstract, not concrete or determinate. He says that "they could not master true beauty because their mythological ideas, the content and thought of their work, were still indeterminate, or determined badly" (Hegel 1975, p. 74). Hegel saw in the stiffness and regularity of Egyptian art a sign of the constraint mind felt, at this stage, confronted by alien matter. For Riegl, regularity and symmetry in art are signs of a *Kunstwollen* that wishes to create a perfect world quite different from the chaotic world of ordinary perception. An unambiguous, planimetric art object is what satisfies this aesthetic ideal. Riegl is indebted to Hildebrand's idea of the "near view" of objects for his understanding of the significance of strict planimetric representation. According to this theory, a plane surface is clearly graspable, while space or depth requires very complex mental operations. Riegl does not say that the Egyptians were incapable of these operations, but only that an object conceived as thing-in-itself, that is, as prior to the disintegrating effects of perception, was a satisfying appearance in the face of what seemed to be arbitrary, threatening, shifting appearances. This is rather different from Hegel's understanding of symbolic art as having its characteristic appearance because mind has not yet recognized its own formative activity.

Although highly haptic styles were not, for Riegl, aesthetically defective, yet their bold pattern against ground and the task of perfecting nature in art carried for him connotations of an ethically defective social hierarchy: "Only perfection has a right to artistic existence. In the art as well as in the life of antique peoples only the right of the strongest is recognized" (Riegl 1966, p. 25).[12] Although he does not dwell on it, I think it is important for him that the *Kunstwollen* of an aesthetic of disintegration occurs in epochs when the "right of the strongest," as he put it, is challenged. Late antiquity coincides with the rise of Christian ethics and seventeenth-century Dutch civilization is celebrated for having won political and religious autonomy from Spain. These connotations are certainly part of Riegl's hope for the future. In the *Communist Manifesto,* Marx's memorable phrase "All

that is solid melts into air" refers to the capitalist destruction of traditional values in the maelstrom of modernity. For Riegl, a very similar sense of modernity has a more positive force. It is as though the partial dissolution of self-contained egos is necessary for the attainment of mutual understanding, sympathy, community, or association in groups without coercive organization. The desubstantialized bodies of Rembrandt's late work and his achievement of a coherent group portrait in which no figure is dominant stood for Riegl as aesthetic realizations of a utopian vision.

Riegl's highly original inflection of the aesthetics of disintegration was a new way of thinking the connection between artistic achievement and the attainment of freedom. In his theory, the haptic ideal is associated with the traditional idea of artistic mastery as exhibiting a freedom from constraint. This "constructive" sense of freedom, as Michael Podro puts it, "is exhibited by the artist in command of his material, composing and controlling pre-existent elements, absorbing them into his own formulation" (Podro 1982, p. 6). The optic or subjective ideal stands for a completely different understanding of freedom, one that involves a degree of passivity, a relaxing of control, even a partial loss of self. In *Die Entstehung der Barockkunst in Rom* (a posthumously published series of lectures), Riegl describes the will as an "isolating, tactile (self-containing) element" and emotion (*Empfindung*) as an "interconnecting, optic (self-dissolving) element" (Riegl 1908, p. 34). One type of *Kunstwollen* wants to subordinate the world to its will, while the other wishes to receive the world. This latter is freedom as creative receptivity. It has precursors in the uncontainable sublime, in Schiller's sense of the positive effects of the sense drive on an overvigilant ego, and in Hegel's theorization of romantic art as an effort to represent the unrepresentable and an acceptance of contingency and ugliness. Riegl wrests a new ideal of freedom out of the arms of fatalistic despair and a new conception of artistic coherence out of the ruin of representation.

The Articulation of Ornament

The most persistent criticism of nineteenth-century design was its inappropriate use of naturalistic motifs. The slogan reiterated by midcentury reformers such as Owen Jones, Henry Cole, and Richard Redgrave among others was that, in the area of ornament as opposed to art, one must follow the laws of nature, rather than simply imitate nature. In a way this complicated the situation, for, as Gombrich notes in his major study of the history of ornament, *The Sense of Order,* there was "a desperate need for an alternative to the two guidelines previously offered to artists and designers—the study of nature and the acceptance of tradition. The first had been severed by the reformers, the second by industry" (Gombrich 1979, p. 54). The reformers had several objections to naturalistic motifs used, for example, on manufactured carpets: illusionistic floral design is too obtrusive for a floor covering that should serve only as a backdrop; it is illogical because we don't walk on real flowers; it is a sham and the shadowing necessarily false. In 1896, Otto Wagner was repeating the same arguments: "Completely objectionable is every restless and robust line or one that actually makes the form appear three-dimensional, thereby producing uncertainty and uneasiness in use. . . . A rich *en-plein* ornament will always clash with the fittings in the room" (Wagner 1988, p. 119).

The reformers had varying solutions to the problem of degraded taste. Ruskin and Morris thought that revolutionary change in the social relations of production, with a return to satisfying creative labor, was the only solution. Jones and Redgrave, however, accepted the necessity of industrial mass production. Owen Jones's faith in the innate good taste of uncorrupted peoples is presented in his lavishly illustrated *Grammar of Ornament* (1856), which reproduces and comments on the beauties of ornament throughout the ages. He begins with an assessment of primitive ornament, offering an illustration of a tattooed Maori head preserved in a museum in Chester. For Jones, the decorative pattern proves that ornament is universal, almost instinctive in man. Although he calls tattooing "a barbarous practice," still "the principles of the very highest ornamental art are manifest,

every line upon the face is the best adapted to develop the natural features" (Jones 1886, p. 13). The reason why modern design has foundered is because the manufacturing process has blunted the instinctive aesthetic sense with its "fatal facility" (p. 155). He recommends that "if we would return to a more healthy condition, we must even be as little children or as savages; we must get rid of the acquired and artificial, and return to and develop natural instincts" (p. 16).[1]

This is the broad context in which Riegl's *Questions of Style* must be understood. He was keeper of a rich collection of oriental rugs in the textile department at the Austrian Museum of Art and Industry, an institution established in 1864 and modeled on the innovative South Kensington Museum, now the Victoria and Albert Museum in London. When Riegl wrote his first book, *Antique Oriental Carpets* (1891), on the origins of certain motifs in the rugs that he traced back to late antiquity in the West, he was aware of how much the English reformers had praised the design of these carpets. *Questions of Style* is a more ambitious book, although it covers some of the same ground. It attempts to trace a history of plant motifs from ancient Egyptian to western medieval times and to the development of the arabesque in the East. Riegl was clearly inspired by an extraordinary book called *The Grammar of the Lotus* by William Goodyear of the Brooklyn Institute of Arts and Sciences, New York. This book was published in 1891, so Riegl must have worked very quickly to produce his own two years later.[2]

It becomes clear in the opening pages of *Questions of Style* that another context for understanding its argument is as an attack on the latest theories in classical archaeology. A few scholars are singled out and accused of holding a vulgarized version of Semper's theory of the origin of decorative motifs: "One scarcely needs to reflect on those extremists who elucidate all ornamental artistic production as original, wishing to regard each appearance in the field of decorative art as an immediate product of the available material and purpose" (Riegl 1893, p. v).[3] One "extremist" is Alexander Conze of the Berlin Museum, an expert in the geometric style of ornament found on artifacts of preclassical Greek civilizations like the

Mycenaean. In his book *Anfänge der griechischen Kunst,* he makes approving reference to Semper as originator of the view that the characteristic shape and pattern on these vases could be elucidated by reference to the local handicrafts of basketry and weaving, which produced characteristic patterns subsequently repeated in paint on clay vessels. He adds that curvilinear patterns can be traced back to metalwork (Conze 1870, p. 4). The other scholar criticized is Kekulé, who argued that primitive peoples only had handicrafts but that, having accidentally produced a pattern with woven materials, they admired it and transferred it to other artifacts. What Riegl found particularly objectionable was that these and other archaeologists working on finds in the Mediterranean regarded the ornament as a local phenomenon.[4] As Gombrich says, Riegl "turned against the lazy assumption that all geometrical motifs must arise spontaneously again and again from the techniques of basketry or weaving" (Gombrich 1979, p. 183).

Riegl cites a passage from Semper's monumental book *Der Stil in den technischen und tektonischen Künsten oder praktische Aesthetik* (1860–1863) that he thinks may have encouraged this tendency in archaeology.

> The transition from the intertwining of branches to the intertwining of plant fibers is easy and natural. From there one arrived at the invention of weaving, first with natural grasses and then with spun threads from vegetable or animal materials. The variations of the natural colors of the fibers suggest their use in an alternating arrangement and the *pattern* comes into being. (Semper 1878, 1:213)

Riegl is quick to point out that Semper does not in fact attribute the first pattern to a mere accident. Rather the weaver recognizes the *potential* of intertwining colored grasses to produce a decorative effect (Riegl 1893, p. 13). This apparently minor distinction makes all the difference in the world; in the first explanation

art is determined by given materials or circumstances, while in the second the artist makes creative use of these. The idea of the *Kunstwollen* is an emphatic affirmation of this creativity.

One way to counter the thesis of the spontaneous generation of ornamental motifs is to demonstrate that they have a continuous history. For this purpose, Riegl seized on Goodyear's *Grammar of the Lotus* (1891), which was based on a hypothesis of widespread dissemination of motifs. In the book on oriental carpets, Riegl had outlined a history of the evolution of plant motifs from late antiquity to the Middle Ages in the Near East. Goodyear's book begins with Egyptian plant motifs and stops in late antiquity. Riegl saw that he could extend Goodyear's story and in the process disprove the naive interpretation of early Mediterranean ornament. Goodyear understood ornament as having symbolic significance. In his book, he demonstrated that many ancient Egyptian motifs that had been identified as various plants are actually all variations on the lotus. The lotus assumes such centrality because, as an attribute of Osiris, it is a symbol of the sun, the resurrection, and creative force and power. With this *idée fixe,* Goodyear traces the transformations of the ubiquitous lotus motif: it appears in the numerous guises of papyrus, rosette, palmette, Ionic capital, anthemion, egg and dart, ivy leaf, fleur-de-lis, and so on. This inventive but overstretched case for the survival and dissemination of the lotus motif was just the sort of lever Riegl needed to uproot the materialist hypothesis.

Riegl's reading of *The Grammar of the Lotus* is, however, far from uncritical. He finds it reductive in another direction: "Where people have apparently followed an immanent artistic urgency, there Goodyear lets symbolism reign, just as the materialists of art theory in the same instance let technique or fortuitous, blind purpose predominate" (Riegl 1893, p. xii).[5] It is instructive to observe where and why Riegl contests Goodyear's identifications. He agrees with Goodyear that the so-called papyrus motif is a simplified lotus in profile view, but while Goodyear contends that the rosette is a representation of the symbolically significant seedpod

or ovary at the center of the flower, Riegl believes it to be a simplified version of the full-face view of the blossom. The aesthetic device of simplification takes precedence in Riegl's identification. Or, to cite another example, both hold that the volute motif (fig. 3) is formed through an exaggeration of the two outer sepals of the three that are visible in a profile view of the lotus. Goodyear ascribes their curled appearance to the look of the actual plant when the sepals fade and droop downward; Riegl suggests that their form might be better explained as an aesthetic decision to mark a contrast between pointed petals and rounded sepals. Similarly, Goodyear will describe the plug shape between the two volutes as a remnant of the middle sepal, while Riegl ascribes its presence to the "postulate of gap-filling," a purely aesthetic device that is characteristic of ancient Egyptian *horror vacui* (Riegl 1893, p. 62).

Perhaps the most significant disagreement Riegl had with Goodyear concerns the origin of the spiral motif (fig. 4). Goodyear announces that "it can be proven to satiety that there is not one spiral in Greek ornament that is not a lotus derivative" (Goodyear 1891, p. 77). The apparently geometric design is, on his view, a close relation of the lotus via an extension of the curling volutes. Because Goodyear is so wedded to the hypothesis of the ubiquity of the lotus symbol in ornament, he does not like to admit the possibility of meaningless, purely decorative, geometric motifs. Riegl, on the contrary, argues that geometric design is not derivative but stands at the very beginning of ornamentation, after an initial period of highly imitative sculpture: "the immediate reproduction of natural things in their full bodily appearance" (Riegl 1893, p. 20). Referring to fairly recent archaeological finds in caves of the Dordogne region of France that revealed remarkably realistic animal sculpture from the Paleolithic period of prehistory, Riegl traces a development as follows:

> Then we have a whole sequence of developmental phases in which this plastic character gradually evaporates; first a sculptural figure that clings

3
Volute motif
Riegl, *Stilfragen*, p. 64

4
Spiral with gap-filling lotus blossoms
Riegl, *Stilfragen*, p. 71

to the plane, then a more of less high relief, a low relief, and finally a mere engraving often accompanied by this low relief, in which one merges with the other. (p. 20)[6]

Riegl saw this process as a gradual deviation from nature that implies a progressive liberation of the imagination. Outlines do not exist in nature; they have to be discovered.

> From this moment art truly won its infinite capacity for representation; by dispensing with corporeality and satisfying oneself with appearance, one has made the most essential step to liberate one's imagination from the strict observation of the real forms of nature and lead it toward a freer treatment and combination. (p. 2)[7]

Once "liberated," line can become the basis of an art form that uses no natural models. The geometric style makes line conform to fundamental artistic principles like symmetry and rhythm. Subsequently, motifs based on natural models like the lotus are introduced and subjected to the same principles of design as line.

The analogy between Riegl's attitude to natural motifs and that of the contemporary Swiss linguist Ferdinand de Saussure (1857–1913) to onomatopoeic word origin is strikingly close. In the *Course in General Linguistics* (1916), Saussure defends the view that linguistic signs are arbitrary, first by pointing out that many words only seem to have a suggestive sonority and then by showing that genuinely onomatopoeic words, once introduced into the language, "are subjected to the same phonetic and morphological evolution as other words" (Saussure 1974, p. 69). There is plenty of textual support for invoking this linguistic analogy (see Nodelman 1966). Both Semper and Riegl explicitly make this connection. In the prolegomena to *Der Stil,* Semper compares his own procedure to what is in fact the method of comparative philology initiated by Franz Bopp:

> Just as in the most recent researches into linguistics the aim has been to uncover the common component of different human linguistic forms [*Idiome*], to follow the transformation of words through the passage of centuries, taking them back to one or more starting points where they meet in a common ur-form . . . a similar enterprise is justified in the case of the field of artistic enquiry. (Semper 1878, 1:1)

Goodyear's procedure would seem to owe something to this model as well. Riegl's linguistic analogy makes it clear that he, in keeping with subsequent linguistic theory, is no longer interested in ur-forms:

> Language also has its elements and the developmental history of these elements is called the historical grammar of the language in question. He who merely wants to speak a language does not need the grammar. . . . However, he who wants to know why a language followed this and no other development and to grasp the place of language within the whole culture; he who, in a word, wants a scientific understanding of the particular language, requires the historical grammar. (Riegl 1966, pp. 210–211).[8]

Riegl's procedure in *Questions of Style* most closely resembles that of the neogrammarians who discovered that sound shifts in the evolution of languages are governed by laws that admit of no exceptions. When plant motifs are brought into ornament they are made planimetric to accord with the geometric forms, and this, says Riegl, "involves a conscious transformation of these figures into a linear schema, just as geometric ornaments are combinations of line according to the laws of symmetry and design" (Riegl 1893, p. 30).

Riegl's insistence on the "unmotivated" (as Saussure would say) character of the geometric style is another stick with which to beat the hypothesis that geometric design is derived from techniques of basketry and weaving. To further his case,

Riegl adduces the example of the Maori of New Zealand who must have independently discovered the spiral motif. The Maori's extensive use of the spiral is not used in conjunction with plant motifs. Nor is it the case that it derives from metalworkers' coiled wire, a popular hypothesis for the genesis of this motif, because the Maori do not work metal. Rather they chip spirals out of the recalcitrant materials of stone and wood, and also tattoo their faces with them (Riegl 1893, pp. 75ff.).

This summary of Riegl's argument in *Questions of Style* has so far suggested two fundamental concerns: first, that the proper study of ornament is an historical tracing of transformations and disseminations; second, that such a history is forwarded by the pressure of principles of design. His analysis of the palmette motif clearly shows just such a design-driven evolution. Riegl first breaks down the motif into its component parts (fig. 5). It is a synthesis of two projections (full-face and profile) of the lotus blossom, modified by a number of aesthetic considerations. In addition to the gap-filling plug, there are also the two drop-shaped forms serving the same aesthetic function. The motif also has highly differentiated volutes and petals. This type also displays a redundancy or "pleonasm" (p. 66) because it retains the original pointed calyx beneath the enlarged volute calyx. The natural model is more or less grist for an inventive aesthetic mill.

Riegl's efforts to demonstrate historical continuities are usually sound, but his interpretation of the derivation of the acanthus leaf motif found on Corinthian capitals seems strained. Like other scholars in the nineteenth century he was unmoved by the poignant Vitruvian anecdote about the origin of this form, but he had an added incentive to mistrust the story, for it is a variation on, or very likely the original of, the theory of spontaneous generation. The ancients believed the Corinthian capital was inspired by a basket of toys left on a girl's tomb that had become overgrown with the acanthus weed. If the motif were based on a natural appearance, in Riegl's history of ornament it would be an unprecedented

5

Palmette showing lotus in profile and half full-face views

Riegl, *Stilfragen*, p. 59

6

Variations on the palmette

Riegl, *Stilfragen*, p. 211

deus ex machina quite outside "the continuous, normal course of the development of antique ornament" (p. xv). While Riegl acknowledges that the Greeks wonderfully animated motifs handed down to them, giving them a sense of movement and a more naturalistic feeling, this does not imply that they directly imitated real living plants (p. 231). He points out that early versions of the acanthus motif do not really resemble the plant and asks: "Why should a weed assume such importance in the history of ornament?" Instead he argues that the motif is not based on the acanthus at all: "The acanthus ornament is in my view originally nothing other than a palmette, or a half-palmette, transformed into a three-dimensional sculpture" (p. 218). Riegl traces a gradual transformation of the stiff petals of the Egyptian palmette, which, adapted by the Greeks, fall to right and left by the second half of the fifth century B.C. In a later example, the bases of the petals sway out from a central axis while the tips point inward (p. 211). This motif, transferred to sculpture, as for a capital, could not reproduce the deep divisions between the petals, and the "acanthus" motif was born (fig. 6).

Gombrich discusses at some length Riegl's derivation of the acanthus motif in *The Sense of Order*. He makes the acute observation that what Riegl presents as transitional forms of the palmette-acanthus seem to show a palmette, with the small chalice-like leaves on the stem of the acanthus plant linking the palmette to a scroll motif. The vegetal form perhaps suggested itself as a way of disguising visually awkward joints and tendril branchings (Gombrich 1979, pp. 184–189). It seems quite likely that this subsidiary connecting device eventually became the major motif in the acanthus leaf ornament. No doubt Riegl was led astray because he was attracted to the intellectual symmetry of the idea that the full-face lotus was the origin of the acanthus motif of the Corinthian capital, just as the profile lotus was the origin of the Ionic capital.

Although Riegl is occasionally blinded by his project and procedures, they sometimes yield insights denied to researchers like Goodyear who have very little sense of the importance of formal innovations. For example, Riegl complains that

Goodyear overlooks the "Hellenistic" kernel in the art of the Mycenaeans and so fails to note the most important moment in the history of classical ornament (Riegl 1893, p. xii). While the flower motifs of early Greek ornament are indeed oriental in origin, the connecting tendril (*Rankenverbindung*) is specifically Greek and, crucially, not based on a natural model. The Egyptians used a geometric curved line to connect motifs in a row and also represented a "stem" motif, although it was conceived as a geometric form. The motif that proved crucial for later development, however, was the geometric scroll pattern with lotus blossoms filling in the gaps (fig. 4). According to Riegl, the Mycenaeans borrowed this motif and gave it the more vegetal, naturalistic character of a wavy line executed in a relaxed manner: "The curved line of the ancient Egyptians is stiff and lifeless compared to the free manner and means in which the same appearance is carried out" (p. 120). Hellenistic artists adapted this graceful tendril used as a means of connecting motifs in a frieze and added branching tendrils so that it became a means of connecting motifs over a whole surface. Riegl is adamant that the development of the wavy tendril motif was a development *within* the history of ornament, brought about by the aesthetic need to connect motifs: "The connection of a series of lotus motifs with wavy lines has no natural model; it is without doubt a purely ornamental invention" (p. 70). If neither the imitation of nature nor the imitation of handcrafted artifacts can satisfactorily explain the history of ornament, then some kind of intrinsic developmental principle—the *Kunstwollen*—must be postulated. This term does appear in *Questions of Style* (p. vii), but not systematically; he also used the phrase "immanent artistic creative drive" (*immanenten kunstlerischen Schaffungstriebe*, p. xii).

Riegl attached a great deal of importance to the tendril motif and in doing so reevaluated the contribution of Hellenistic art. The Greeks resolved the two major tasks facing ornamental design in early antiquity—the perfecting of individual motifs and the graceful interlacing of these motifs.

A unifying historical thread can be traced in both directions from the most ancient Egyptian to Hellenistic times, that is, up to the point that the Greeks had brought the development to its culmination: at which point it knew, on the one hand, how to lend perfect formal beauty to the individual component motifs and, on the other—and this is its special merit—had created the most pleasing type of connection between the individual motifs, namely the "line of beauty," or the rhythmically waving tendril. (p. 47)[9]

In retrospect, Egyptian art can be characterized by its disconnectedness, by its placing of motifs in a simple row, or to cover a surface, by repeating alternating rows of motifs in opposing directions. Hellenistic art, on the other hand, attains a high degree of fluency, interconnectedness, and variation (p. 234). The Hellenistic tendril is, so to speak, allowed to grow freely over the garden wall: "The elegant movement is apparently completely free; the symmetry, though still adhered to, does not impress itself on the eye in a noticeable way" (p. 236). The elaboration of the all-over pattern is carried forward in characteristically different ways in western late antique and medieval ornament and in Byzantine through to Moorish versions of the arabesque.

What Riegl seemed to be aiming at in *Questions of Style* was a history of ornament with a single, continuous trajectory—from the "simple row" of the Egyptians to the systematically elaborated, all-over pattern of late antiquity. Although the analogy is not explicitly drawn by Riegl in this context, this is clearly an achievement of the same order as the mind's formulation of coherent experience and discursive thought. Implicit in this achievement is an enhanced intellectual flexibility and spiritual freedom. Riegl evokes the moral connotations of stylistic forms on several occasions, but perhaps most explicitly when he equates the wavy tendril with Hogarth's "line of beauty," cited in English in the text (p. 47).

Particularly when discussing the elaboration of an all-over pattern, Riegl uses a vocabulary that draws on contemporary philosophy of mind: for example he suggests that the task of Hellenistic ornament related not so much to the handling of individual motifs "but rather to the existing mass of elements in the interrelated system" (p. 234). The philosophical basis for this developmental psychology of motifs and their elaboration found in *Questions of Style* is a particular vision of the mind and its activity put forward by the German philosopher Johann Friedrich Herbart. The Herbartian conception of mental activity, which had a great vogue in the nineteenth century, is concerned with the mind's project of ordering the elements of experience into a systematic whole. As a result, its use as a model of artistic development carries a built-in bias in favor of highly articulated systems. According to Herbart's theory, the mind receives individual, disparate presentations (*Vorstellungen*) that must be either assimilated with past or contiguous presentations or else suppressed. In this way, the mind constructs a coherent picture of the world and, at the same time, maintains its own unity. The mind "must either assimilate or mutually cancel out the manifold of diverse presentations if personal identity is to be possible" (Herbart 1850, 1:98).

Some of the details of Herbart's description of mental activity are especially well suited for application in an art historical context, where motifs and their connection take the place of presentations and their systematic elaboration. Herbart argues that once presentations are maintained by the mind they acquire a certain force capable either of inhibiting other new presentations or enforcing the realization of similar ones. The presence of mutually inhibiting presentations is a problem for consciousness that must be resolved by the expulsion of one presentation or by weakening the force of both. While different qualities of the same type, or as Herbart expressed it, "from a single continuum," come into conflict, presentations of different types, say color and sound, are easily fused in experience. Herbart brought this conception of the reciprocal inhibition and fusion of presentations to bear on the problem of aesthetics: "It all depends on how the different rules of reproduction that are produced by the individual forces of the design fit together.

In accordance with how far they facilitate each other or conflict in the unfolding of their series, the object will be beautiful or ugly" (Herbart 1850, 2:133).[10] Another feature of Herbartian psychology that finds aesthetic application, and that underlies Riegl's sense of ornamental organization, concerns the organization of presentations and concepts. According to Herbart, the mind tends to subsume an increasing range of concepts under ever more general terms, establishing orderly associations of ideas and patterns of expectation that facilitate and refine one's apprehension of the world. The mind constructs a formal logical system so that "the ease of a general synopsis is enhanced as far as possible" (Herbart 1850, 1:89). Ornamental motifs could similarly be regarded as initially incompatible and discontinuous until the Greeks succeeded in uniting them into a coherent, systematic unity that facilitates aesthetic enjoyment.

Riegl was not the only art historian to adapt Herbartian psychology to a theory of the progressive articulation of motifs. In 1893, the same year that *Questions of Style* appeared, Heinrich Wölfflin published an article very clearly inspired by Herbart called "Die antiken Triumphbogen in Italien" ("Antique Triumphal Arches in Italy"). A comparison of the two appropriations reveals what different uses they made of the same theory. Riegl used it to underpin the high valuation he placed on late antique all-over ornament, while for Wölfflin it served to reinforce the classical norm. Wölfflin began with the assumption that the history of western art had two peaks of development, one in antiquity and one in the Renaissance. The essay aims to show that the familiar division of Renaissance art into early, high, and late periods can also be seen in antiquity. He chose the triumphal arch as a building type and traced an historical development that, like Riegl's, involves increasing articulation and differentiation, together with enhanced integration (fig. 7).

Wölfflin first isolated the basic elements of the arch: a lower mass of wall with piers and entablature pierced by a gateway, an attic story that usually carries an inscription, and, on top, a triumphal statue. "Here, crowded together in a small

space, is an abundance of motifs capable of development" (Wölfflin 1946, p. 52). The development consists of the progressive improvement of the formal relationships between the elements. Originally "crowded together," they finally become systematically related to one another. "Here a process is taking place in almost typical purity that is repeated in all architectural development: instead of similar forms come differentiated forms, instead of loose connection, a whole in which each part is integrated" (p. 53).[11] Principles of formal articulation are at work organizing these elements in a rational way, in the same way that Herbart saw the mind's activity taking up and systematically elaborating the raw material of its presentations.

The example of an early Roman arch seemed to Wölfflin uncomfortably proportioned and incompletely integrated. The low, wide gateway of the Arch of Aosta (25 B.C.) is flanked by narrow walls. Only dwarf pilasters fit the space between the high base and the arch vault (p. 54). The top of the archivolt meets the entablature abruptly, and there is no closing console to smooth the transition between the two (p. 55). A later example, the Arch of Gavi in Verona, shows better proportions, but a new element, the Corinthian capital, is not properly integrated. With its dominant vertical lines, the capital is designed to carry a horizontal load and cannot convincingly support the vertical springing of an arch. Their juxtaposition therefore creates a dissonance, or in Herbart's terminology, they are mutually inhibiting presentations (p. 58). Another new element, however, resolves an ambiguity present in the Arch of Aosta; horizontal articulation on the intercolumnar surfaces introduces a desired differentiation of forms (p. 58).

The Arch of Titus (A.D. 81) is regarded as a peak of development. A radical differentiation of elements has emerged, particularly between the supports of the arch and those of the entablature: the two support systems rest on bases at different levels and the acanthus capitals are used for the entablature while a simple cornice supports the arch. "No longer are two analogous forms presented that compete with each other: rather it is attempted to keep these elements optically separate in

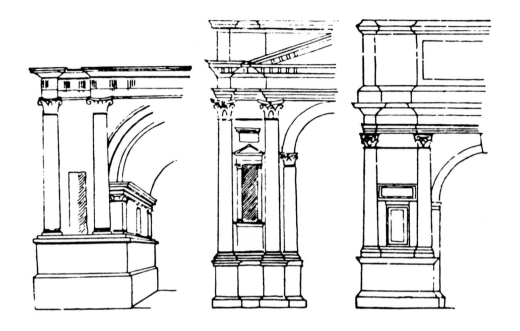

7

From Heinrich Wölfflin's "Die antiken Triumphbogen in Italien"
drawings showing from left to right
the Arch of Aosta, Arch of Gavi, and Arch of Titus

every way" (p. 59). Other formal resolutions are observed. An interval left between arch and entablature is bridged by a console, effecting a smooth transition between formerly discontinuous elements. The spandrels now accommodate sculpted victories (p. 60)—apparently in accordance with the principle of design Riegl called "gap-filling."

A process of dissolution sets in after the achievement of perfect articulation. Highly decorated surfaces begin to lose their architectonic sense and forms are reduplicated. The Arch of Septimius Severus (A.D. 203) marks the "transformation of architecture into a painterly style" (p. 66). Wölfflin's discussion of this late Roman arch betrays a difficulty intrinsic to this critical procedure. He observes formal dissonances but adds that "one ought not to judge these dissonances according to the impression that they make in a geometric elevation on paper. In reality they are drowned by the great tracts of light and shade in accordance with which the whole structure is composed" (p. 68). Given a critical procedure that traces the historical elaboration of forms culminating in a coherent system, postclassical styles can only be regarded as lacking coherence. Wölfflin tried to avoid this conclusion, first by suggesting that the dissonances in the Arch of Septimius Severus are not a defect but a positive principle and then by claiming that, properly viewed, the dissonances disappear. It is necessary, he claims, to appreciate its painterly form of coherence. But the possibility of alternative grounds for appreciation throws the whole critical procedure into question—perhaps one should seek a different form of coherence for preclassical styles as well. In any case one is forced to surrender a monolithic view of what counts as coherence and, with it, any critical procedure that assumes such an ideal.

The problems inherent in the Herbartian developmental model of art history are more apparent in Wölfflin than in Riegl, mainly because Riegl stresses the principle of interconnectedness in pattern making, which he sees as an achievement of Hellenistic ornamentation. Postclassical styles are therefore rescued from the negative assessment of Wölfflin's essay. The very nature of the theory, however,

prohibits a multiple typology of style. The development of style in both *Questions of Style* and "Antique Triumphal Arches" is governed by abstract principles of design and tends to be somewhat deterministic and rationalistic. Riegl's reservations about the suitability of the model for the understanding of art and design occasionally surface in *Questions of Style*. While he posited abstract laws of design, he also maintained that strict adherence to them depletes aesthetic value. People's deviations from the strict rules of decorum and nature's imperfections are what make them interesting to us.

> The geometric artistic forms stand to the other artistic forms in the same way that the laws of mathematics stand to the laws of animate nature. It happens as little in the operation of natural forces as in the moral comportment of people that absolute perfection is produced: deviation from abstract laws affords now and then a diversion, arrests occasionally the tedium of eternal monotony. (Riegl 1893, p. 3)[12]

By 1909 Wölfflin was voicing similar sentiments:

> The eye wants to overcome difficulties. One should of course set it tasks capable of solution; but the whole history of art is proof that this morning's "clarity" is now boring and that visual art can afford to dispense with partial obscurity, momentary visual puzzlement, as little as music can dispense with dissonances, false endings, etc. (Wölfflin 1909, p. 336)

This is a prelude to the *Principles of Art History,* in which Wölfflin introduced a dual typology of style and a conception of periodic change in stylistic development.

Riegl responded to the difficulties of the historical procedure in *Questions of Style* by formulating a multiple typology of style. He seems to have belatedly realized that the Herbartian model carries with it a bias in favor of an aesthetic of clarity and rational articulation. In other words, its most obvious application would be as a new foundation for the reassertion of the classical ideal. This is how it operates in Wölfflin and in another art theoretical treatise, *The Problem of Form in the Visual Arts* by Adolf von Hildebrand, which was also published in 1893. Both Wölfflin and Riegl read and appreciated this book and revised their art theories in response to it. The sources of Riegl's mature historiography are diverse, but in large part his theory is a synthesis of ideas borrowed from Hildebrand and from morphologies of style in Hegel's aesthetics.

Late Roman Art and the Emancipation of Space

Questions of Style is dominated by a theory of motifs and their elaboration. The overriding purpose of the book was to prove that ornament has a continuous history and that motifs must be understood with reference to that history rather than to immediate circumstances, materials, or techniques. The problem facing Riegl in *Late Roman Art Industry* was rather different. Most nineteenth-century accounts of the history of western art did not challenge Winckelmann's assessment that art began a slow descent after the death of Alexander the Great. Judged according to criteria based on classical Greek art, it is hardly surprising that Hellenistic, late Roman, and early Christian art were not aesthetically appreciated. One notable exception to the genéral disparagement was the writing of Franz Wickhoff, the senior professor at the University of Vienna during Riegl's time. He found premedieval painting and relief sculpture suggestive of an impressionistic, subjective sort of naturalism as opposed to the objective naturalism of classicism (Wickhoff 1912). His enthusiasm for the paintings of Velázquez and Rembrandt and for late nineteenth-century impressionism made him sympathetic to nonclassical styles. Riegl took a similar line but his work is far more systematic. In *Late Roman Art Industry* he argued that late Roman art should be understood not as a decline caused by external factors such as barbarian invasions, but rather as a necessary part of the development from the antique to modern forms of representation. The period's anticlassical tendency is said to be a stage paving the way from one to the other. He wanted to show that it had its own principles of design and that it played an important transitional role in the history of art.

In order to make this case, Riegl modified the concept of the *Kunstwollen*. As first introduced in *Questions of Style,* it had asserted the independence of the decorative urge from available materials, practical necessities, or technical constraints.

> In opposition to this mechanistic conception of the essence of works of art, I substituted in *Stilfragen*—for the first time, as far as I know—a teleological one, in which I see in the work of art the result of a specific and purposeful *Kunstwollen* that asserts itself in conflict with practical purpose, material, and technique. (Riegl 1927, p. 9)[1]

In *Late Roman Art Industry,* the *Kunstwollen* became the basis of a whole theory of art history. It is a fundamental artistic intent, common to all types of art, which insures the integrity of artistic production and the continuity of art's history. Such an all-embracing scheme presupposes that one can isolate something essentially artistic in all types of art, architecture, and craft—Riegl defined this as "the appearance of objects as form and color in the plane or in space" (p. 19). The notion of some purely artistic character and the *Kunstwollen* are intimately related. The theory holds that transformations of certain highly formal characteristics of art are the result of shifts in aesthetic sensibility or of changes in the way people regard their relationship to the world.

In proposing this theory, Riegl was yet again attacking what he took to be the ascendant "sub-Semperian" theory of art. He made the radical claim that practical utility, raw material, and technique have only negative functions: "Thus the latter three factors no longer have those positive creative roles attributed to them by Semper's theory but rather restraining, negative ones: they are, so to speak, the coefficients of friction within the entire products" (Riegl 1927, p. 9). Although this recurrent polemic remains in the foreground, Riegl also intervened in other methodological disputes. For example, he launched a critique of iconography, a concern that also surfaced in his reaction to Goodyear in *Questions of Style*. Riegl excluded matters of content from consideration because he believed that they could not be fundamental artistic components, since meaningful motifs have only marginal importance in architecture and craft. In an interesting footnote at the end of the book, he explained why he thought art historians should not one-sidedly concern themselves with content or subject matter. He spoke of the "confusion between art history and iconography, even though creative art is not concerned with 'what' but with 'how,' and lets 'what' be represented, particularly through poetry and religion. Iconography thus reveals to us not so much the history of the *Wollen* in the visual arts but rather the poetic and religious *Wollen*" (p. 394).[2] While a connection can be made between these two kinds of *Wollen,* Riegl held that they must first be separated out. "In the creation of a clear

separation between iconography and the history of art, I see the precondition of any progress of art historical research" (p. 394). The distinctively artistic *Wollen* is revealed in the *handling* of motifs, not in their literal meaning. The first chapter of the book is devoted to architecture because, as a nonfigurative art, it lends itself to Riegl's formal analysis. He said that both architecture and craft reveal the nature of the *Kunstwollen* with "mathematical purity," while figurative art often distracts attention from what is truly artistic. However, many of the descriptions of buildings in that chapter are quite unintelligible without reference to the chapter on sculpture. The reason for this is that the great innovation of *Late Roman Art Industry* is based on a theory of vision that privileges relief sculpture: Hildebrand's *Problem of Form in the Visual Arts*. A brief synopsis of the argument of that book is therefore required.

Hildebrand's Problem of Form

Hildebrand's book is based on nineteenth-century post-Herbartian psychology of perception.[3] The theory, now discredited, held that the eye projects a plane image on the retina and that a three-dimensional image is constructed out of a number of these individual, two-dimensional perceptions. Vision, operating in a way analogous to touch, moves around the object and the mind synthesizes these disparate, partial sensations. This theory of vision found its way into (misguided) interpretations of cubism via Kahnweiler's influential essay.[4] Hildebrand calls this cumulative sort of vision a "near view" of objects: the closer the eye moves to an object, the more eye movements or shifts of point of view become necessary to grasp the form. On this account, the apprehension of the form of an object derives from a temporal succession of sensations and so lacks synoptic unity: "Instead of a unified synoptic impression there appear disparate individual impressions that are brought into relation with one another by means of eye movement" (Hilde-

brand 1961, p. 10).[5] A comprehensive grasp of things can only be attained from a "distant view" when the eye is immobile and can take in the total phenomenon simultaneously. "Thus we grasp a unified image of a three-dimensional complex only from a distant view, the latter representing the sole unified conception of form for acts of perception and presentation" (p. 12).[6] But the distant view lacks the full articulation of three-dimensional form attained from a near view. From a distance, we receive only an attenuated sense of form by interpreting certain features of the two-dimensional image such as shading, foreshortening, and over-lapping. "The distant view of something three-dimensional gives a two-dimensional optical impression, which, however, by means of certain characteristics of the appearance, calls up ideas of movement that are, so to speak, already latent in the appearance" (p. 11).[7] In ordinary experience, then, a problem exists for vision: its perception of the world is either a three-dimensional aggregate or a synoptic plane. Hildebrand claimed that in ordinary experience the near and distant views are antagonistic: what is lacking is a clear relation between the two-dimensional impression and the sense of the object's spatial form: "The flat optical impression and the ideas of movement surely relate to the same object, but they stand in no clear relationship to one another" (p. 12). The task of art is to reconcile these two modes of perception.

A reconciliation of the conflict that exists in ordinary perception is achieved in visual art that presents a fully three-dimensional figure in a unified plane. The account that Hildebrand offered of how this is achieved is, in fact, a perceptive analysis of the aims of classical relief sculpture. No doubt his understanding benefited from his own practice as a sculptor in the neoclassical mode. In Hilde-brand's prescriptive aesthetics, the field of the depiction must be at a certain distance and at right angles to the line of sight (p. 24). The artist should describe the contour that is most revealing. The differences between the optical plane and the form can be minimized in a number of ways: by positioning figures in such a way that steep recessions are avoided, by rendering necessary recessions

obliquely so that they can be read simultaneously "in depth" and "in the plane," by restricting the elements of the composition to stratified planes parallel to each other. These devices, together with the use of overlapping to facilitate transitions between planes, make possible a perceptual experience that reconciles the formerly incompatible operations of reading continuously across the plane and constructing a three-dimensional form (pp. 27, 28). The mind enjoys its own harmony and unity when the two perceptual operations are mutually reinforcing rather than antagonistic (p. 13).

If Hildebrand's theory of art provided a great deal of valuable material for the subsequent development of Riegl's historiography, it also posed a serious problem for him. The theory raises classical relief sculpture to an aesthetic norm for art in general, something Riegl strenuously sought to avoid. Yet the idea of different modes of vision clearly appealed to Riegl as a supplement to the varying relationship of mind to world that he derived from Hegel. His borrowings from Hildebrand, therefore, had to be tailored to suit quite different purposes. While Hildebrand's concern was to formulate a scientifically grounded aesthetic norm, Riegl's was to use the psychology of perception to underpin a plurality of stylistic types. There are also important differences in the detailed elaboration of the theory.

In the book draft that Riegl was preparing when he was commissioned to write *Late Roman Art Industry,* there is a section called *"Form und Fläche"* in which Riegl presented a modified version of Hildebrand's theory. It is clear that Riegl's conception of the "near view" is completely different from Hildebrand's. According to Riegl, this view yields a two-dimensional surface, because shadows indicating depth disappear on close inspection and because eye movement is restricted. Like Hildebrand he held that the distant view is two-dimensional, but he distinguishes between two sorts of planimetric representation, one that is literally and objectively flat and one that is an optical illusion, a "subjective surface" (Riegl 1966, p. 130). Modeling shadows that signal three-dimensionality and call up past tactile impressions are only visible at a "normal" distance from the object.

As the distance between eye and thing exceeds that of the normal view, the opposite process is reactivated: modeling disappears more and more behind a growing thickness of the intervening wall of air, until finally only a uniform surface of light or colors reaches the retina of the eye, which we will designate by the term "distant view." (p. 130)[8]

These categories of vision must not be taken too literally; they are really just different ways of grasping our relationship to the external world in works of art. The near view describes an immediate sensory perception of an object. The normal view involves perception of isolated objects combined with a unifying survey of the whole. From a distant view, a synoptic vision of the whole requires extensive employment of subjective thought. While Riegl derived these three possible ways of grasping the world in representation from Hildebrand's theory, he did not privilege any one. A schematic history and typology of style based on a progression from the near to distant view, that is, from Egyptian art to impressionism, is sketched in the book draft but becomes more thoroughly articulated in *Late Roman Art Industry*.

The Late Roman *Kunstwollen*

In the opening chapter of this work Riegl speculated about the origin of the artistic drive, suggesting that antique peoples were confronted by a fundamental conflict. They understood the external world, by analogy with the sense of their own bodies, as made up of individual, material objects. But visual perception gave them a muddled and indistinct picture of the world. In order to overcome this conflict, they created monolithic works of art that suppressed all indistinct and ambiguous appearances.

The peoples of antiquity perceived material individuals in the external world by analogy with their (supposedly) familiar human nature (anthropomorphism), in different sizes of course, but each composed of well-integrated parts brought to an indivisible unity. Their sense perception showed them external things confusedly and unclearly intermingled; by means of visual art they isolated single individuals and presented them in their clear, self-contained unity. (Riegl 1927, p. 26)[9]

These self-contained objects were separated by space conceived of as a void or simply as the negation of matter. The original *Kunstwollen,* then, consisted of the formation of independent, isolated objects and in the denial of space. Antique art "had to negate and to suppress the existence of space because it constituted an obstacle for the absolute individuality of external objects in the work of art" (p. 27). Yet this ideal conception of the art object as a purely objective impenetrable thing in a void was found to be an impossibility, for "we possess certain knowledge of the self-contained, individual objects only through the sense of touch" (p. 27). But subjectivity must be involved in combining single tactile sensations. Riegl concluded: "Hence it follows that even the conviction of tactile impenetrability as the most fundamental prerequisite of material individuality is no longer owing only to sensory perception, but also to the supplementary intervention of thought processes" (p. 28).[10] An object that is totally self-contained and independent of the perceiver is one that is simply not perceived—a thing-in-itself. Vision necessarily involves processes that synthesize sensory perceptions and condition and change the object of perception. Our mental framework becomes part of the object perceived, and the latter ceases to be a purely objective, independent entity.

The argument proceeds by showing how this fundamental artistic aim and the problems associated with it determine the appearance of antique art. The aesthetic ideal of material unity is achieved if the object is kept strictly to the plane. The specific *Kunstwollen* of antique art is thus formulated as "the representation of

individual forms in the plane" (p. 19). The representation of depth is avoided because its perception requires complex subjective mental operations. But forms are barely visible unless they protrude from the plane.

> Thus from the very beginning a particular perception of the dimension of depth was required, and on this latent contradiction rests not only the basis for the conception of relief in ancient art, but also half of the development that took place within the visual arts of antiquity. The other half of this development came . . . from the gradual penetration of the pure sense perception of the material individuality of objects by a subjective idea. (p. 31)[11]

Together these impinge on the artistic ideal of antiquity and engender stylistic development.

Riegl divided the development of antique art into three phases. The first phase maintains as far as possible the appearance of a unified, isolated object adhering to a plane. He calls this the "tactile" or "haptic" plane,[12] or in terms of how it is perceived, a near view of objects (p. 32). This phase is optimally expressed in ancient Egyptian art, which stresses a clear outline flat against a material ground. The avoidance of a sense of space is perhaps best indicated by the practice of hollow relief, in which the ground is higher than the figure. The human figure is contorted so that relations in depth are "cunningly transformed into relations in the plane" (p. 97). Not only are formal configurations that demand subjective supplementation avoided, so are facial expressions or gestures that indicate subjectivity. "Foreshortenings and shadows (as betrayers of depth) are avoided just as scrupulously as expressions of mental states (as betrayers of the subjective life of the soul)" (pp. 32–33).

The second phase is marked by the appearance of projections on the surface of objects, but these are still clearly linked to the ground plane. The protrusions cast

soft shadows that, unlike deep shadows, do not disturb the tactile homogeneity of the surface. In order to perceive the shadows properly, one must withdraw from close range and attain what is called a "tactile-optical" conception of things. "The conception of objects that is recognized by this second phase of antique art is thus a tactile-optical one and, in optical terms, a normal view; it is achieved in its purest form, comparatively speaking, in classical Greek art" (p. 33).[13] A certain amount of depth is recognized in classical relief, but only in so far as it is contained within the figures, which themselves adhere firmly to the ground plane.

Finally, in the third phase, objects appear in their full three-dimensionality. Thus space is recognized, although not yet as infinite space between material bodies, but rather as self-contained, "measurable" space (p. 34). Measurability is one of Riegl's key concepts. He suggested that an object's material unity is enhanced for the perceiver if it has an easily cognizable geometric shape whose relative dimensions are immediately apparent. Even space itself, if confined to strict geometric boundaries and articulated to facilitate measurement, assumes an objectlike definition and density. This point is important for Riegl's sense of the interior of late Roman buildings and relevant to his observation about the "crystallization" of their sculptural forms. The three-dimensional, self-contained objects of the third phase are still organized in relation to the plane, but now they have relinquished any tactile connection with it. Indeed there is no longer any secure tactile plane. "This plane is no longer tactile because it contains interruptions achieved through deep shadows; it is, on the contrary, optical-colored, whereby the objects appear to us from a distant view and in which they also blur into their environment" (p. 35).[14] The artistic ideal of late Roman art can thus be formulated as follows: "The conception of things recognized by this third phase of antique art is thus a truly optical one, and indeed a distant view, and confronts us in its purest form, comparatively speaking, in the late Roman Empire" (p. 35).[15]

The characterization of the third, late Roman phase is particularly problematic. How, for instance, can a fully three-dimensional object be placed in a "strictly and positively emphasized plane" (p. 35)? Once again relief sculpture seems to

serve as the paradigm of Riegl's morphology. The chapter on sculpture begins with an extended account of one of the reliefs on the Arch of Constantine, *The Imperial Distribution of Money*. The strictly symmetrical composition makes it planimetric, but the individual figures are deeply undercut and close together so that dark shadows obscure the ground. The palpable, material plane of classical art is dissolved and in its place is an "optical" plane. In his helpful discussion of this phenomenon, Otto Brendel refers to the optical plane as a foreground plane. "Riegl described a gradual change of emphasis from the material ground—the 'neutral' ground of earlier reliefs—to the optical plane which forms a 'foreground,' because we recognize space behind it" (Brendel 1979, pp. 63–64). In other words, there is a shallow spatial interval behind the foreground plane that we can understand as a treatment of space midway between the true antique denial of space and the modern representation of three-dimensional space. This is an illuminating reading of certain late Roman reliefs. Problems arise, however, when this morphology is attached to buildings, such as the Pantheon, that are also said to be set in relation to the plane.

The History of Architecture in Antiquity

Having defined the general artistic ideals in antiquity, Riegl then systematically showed how these were manifested in the various visual arts—architecture, sculpture, painting, and crafts. The chapter on architecture is particularly ingenious and problematic. Riegl accepted the current view that antique religious architecture followed two very different systems, the *Langbau* or longitudinal building and the *Zentralbau* or centrally planned building. These systems, according to Riegl, are opposed to one another like movement and rest (Riegl 1927, p. 24). Yet the very possibility of architecture depends upon the dialectical reconciliation of the two

systems. One system emphasizes the articulation of space or the creation of a spatial interior, the other consists of the arrangement of masses that form self-contained, stereometric exteriors.

The fundamental purpose of architecture is defined by Riegl as "the formation of confined spaces within which man can move freely" (p. 25), that is, a combination of the opposing aims of the two architectural systems. Definition of boundaries tends in the direction of sculpture, while the opening up of interiors tends toward infinite, free space. Only some marriage of the two produces architecture. The opposition of architectural systems is clearly related to the opposition operating within antique art as a whole. The centrally planned building is associated with the artistic ideal of self-contained impenetrability, the longitudinal one with the necessary articulation of space or recognition of depth. It follows, then, that early antique architecture, which like the other arts of the period restricts space to a minimum, should be dominated by the centrally planned type of building. The history Riegl describes is thus a gradual penetration of the aims of the longitudinal type into the purely pyramidal building. As this history develops we see that the arrangement of masses is sometimes expressed in the form of the interior, and conversely the exigencies of interior space appear in the treatment of the exterior. This interpenetration of the ideal systems accounts for some of the difficulty and subtlety of Riegl's theory.

The architectural aim of forming an isolated object is most perfectly realized in the Egyptian pyramid. Each of its four sides is a uniform, plane triangle—a shadowless, unarticulated surface with sharply stressed boundaries. In fact it answers the *Kunstwollen* of the age to grasp a unified object so completely that it "should be called sculpture rather than architecture" (p. 36). What interior space does exist is broken into dark, narrow chambers that do not evoke an impression of space. "From the outside, the exterior of the Egyptian temple with its uniform walls appears tactile; in its interior, it disintegrates into microcosms each filled with individual shapes" (p. 38). In his posthumously published book draft, Riegl made a suggestive point about the Egyptian pyramid being consistent with a

"spiritless" depiction of man—it is an edifice that makes no reference to "interiority" (*das Geistige*) (Riegl 1966, p. 140). This closely follows remarks made by Hegel in the section of *Phenomenology of Spirit* on natural religion.

> The first form, because it is immediate, is the abstract form of the understanding, and the work is not yet in its own self filled with Spirit. The crystals of pyramids and obelisks, simple combinations of straight lines with plane surfaces and equal proportions of parts, in which the incommensurability of the round is destroyed, these are the works of this artificer of rigid form. (Hegel 1979, p. 421)

The classical Greek temple displays the effects of two related pressures on architecture: the demand for a longitudinal interior space and the necessary recognition of the depth dimension. The demand for space is expressed on the exterior and so breaks up the crystalline form of the pyramid. We can no longer conceive of it as an impenetrable, tactile object. Instead we enjoy the relation of parts to the whole. In order to appreciate the columned portico, the spectator must withdraw to a moderate distance "where tactile clarity of the details and the optical survey of the whole are able to be valued to the same degree" (Riegl 1927, p. 38). The columned portico is the architectural equivalent of classical relief sculpture. "The columned porticos collecting shadows like the folds of classical drapery express in a limited manner an additional recognition of depth and space in the objects. Here the eye immediately rests on the closed wall of the cella as it does on the flat plane of a relief" (p. 39).[16] In his analysis of the Greek temple, Riegl identified the relationship between the opening up of interior space and the loosening of tactile coherence through a change of exterior shape and the decorative play of shadows. Both these factors indicate "the gradual penetration by subjectivity into the pure sensory perception of the material individuality of things" (p. 31).

The beginning of the optical phase in the development of antique art is exemplified by the Pantheon. Yet the expectation we might reasonably have formed on the basis of the foregoing examples is here counterpointed. We are confronted by a strictly symmetrical, centralized, unarticulated rotunda that at first sight looks like a regression to the Egyptian ideal. Riegl explained how they differ. Although they are both designed to elicit a sense of their tactile unity, the earlier type is restricted to the plane, while the later one is a fully three-dimensional mass. Instead of a sharply defined triangular plane, the Pantheon presents a restless curve that draws the eye into depth. While the pyramid can be conceived in an immediate intuition, the rotunda calls on complex subjective thought processes and memories of past tactile impressions as one attempts to conceive it as a whole (p. 42). Riegl says similar things about the introduction of the narrative cycle in figurative art, which forms a continuous band like that encircling Trajan's column (pp. 124–125).

Although the Pantheon is fully three-dimensional, Riegl was at pains to show that this does not imply the recognition of infinite space. The enclosed shape of the Pantheon calls attention to the mass of the building itself, not to the surrounding free space. Riegl thought that we are likely to find the Pantheon's shape severe or harsh because we expect buildings to form a connection with infinite space, the way the spire of a church perforates the atmosphere (pp. 68–69). This seems intelligible and even convincing, but Riegl also maintained that the rotunda is set in relation to the plane. He seemed to think that the appropriate way of viewing this building, and indeed all antique art and architecture, is to imagine it projected onto a plane. This is because depth is a problem for this *Kunstwollen,* and free space is not yet recognized. Riegl said of the "near view" that "every figure appears here circumscribed by a firm outline and thus distinctly self-contained and isolated, with the surrounding ground, on the other hand, interpreted as a necessary evil" (Riegl 1966, p. 135). Because it is symmetrical and uniform, the Pantheon might be thought amenable to this perceptual adjustment.

Another feature of the third phase of the antique *Kunstwollen* is that individual parts become disconnected from one another and dissolve the tactile coherence of

the object. This does not seem to apply in the case of the Pantheon, except perhaps in the treatment of the interior (fig. 8). The first impression of the interior is that of a sharply defined block of space. Its immediately graspable symmetry and measurability awaken a compelling feeling of tactile unity that is ordinarily only aroused by a material form (Riegl 1927, p. 45). But Riegl saw in the niches around the cylindrical wall the beginnings of a new treatment of architectural form. The niches have a double significance. Firstly, they herald a new optical decorative system: the shadows in the hollows contrast with the light wall surface, creating a rhythmic, coloristic surface. For Riegl, this decorative system was a development of the columned portico where the soft shadows were seen as a complement to the light forms. Here the dark shadows are salient in the same way that the deeply incised folds of drapery in, say, the Constantine reliefs predominate (p. 103). Secondly, the niches prefigured architecture as an arrangement of masses, which is a distinctive feature of the late Roman period. The small niches are said to form a patterned ground that has the effect of isolating the central space from the ground. "The deeper artistic aim pursued by the introduction of niches was a more effective definition of the individualized central interior space as respects depth and a more conspicuous isolation from the ground plane" (p. 45).[17]

This latter role played by the niches seems to me especially problematic. It is a case of Riegl extending observations across different arts—a strategy that for the most part yields very interesting observations. In this example, certain effects in relief sculpture and crafts are made to inform architecture. According to Riegl, an arrangement of masses consisting of a number of small components and a large central one gives the impression of a main pattern set off against a subsidiary background one. But the idea of projecting a large multiform building on a plane and seeing it as pattern and ground seems implausible, except perhaps from a bird's-eye point of view. When one is dealing with a complex of interior spaces, like that in the interior of the Pantheon, such a perceptual adjustment seems even less likely.

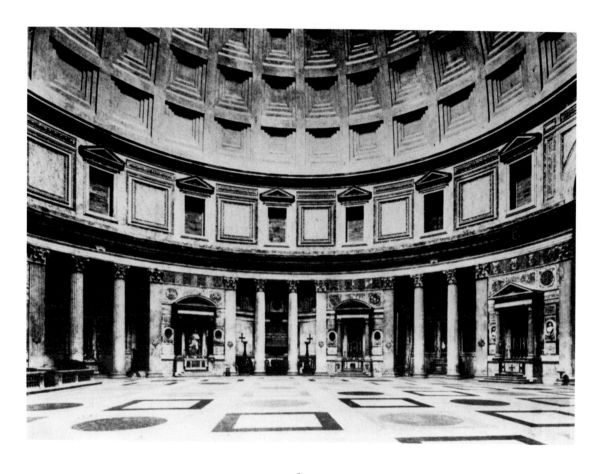

8

Pantheon, Rome

interior

In the preamble to the chapter on architecture, Riegl established that a character-istic trait of late Roman religious building is *das Gemeinsame* or common style which unites the two fundamental architectural systems, the longitudinal and centrally planned buildings. The so-called Temple of Minerva Medica in Rome shows a marked tendency to "animate" the self-contained, centrally planned build-ing. The apsidal lobes that were only carved out of the interior of the Pantheon now appear on the exterior, fragmenting its tactile integrity and demanding a sub-jective coherence. Riegl regarded this as marking the demise of the tactile ideal.

> If one recalls that the creation of clearly defined centralized unities was the principal aim of ancient architecture (and the visual arts generally), one must conclude that with the appearance of the arrangement of masses the architectural *Kunstwollen* appears to be broken through and annulled in no less fundamental fashion than in the case of the emancipation of space. (p. 48)[18]

Another innovation of the Minerva Medica is the introduction of windows. Previously there had been no obvious windows in monumental architecture be-cause from a near view they would look like "disturbing holes in the wall, an unpleasant disintegration of the tactile material by pure optical-colored, insub-stantial voids, like shadows": "Thus the precondition for the acceptance of win-dows into monumental art was a distant view, which lets the shadowed hollows in their rhythmic alteration (symmetry of sequence) and the bright part of the wall in between them appear on the same plane as a coherent optical unity" (p. 49).[19] In addition to the decorative rhythmic alteration of light and shade, the windows also create an immediate relation between interior and exterior. The gaze is attracted out of the enclosure and into infinite space, anticipating the future direction of artistic development (p. 50). Riegl was aware of the psychological

implications of this. He referred back to the introduction of windows when he noted the first use of engraved pupils in portrait heads, a technique of indicating darkness that would only be acceptable in an art culture committed to the distant view (p. 133).

Having traced the history of centrally planned architecture, Riegl now aimed to show that the longitudinal type is the motivating force behind its development.

> The clear and enclosed unity of the material individual in architecture as required by ancient art obviously found its greatest satisfaction in the centralized building; but the essential driving force was, for obvious reasons, the basilica of axial building. The axial building was created for the movement of people in its interior. Movement, however, necessitates release from the plane, the recognition of deep space, the emergence of the material body out of itself and into intercourse with space. (p. 51)[20]

Riegl argued that during the first century of the Roman empire the formation of spatial interiors was resisted. For example, in Pompeii rooms open onto an open court and market spaces were originally open courts later covered over with a wooden roof for practical purposes (p. 52). The significance of this genesis, according to Riegl's highly contentious view, is that the use of a wooden roof was thereafter always perceived as merely provisional and so did not, for the Roman observer, create an enclosed interior space. "The Romans of the empire, however, only saw the enclosed plane of the walls in the central nave but failed to see the space enclosed by them because the monumental closing overhead (the vaulted ceiling) was lacking" (p. 54). By the third century of the empire, enclosed oblong public bath buildings were being constructed. The problem for the architect was how to make the space contained and substantial. This was done by dividing the room with pillars and cross vaulting into three centralized compartments. This unified space "is no longer an immediate intuition as in the Pantheon,

for now an additive reflection is required" (p. 55). Because the basilica with its wooden roof did not create space for the contemporaneous observer, there was no need to articulate the space into graspable cubes like the public bath interiors. The effect of basilicas for a modern observer is highly perspectival, but this is a misleading impression. Perspectival space is a section of infinite space, which at this stage is not yet recognized.

> A closer observation teaches, however, that such an unnatural break in the regular development did not exist, and that with the central nave of the basilica the ancient Roman Christian did not at all wish to create an enclosed interior space nor a perspectival section of the space, which the modern spectator projects into it. (p. 58)[21]

Our sense of the basilica as perspectival, then, is anachronistic; the basilica conforms to the antique *Kunstwollen*. Yet it also anticipates later art in its extreme tactile disintegration. The lively interplay of light and shade among the closely packed columns and the windows breaking up the wall above produce a pronounced coloristic effect, although relative to the light and movement of a baroque interior it is still minimal. It would seem from Riegl's description that the basilica is hardly a building at all: there is no true ceiling and no connection is made between the columns and the roof.

> The deliberate elimination of all tactile connections between the parts of the building in the early Christian basilica resulted in it (and also the centralized building to a lesser extent) losing the impression of necessity and tight organic coherence of all the parts that classical and also modern art demanded of composition. (p. 59)[22]

While the centrally planned building maintained its connection with the plane and with the idea of relief, "the basilica consciously gave up these and thus truly made the way clear for medieval and modern art to succeed in placing the individual in free space" (p. 62). The modern observer's anachronistic perception of the basilica as perspectival is not then wholly misleading; the basilica is susceptible to perspectival effects because it prefigures that conception of space. Riegl pointed to a basilica and surrounding building near Ravenna that, under favorable conditions, make a very painterly impression. Although the basilica was far from aiming at union with infinite space, "the way for the later development was opened up, and for that reason the basilica element embodied that which modern art could utilize for its purposes" (p. 69).

Although Riegl's account of late Roman art provides a rationale for its distinctive appearance, it turns out to be essentially negative: the dissolution of tactile coherence. In Riegl's overall historical scheme the moment is pivotal, for, without a phase of art lacking in tactile integrity, the conception of infinite space that informs Renaissance architecture and perspective construction would not have been possible. Yet it is hard to see how any *intrinsic* aesthetic value can attach to this *Kunstwollen*. The idea of a new decorative system consisting of a rhythm of light and shade is meant to serve this purpose. "Ancient artists could not have wanted perspectival spatial unity, because it would not have produced for them artistic unity. They still searched for this in the rhythm of lines in the plane, to which was gradually added during the Roman Empire the rhythm of light and shade" (p. 112).[23] However, the idea of the optical plane as the correlative of a form of subjective coherence is not fully developed in *Late Roman Art Industry*. Instead of providing a strong sense of an alternative form of coherence, the book stresses that the lack of tactile coherence in late antiquity was deliberate and historically necessary. Instead of a positive aesthetic ideal for late Roman art, we are given an apologia.

Riegl overcame the shortcomings of *Late Roman Art Industry* in his next book *The Dutch Group Portrait,* in which he defined several kinds of coherence to cover the

history of the genre. The conviction governing his earlier work—that placing works of art within a developmental series secures for them aesthetic validity—seems in this last book to be replaced by a procedure conferring aesthetic value by formulating self-validating artistic ideals specific to the works in question. It is clear that Riegl really wanted to have it both ways. He thought that the inner logic of an historical trajectory would secure for each moment of art's history a kind of necessity and legitimacy. Yet he also wanted each period style to be appreciated in its own right as having intrinsic aesthetic value. There is a conflict between these two positions. The dialectical history implied by *Late Roman Art Industry* suggests that the art of that period is the antithesis of classical organic unity, which is destined to be superseded by a new form of spatial coherence in the Renaissance. Its antithetical position in Riegl's scheme means that we are obliged to conceive of it as not-classical.

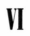

VI

Dutch Group Portraits and the Art of Attention

While Riegl's *Late Roman Art Industry* has received the greater share of critical attention, it seems to me flawed in comparison to his *The Dutch Group Portrait* (*Das holländische Gruppenporträt*, 1902).[1] This masterly study extends the pattern of historical development advanced in *Late Roman Art Industry* to cover the history of Dutch group portraiture from the early sixteenth through the mid-seventeenth century. Part of its success must be attributed to its concentration on a relatively short historical period and its restriction to a single genre. It also introduces some new critical strategies, the most pronounced of which is a recognition of the importance of figurative content. In addition, it offers a fully developed conception of a kind of composition whose coherence does not lie in the object but rather in the consciousness of the beholding subject.

Riegl's apology for late Roman art is based on its position as a transitional stage between antique and modern art: since its task is the dissolution of tactile coherence, the style is deliberately fragmented and shadowy. Yet the first steps taken here eventually issue in seventeenth-century Dutch art's representation of free circumambient space and of intimate interpersonal exchanges. In the introduction to *The Dutch Group Portrait,* Riegl specifically relates Dutch art to its early forerunner.

> Art history distinguishes between two manifestations of three-dimensional space: cubic space, which clings to material forms, and free space between figures. An art such as that of antiquity, which regarded individual things as existing objectively, could not represent free space. Only Christian art which was emerging during Roman imperial times emancipated free space, but this was still in rather shallow depth, between two figures, more on a flat surface than in infinite free space. Significantly, the physical bridge from figure to figure was built at the same time as that between persons, which we call attentiveness in the Christian sense. (Riegl 1931, pp. 22–23)[2]

Both early Christian and Dutch art strive to make space embrace disparate elements and to create psychological bonds. Riegl sets out to show how these two unifying elements were perfected in Dutch group portraiture: "The general developmental tendency appears here to be directed toward binding the figures physically with the surrounding free space and psychologically with the external world: both subjective tendencies" (p. 64). The terminology in the later book is also somewhat altered. The opposition between haptic and optic ideals is now subsumed under a more general opposition between objective and subjective tendencies. The haptic/optic pair was confined to the characterization of different conceptions of space; the subjective/objective pair includes these but also encompasses certain psychological attitudes. No doubt this innovation was dictated by Riegl's new concern with matters of content.

The Psychological Typology

The exclusive interest in conceptions of space and objects that we find in *Late Roman Art Industry* is now supplemented with an attempt to characterize people's psychological relations to the world and to others. These attitudes are ranged on the scale from objective to subjective. They are will (*der Wille*), feeling (*die Empfindung*), and attention (*die Aufmerksamkeit*). I have not discovered an obvious source for these terms, but they occur frequently in post-Kantian empiricist psychology of the period.[3] They form a quasi-Hegelian progression toward increasing levels of inwardness and decreasing egotistical isolation.

The first attitude, will, is directed toward subsuming the external world through action. "Action is, however, a triumphant conquest over man's environment understood as his antagonist; the will thus endeavors to isolate the active individual

over against his environment" (Riegl 1931, p. 13).[4] The terminology of this passage indicates the connection Riegl sees between the strict isolation of form in a strongly haptic style, such as the Egyptian, and the isolation of the individual struggling in a hostile environment. Any interpersonal relations at this stage are marked by patterns of domination and subordination. Perhaps Riegl gets some of his inspiration for this psychological type from Hegel's description of the oriental despot in the *Philosophy of History* who subordinates the wills of all others to his own. Hegel says that in the oriental world "Justice is administered only on the basis of external morality, and government exists only as the prerogative of compulsion" (Hegel 1944, p. 111).

The second psychological attitude is that of feeling. At this stage, epitomized by the Greeks, the other is no longer simply regarded as an obstacle to be overcome. Instead, it elicits an emotional response. Some light can be thrown on these first two categories by referring to the lectures on Roman baroque art that Riegl gave during the years 1901–1902, that is, just prior to the publication of *The Dutch Group Portrait*. They were posthumously published in 1908 in a volume entitled *Die Entstehung der Barockkunst in Rom*. In the book, it becomes clear that Riegl first envisaged just two diametrically opposed attitudes to the world: will which is isolating and feeling which is interconnecting. "The psychological isolating element is the will, which is always egotistical: maintenance of the individual in some form. The binding or connecting element is feeling, emotion, which strives for unification with the universe, transcendence of the individual" (Riegl 1908, p. 50).[5] The exaggerated shapes and positions of Roman baroque art are understood by Riegl to be the result of feeling or emotion breaking through the domination of the will. So, for example, the figure of Giuliano de' Medici on the tomb by Michelangelo shows his body masterfully directed outward while his head turns sharply to the left, suggesting an inner conflict (pp. 33–34).

When Riegl came to discuss Dutch art, he found he needed to isolate a new psychological attitude, "attention." Neither action nor passion adequately de-

scribes the contemplative attitude of many Dutch portrait figures. Both the willing and desiring selves want to change the world or to consume it. An attentive attitude is in these respects disinterested. *Aufmerksamkeit* is a curiously double-edged term. On the one hand, it means watchful, vigilant, or alert; on the other, it has connotations of courtesy or kindness. It seems to balance within itself, then, self-love and empathy. Just as some dissolution of the boundaries of objects is necessary for the representation of free space, so some dissolution of the boundaries of the ego is essential for interpersonal relations.

<hr>

The Dutch *Kunstwollen*

<hr>

The *Kunstwollen* of Dutch art as a whole is said to be the representation of free space and attention. As Riegl uses the term, attention is not just a new attitude to the world but also the basis for a new kind of coherence. What holds Dutch group portraits together is the engagement of the attention of the depicted figures as well as that of the spectator. We will have to get a clearer idea of this key concept.

Riegl describes attention as a deep concern for the world and an attitude that involves both humility and self-esteem. "Attention is passive, as it permits itself to be impressed by external objects and does not try to subdue them; at the same time it is active as it searches for the objects without intending to make them subservient to selfish desire" (Riegl 1931, p. 14).[6] This relationship of mind to things is delicately balanced: the object remains independent and intact in so far as the mind is receptive, yet the subject also retains his or her independence and autonomy, being free from the constraints of appetite or desire.

Riegl understood attentiveness as the basis for coherence in Dutch art: the union of the figures brought about through their concerted attention and the attentive-

ness of the spectator are the two binding elements. He set this principle of coherence in opposition to the Italian device of making action and the will serve as the basis of unity. In order to appreciate Dutch art, we have to take account of this difference.

> If one seeks in it action involving the will in the Italian manner, then it remains unintelligible; instead this is replaced by a spiritual or psychological exchange, in which emotion and attention play a greater role than the will, and which invites an intimate contemplation so characteristic of the Netherlandish people. (p. 13)[7]

Riegl distinguished between different modes of attention. Attention in sixteenth-century Dutch art is said to be relatively "objective" in character. He did not mean by this, however, that it has remnants of the more objective psychological attitude, will. Rather, he would appear to be using a distinction first made by Schopenhauer between a transcendent, impersonal attitude and a more individualized attitude that involves the whole subject and is directed at objects determined in space and time. In Schopenhauer's scheme of things, one is exercising a form of "objective" apperception when contemplating objects transcending space and time, what he calls Platonic ideas. The engagement of subjectivity, on the other hand, involves spontaneously constituting the objects of experience in a Kantian sense and also expressions of feeling and the will. Given this schema, Riegl's theory of the development of Dutch art begins to make sense. In early Dutch art, as opposed to that of the seventeenth century, "attention was thought to be absolute and enduring rather than momentary, and the spectator was equally considered as absolute and ideal rather than individual" (p. 45). This absolute or objective form of attention is in many respects like Schopenhauer's description of man's capacity to free himself from the subservience of the will and to contemplate a thing

"plucked from the stream of the world's course." Schopenhauer said of this capacity that it produces a state where "simultaneously and inseparably, the perceived individual thing is raised to the Idea of the species, and the knowing individual to the pure subject of will-less knowing, and now the two, as such, no longer stand in the stream of time and of all other relations" (Schopenhauer 1969, 1:197).

Schopenhauer connected this "objective tendency of mind" with artistic genius and praised Dutch artists above all for their ability to focus this sort of attention.

> Inward disposition, predominance of knowing over willing, can bring about this state in any environment. This is shown by those admirable Dutchmen who directed such purely objective perception to the most insignificant objects, and set up a lasting monument of their objectivity and spiritual peace in paintings of still life. The aesthetic beholder does not contemplate this without emotion, for it graphically describes to him the calm, tranquil, will-free frame of mind which was necessary for contemplating such insignificant things so objectively, considering them so attentively, and repeating this attention with such thought. (Schopenhauer 1969, 1:197)

Hegel made a very similar comment on Dutch art in the section on painting in the *Aesthetics*. He describes the typically *deutsch* (Dutch or German) trend of mind as homely or bourgeois and as displaying "a self-respect without pride." Dutch painters, he continues, "link supreme freedom of artistic execution, find feeling for incidentals, and perfect carefulness in execution, with freedom and fidelity of treatment, love for what is evidently momentary and trifling, the freshness of open vision, and the undivided concentration of the whole soul on the tiniest and most limited things" (Hegel 1975, 2:886). Both Schopenhauer and Hegel seem to have regarded still life and genre painting as the most telling forms of Dutch art.

In many ways, Svetlana Alpers's revisionary approach to Dutch art is a revival of this tradition. In *The Art of Describing: Dutch Art in the Seventeenth Century* (1983), she emphasizes the descriptive nature of the art and contrasts this attention to the world with the priority given to painter or viewer in Italian Renaissance painting. In an essay that connects this theme with feminist politics, "Art History and Its Exclusions" (1982), Alpers exemplifies the Dutch artistic attitude with Vermeer's *View of Delft:* "In Vermeer's painting, Delft seems neither ordered nor possessed, it is just there for the looking. It is as if visual phenomena are there without the intervention of a human maker" (Alpers 1982, p. 187).

Group Portraiture

Although it is true that portraiture was the most popular branch of painting in seventeenth-century Holland, Riegl's exclusive treatment of group portraiture was prompted more by his belief that it is the most complete expression of the Dutch *Kunstwollen* (Riegl 1931, p. 21). A portrait conveys an impression of inward psychic life and so must suppress action or some merely fleeting emotion. The same is true of group portraiture, but an acute artistic problem arises because the motionless figures must somehow be brought into relation with one another. Riegl thought that the central problem confronting the painter of group portraits was that of finding a means of uniting the group without diminishing the inwardness of its members.

It is very likely that Riegl formulated this problem of group portraiture with the help of observations made by the Hegelian art historian Karl Schnaase, who, in his *Niederländische Briefe* (1834), compares the isolation of figures in ancient painting with the interconnectedness of figures in later Christian art.

The forms remain isolated, scarcely attending to one another, shown mostly in profile or frontally. Groups, when they are concerned with a mere external action, are often arranged with extreme elegance and delicacy. . . . But we never find a group in the spiritual sense that makes manifest to us through position, bearing, and form their relation to each other, the reciprocity of speech and feeling, the inner bonds of intimate relationship through which the individual isolation is overcome, and shows the whole as forming the spiritual character of a family, a community between members and a unity with their environment. (Schnaase 1834, p. 96)[8]

Unlike Schnaase, however, Riegl made a firm distinction between the ideas of the family and the group. A family portrait is unavoidably hierarchical in structure and so is compositionally akin to an individual portrait, but a group portrait represents something else: "The Dutch group portrait is neither an expanded version of an individual portrait nor, so to speak, a mechanical collection of individual portraits in one picture: rather it is the representation of a free association of autonomous, independent individuals" (Riegl 1931, p. 2).[9] Riegl was also doubtless aided in his project by the work of a student of Schnaase, W. Lübke, who in 1876 published a Hegel-inspired article on portraits of militia companies and regents. Lübke charts a development within group portraiture from the sixteenth century's undifferentiated row of heads to the mid-seventeenth century when "one aimed at more animated expression, greater freedom of arrangement, greater diversity both in characterization and in the painterly portrayal of individuals" (Lübke 1876, p. 4). The article is suggestive, but its unrestrained rhetoric of social and artistic progress is quite foreign to Riegl's treatment of the same material.

In Riegl's account, then, attention and group portraiture are inseparable terms. Portraiture depicts individuals in attentive attitudes in an effort to grasp their

physiognomy and personality. Action always weakens a portrayal "because, on the one hand, every action has some distorting effect on the features, but, on the other hand—and this is the main reason—the attention of the spectator is drawn away from the personality" (p. 21). The necessity of attentiveness, then, actually inhibits other means of unification, ruling out the immersion of the figures in a common action or emotion. Further, the equality of voluntary members of a group precludes a strongly hierarchical arrangement. Yet attention is also the solution to the problem of coherence in group portraits: attention has an object and if those depicted focus on a common object, whether visible or not, then a voluntary psychological accord is implied. This kind of coherence is not the sort that comes ready-made; rather, it demands a high degree of imaginative supplementation and attentiveness on the part of the spectator. The coherence of group portraiture and, by implication, all Dutch art is external.

Internal and External Coherence

Another characteristic of portraiture is the way the depicted figures are presented to a spectator. Unlike narrative painting, which presents a self-contained world within the picture space, the portrait figure is often actually addressed to us. By its nature, portraiture establishes an intimate relationship with the viewer—it exists for a beholding subject in a particularly pronounced way. Instead of resorting to a unifying narrative, group portraiture invites the beholder to complete the scene. Riegl isolates two fundamentally different forms of coherence, "closed internal coherence" (*die geschlossene innere Einheit*) which involves the interrelatedness of elements within the picture, and "external coherence" (*die äussere Einheit*) which includes and depends upon the spectator to complete the scene. He shows how it is possible to compensate for the diminished internal coherence needed to preserve

the quality of portraitlikeness by augmenting the external coherence, making a painting cohere by implicitly including the spectator.

The rapport with the spectator is partly achieved by the outward gaze of depicted figures. In conjunction with this are certain formal features, some of which tend to make a picture more self-enclosed, complete in itself, while others tend to open the painting up to make its virtual time and space continuous with the spectator's, thereby allowing him or her to figure in the scene portrayed. An obvious way of opening a depiction is to break up the lateral relationships and looks within the painting and to direct the looks outward. But Riegl observes that the outward glance is not a necessary feature of external coherence, which can be achieved by many different means. One alternative means is exemplified in Rembrandt's etching of the raising of Lazurus (fig. 9). This shows an apparently internally unified scene whose focus is Lazarus. But Rembrandt shows us the scene through an arch, which has the effect of pointing back to the spectator and of suggesting that "the painted scene exists only for him" (p. 204).

All compositional or formal features are ranged on a scale from objective to subjective and so are the overall "conceptions" of the works. The pictorial conception (*die Auffassung*) of a painting specifies something about its content and about its principle of coherence. Each of the Dutch paintings that Riegl considers is analyzed first in terms of its conception and then in terms of its composition. This is an important innovation. While he had advanced a strictly formalistic approach in *Late Roman Art Industry,* in *The Dutch Group Portrait* he divides his attention equally between compositional arrangement and psychological exchanges or narrative devices that also contribute to a picture's coherence. In doing this he reconciled the two major theories of coherence descended from the *Rubensiste* conception of visual unity and the *Poussiniste* or neo-Aristotelian conception of narrative unity.

One of the major oppositions at work in *The Dutch Group Portrait* is between the Dutch and Italian stylistic types. The latter serves as an antithesis to the aims of

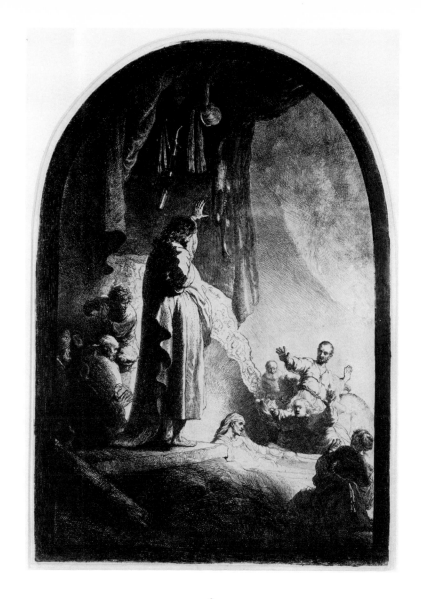

9
Rembrandt
The Raising of Lazarus
1632
etching, 37.5 × 25.5 cm
Rijksmuseum, Amsterdam

Dutch art, but curiously is also an important lever in the historical development of it, particularly as regards the school of Amsterdam. According to Riegl's scheme of development, the original, pure, abstract attention must somehow be brought down to earth—fixed in space and time and tied to an individual subject. This is accomplished by importing some of the narrative devices and the spatio-temporal determination typical of Italian art. The schools of Amsterdam and Haarlem take somewhat different paths; Amsterdam, and particularly Rembrandt, incorporate dramatic scenarios into group portraits while Haarlem and its leading artist, Frans Hals, take on the expression of feeling, particularly joy and pleasure in life.

Riegl's conception of this Italian paradigm, borrowed as a means to a Dutch end, is clearly the Renaissance ideal first articulated by Alberti. Its coherence is typically internal. That is, it contrives a unity that is independent of the spectator. Subordination, action, and narrative completeness are the key unifying conceptions. Outward action, rather than inward sentiment, is emphasized.

> The Italians worked throughout the Quattrocento on the solution to the problem of representing all the members of an individual figure so that they would follow a single act of will and all the figures of an *historia* as participating in one action. . . . Will, action, and subordination apparently again dominate the conception, as in antiquity, and, looking back, the Italians of the sixteenth century were not mistaken when they described the preceding epoch as a *Rinascimento* of classical antique art. (pp. 16–17)[10]

Riegl appears to hold a theory of ideal types that combine certain conceptions and compositions. For example, the Italian type with its strongly subordinating conception most readily combines with a compact, pyramidal grouping. Dutch "co-

ordination," on the other hand, calls for planimetric compositions and vertical axes. More interesting is how he sees these ideal types decomposed and reassembled in hybrid forms, balancing the subjective valence of one element against the objective valence of another. In Rembrandt's *Anatomy Lesson of Doctor Tulp*, for example, a dissolving atmospheric effect is compensated for by a subordinating conception and a marked pyramidal grouping: "One realizes how the strict pyramidal arrangement of the figures with its effect of unifying in the plane counteracts the dissolving effect of space" (p. 191). In this way, the general character and continuity of the *Kunstwollen* are maintained. On the whole, then, the Dutch stylistic type is favorable to portraiture, while the Italian is not. Yet Riegl remarks that Dutch painting's achievement of *Freiraum* or circumambient space can be detrimental to portraiture if figures are allowed to melt too much into the atmosphere. The Dutch tendency toward subjectivity needed a curb in order to prevent its degenerating into compositional arbitrariness, and group portraiture provided just such a disciplined norm; it exerted "an objectivistic and thereby retarding and conservative influence, but it was generally beneficial and regulating" (p. 25).

Three Conceptions of Dutch Group Portraiture

Riegl elaborates a typology of conceptions informing Dutch group portraiture that also mark the three stages of its historical development. The numerous figures in the early groups are combined by the use of *symbolic* attributes signifying common membership in a corporate body. During the second stage the figures are brought together by their common participation in some *genrelike* activity, perhaps a meal or a ceremony. In the final phase a *dramatic* scene is contrived that

subordinates the figures but also sets them in immediate relation with the spectator.

Dirck Jacobsz's *A Company of the Civic Guard* (1529), identified by Riegl as the Kloveniers' Guild, is the earliest known portrait of a militia company (fig. 10). This "symbolic" group portrait has no narrative or action; the men stand in two rows with little interplay and no obvious leader. In order to understand the men as a group, we must read their gestures: they point to their rifles or to their captain, or indicate solidarity by resting a hand on a neighbor's shoulder (Riegl 1931, p. 42). The quality of attention valued in early Dutch art is reflected in the quiet, transcendent gazes of Jacobsz's figures: "Attention in this early phase betrays much of the ideal release from every restriction in space and time" (p. 44). The spectator is equally abstracted:

> It is thus almost modern subjectivism that is expressed here, from which, however, one essential feature is lacking: the individuality of the subject; for, as was repeatedly stressed, the gazes of the militiamen do not converge on a single point or person, but their points of focus are distributed over a wide field within which countless spectators are found. (p. 44)[11]

Compositionally, the figures are locked in a plane, inaccessible to the spectator. This arrangement seems pictorially expressive of a kind of attention that regards its objects as fundamentally independent and self-contained. However, this painting is at the objective end of an historical trajectory that will eventually issue in a kind of painting that, as Michael Podro put it, "leads us to be aware of an interplay between those objects and our own mental life" (Podro 1982, p. 94). This direction of development is perhaps most evident in the dark, uniform background of Jacobsz's *Company*.

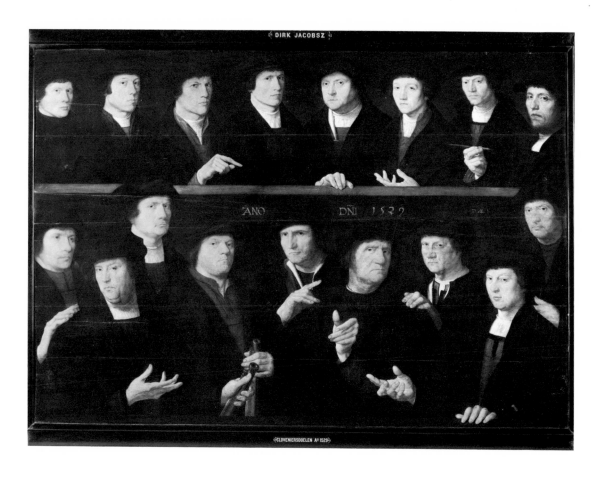

10
Dirck Jacobsz
A Company of the Civic Guard
1529
central panel of three, 122 × 184 cm
Rijksmuseum, Amsterdam

> It is not yet a question of a pronounced shadowy space, as it was in the
> case of seventeenth-century chiaroscuro; but, in a more or less clearly
> acknowledged impulse, the direction is here already taken of treating
> space by means of a definite hue as a coherent thing and in so doing
> inserting between the individual self-contained figures an uninterrupted
> unifying medium. (Riegl 1931, p. 49)[12]

Between the years 1580 and 1624, Riegl contends, Dutch group portraiture assimilated genre elements. This change was brought about by a change in religious attitudes that first of all affected the treatment of religious subjects (pp. 104ff.). Particularly in northern Europe, morality came to be considered an attribute of the individual conscience instead of an objective norm. In Holland, this resulted in the depiction of religious scenes in such a way that they look as though they were personally witnessed. This intimate representation of great historical events Riegl calls "genrelike" (*genremäßige*). "The natural consequence of that was the removal from religious art of what the subject encounters as mere alien, objective events, and their replacement with a secular art, which had to represent the subjective life of the individual" (p. 104).[13] The second phase of Dutch group portraiture takes account of this subjective life by depicting emotional exchanges between people. Accordingly, while the *Kunstwollen* of the symbolic type was the representation of "attention without feeling" (*gefühllose Aufmerksamkeit*), that of the type influenced by genre conceptions is "attentive sympathy" (*aufmerksames Mitgefühl*). The qualifying "attentive" guards this type against assimilation to a kind of painting that makes the physical manifestation of emotion, say lovers embracing, the basis for an entirely internal coherence (p. 108).

One way the genrelike group portrait is made to cohere, then, is through the figures' expression of fellow feeling. Yet it also makes use of the Italian conception of organizing figures around an event or a dominant figure. This last-mentioned

emphasis on leadership Riegl connects to the precarious military situation during the northern provinces' revolt against Spain. Yet, at the same time, he does not want to compromise his conception of the autonomous development of art.

> One must be wary of the view that this innovation was given rise to by the reorientation of the nature of the militia company referred to above: rather, both are parallel phenomena caused by one and the same higher force, which the Dutch of this epoch expressed in the strict subordination of parts under a dominating element as the desirable expression of the unity of the whole. (p. 110)[14]

Obviously this compromise solution is highly unsatisfactory.

The nature of the event that unites the genrelike type is not a past historical event, nor an immediate dramatic event: "For the first time we encounter a collective event making manifest the unity of the represented group of militiamen, and not an historical event that took place in the past but rather an oft-repeated one whose very meaning lies in this frequent, typical repetition; in a word, a genrelike event" (p. 85).[15] Riegl's stress on the recurrent nature of the genre-like event is connected with his notion of the gradual development within Dutch art toward the convincing representation of instantaneity. The genrelike group portrait has a temporal value that is neither timeless nor immediate, but something in between.

A Company of Captain Dirck Rosecrans (1588) by Cornelius Ketel is a good example of this type (fig. 11). Riegl notes that its new conception is evident from the fact that for the first time full-length, life-size figures appear; feeling permeates the whole body. The chief unifying device is subordination to the three figures in command, who form a prominent group. Through the captain's gesture the company is presented to the spectator. The action, therefore, is not one that is internally complete. "The motif of presentation as such is therefore specifically

11

Cornelius Ketel

A Company of Captain Dirck Jacobsz Rosecrans and Lieutenant Pauw

1588

208 × 410 cm

Rijksmuseum, Amsterdam

Dutch, because the whole action consists in drawing the attention of the other (and in this case, the spectator) to something" (p. 112).

The genrelike phase is compositionally the most Italianate of the three. It is hierarchical and fills three-dimensional space. The stress on physicality no doubt damages its portrait character, but Riegl holds that a phase of group portraiture strongly influenced by Italian art was necessary to arrive at a more advanced, subjective form of attention that is individualized and determined in space and time. The idea of a necessary, dialectical movement in history is still very much alive in Riegl's account: "Of course it was not a matter of artistic caprice practiced by the Dutch masters but a compelling necessity that had determined the course of artistic development in the north" (pp. 116–117).[16] The account of Rembrandt's accomplishment, and that of the third phase generally, is couched in these terms. The dramatic group portrait first tightens internal coherence through subordination and action, but then uses this as a powerful springboard to launch a kind of external coherence that sets the depicted figures in an immediate temporal and spatial relationship with the spectator.

Rembrandt

Riegl's analyses of Rembrandt's three famous group portraits, *The Anatomy Lesson of Doctor Nicolaes Tulp* (1632), *The Night Watch* (1642), and *The Syndics of the Clothdrapers' Guild* (1661/2), are worth considering in some detail. The Rembrandt group portraits are used by Riegl to represent three stages of the artist's development. However, since they all belong to the general type of dramatic group portrait they also have certain features in common. The figures all participate in an action that subordinates them to a dominant figure. The resulting internal

coherence would cut off the necessary link with the spectator if he or she were not directly hailed and personally called upon to observe or to participate in the action and its immediate space and time. Compositionally, the dramatic type returns to the plane and to strict symmetry, but Riegl shows how these formal features are now differently conceived—they serve optic rather than haptic ends.

The Anatomy Lesson of Doctor Tulp (fig. 12) is Rembrandt's first group portrait, and the unifying conception based on subordination is very pronounced. Doctor Tulp addresses his colleagues, who attend to his speech and demonstration. External coherence seems here to have been entirely abandoned in favor of a closed, internally complete scene. However, Riegl notes that the uppermost figure looks out at us (Riegl 1931, p. 108). Given that we now know this figure is a later addition, it seems Riegl was mistaken in reading the outward gaze of the man holding a list as "sightless." For Riegl, the painting's coherence is achieved by means of a double subordination: "firstly, between Tulp and the seven surgeons who together subordinate themselves to him as the speaker; secondly, between the surgeon at the top and the spectator, which latter is subordinated to the first and by this means, in turn, also to Doctor Tulp" (p. 183).[17] The attentive surgeons are subordinated to Doctor Tulp who, though off-center, is clearly distinguished from the others. The second subordination is effected through the top figure (or the man with the list), who singles out the spectator with his look and subordinates him or her to Doctor Tulp with his pointing gesture. More recent scholarship on the *Anatomy Lesson* confirms Riegl's sense of the implicit external coherence, suggesting that the painting's *mise-en-scène* is the annual public anatomy attended by a large audience whom Tulp also addresses (Heckscher 1958). Thoré-Bürger was the first commentator to suggest that the painting implies an audience: "Perhaps there are other spectators in the room since the professor looks out as though addressing an audience we cannot see." He concludes, "Rembrandt's compositions are never imprisoned in their frames: infinite space beyond the frame is always implied" (Bürger 1858, p. 196).

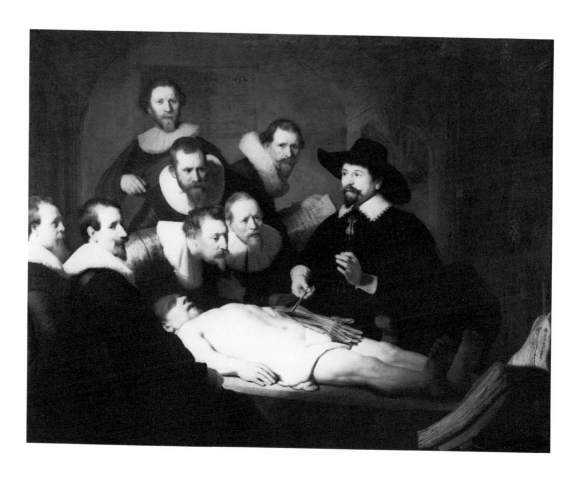

12

Rembrandt

The Anatomy Lesson of Doctor Nicolaes Tulp

1632

166.5 × 216.5 cm

Mauritshuis, The Hague

The painting also has a double compositional coherence: "objective coherence in the plane and subjective coherence in space" (Riegl 1931, p. 185). The autopsy table provides what Riegl calls a *Raumzentrum,* a space-creating object, but at the same time the group adheres to a planimetric, triangular composition. Light and shade also create an atmospheric density, although it has not yet reached the fully homogeneous effect of chiaroscuro. The integrating force of the plane composition counteracts the dissolving effect of the atmosphere: "And finally one becomes aware that the chiaroscuro of the free space at no point merges with the shadows cast by the bodies, nor do they intermingle; rather, the group of figures is raised like a pattern from a ground" (p. 191).[18] The distinction made here between the use of shadow for modeling and for pictorial unity is not Riegl's own. It derives from the widely read theorist of art Roger de Piles (1635–1709). In his *Cours de Peinture par Principes* (1708), de Piles defined two uses of light and shade in painting. One kind models objects or figures and makes them tangible. The other kind, *clair-obscur* proper, involves the distribution of light and shade over the whole picture surface. According to de Piles, if the artist only makes use of modeling shadows the eye tends to jump from object to object. With *clair-obscur,* however, unifying masses of light and shade allow the eye to embrace a multiplicity of things at once. Interestingly, de Piles understands modeling shadows as an objective registration of how light falls on objects, while chiaroscuro can be freely distributed: modeling shadows "forces the painter to obey them, while chiaroscuro depends totally on the imagination of the painter" (de Piles 1969, p. 363). Both de Piles, with reference to the artist, and Riegl, with reference to the spectator, connect tactile, self-contained objects with the restriction of the imagination and chiaroscuro with subjectivity and the imagination's free employment.[19]

The Night Watch (fig. 13) is an extraordinary group portrait, even if it is clearly related to Ketel's *The Company of Captain Dirck Rosecrans* discussed above. The militiamen are subordinated to the captain, who is ordering his lieutenant to have

13
Rembrandt
The Company of Captain Frans Banning Cocq and William van Ruytenburch
known as *The Night Watch*
1642
363 × 437 cm
Rijksmuseum, Amsterdam

the company march out. The men show their subordination by preparing for the moment when the order will be given. The company is treated almost as a background behind the officers. This too is part of the logic of the genre's development: "Having originally adopted it, Rembrandt has here drawn the ultimate consequences from the principle of subordination. It is undeniable that the development was forced in an extreme direction once this principle was admitted" (Riegl 1931, p. 195).[20] It meant the loss of coordination, attention, personal characterization, in short, the denial of group portraiture. Yet despite this emphasis on action and a subordinating expression of will, Rembrandt has followed the Dutch *Kunstwollen* in his choice of the moment depicted. He painted not the obvious *effect* as would Rubens, for example, but the mental *cause* (p. 200). "Like a true Dutchman, Rembrandt has painted not so much the action itself as the preparation for it: it is the psychic intention, the intellectual conception, attention to what is going to happen, that he has represented" (p. 197).[21] Because actions serve to express the men's attentive attitude and their intention, the painting demands great imaginative supplementation on the part of the spectator. "This shifting of the action to its initial phases is fundamentally nothing other than that truly Dutch one-way traffic in the early group portraits, which comes to a standstill halfway and requires completion by the spectator based on his previous experience" (p. 197).[22] Connection with the spectator is also enhanced by the appearance of forward movement. This movement is the master stroke, for it transforms subordination and internal coherence into a means of creating external coherence (p. 199).

The painting is a giant step toward the modern conception of art as the representation of subjective experience. The scene is littered with the partial, fragmentary, and contingent—down to a barking dog. The frame is made to mask a continuous space as a drummer enters from the right and a boy with a powder horn runs out at the left. Very nearly disregarding the norms of group portraiture, Rembrandt has used chiaroscuro to its ultimate effect of immersing the figures in vibrating

light and shade. Nothing, it seems, could be further from the haptic ideal of perceptual clarity. Yet some objectivizing features still remain. For example, the painting is strictly symmetrical. The early copy of it in the National Gallery in London shows that the arched portico was centered before the painting was trimmed.

The symmetry of *The Night Watch,* however, ought to be understood in a new way. Riegl suggests that classical art grouped things symmetrically because symmetry was then thought to display the essential, objective nature of things unclouded by sense experience. Rembrandt's symmetry is the extreme opposite of this; his figures are so arranged for the viewing subject (p. 208). Similarly, adherence to the plane is here conceived in a new, subjective way. It now forms what Riegl calls an optical plane (*eine optische Ebene*). He argued that "there are two kinds of appearance in the plane: the haptic, in which things seen at close hand stand side by side in tangible height and breadth, and the optic, in which things viewed from a distance offer themselves to the eye, even though they are actually dispersed behind one another at different spatial depths" (p. 208).[23] With *The Night Watch,* and more especially with *The Syndics,* Rembrandt realized that the way to immerse figures in free space was with symmetry and a plane composition. Bodies are partially desubstantialized so that they merge with the chiaroscuro (p. 215).

The Syndics of the Clothdrapers' Guild (fig. 14) shows five half-figures seated around a table plus a servant in the background. The unstressed chief syndic subordinates the others with his speech. He also addresses a person or persons (*eine Partei*) outside the picture. The other syndics while listening intently also look with great intensity out of the picture to gauge the reaction of the party.

> By the handling of the speaker described here, by which he demands the attention of the other seated figures, it is unambiguously stated that the latter at least in part take account of his words. These figures have

14

Rembrandt

The Syndics of the Clothdrapers' Guild

1661/2

191.5 × 279 cm

Rijksmuseum, Amsterdam

their collective gaze directed toward the spectator, that is, a party (which again in this case should not be considered limited to a single individual because of the dispersal of their gazes), and observe them with great intensity and a slight admixture of self-esteem. (p. 210)[24]

In this way they maintain a degree of autonomy. The spectator is called on to imagine this group to his left. The complete picture, so to speak, only exists in the consciousness of the beholder. Riegl believes that this painting represents the pinnacle of the development of Dutch group portraiture: "The ideal of Dutch group portraiture appears here to be realized in that the carriers of internal and external coherence in the pictures are no longer split but are identical, so that now the most complete individualization of external coherence in space and time appears actually achieved" (p. 211).[25] Although the figures are arranged around a table, it does not act as a *Raumzentrum*. The point of view is so low that the surface of the table is not visible, so instead of defining three-dimensional space, its horizontal edge actually obscures spatial relationships and compresses the figures into a very shallow space (p. 214).

The pattern of historical development in *The Dutch Group Portrait* is one of tension between oppositions, followed by reconciliations. It is fundamentally a model of problem solving: "for every such solution means nothing other than the compromise between preceding conflicts" (p. 82). We can see this pattern clearly in Riegl's discussion of Rembrandt. The problem of achieving spatial and temporal immediacy in group portraiture is solved in the Tulp *Anatomy* through action and subordination. The resulting loss of external coherence is remedied in *The Night Watch* by making subordination serve the end of movement toward the spectator, but the norms of group portraiture are very nearly abandoned. Finally, with *The Syndics* a means is found to unify the group internally, while still preserving the autonomy of the members and positing a strong link with the spectator. The space is optically homogeneous but it does not dissolve or obscure the figures. And all this is accomplished in a single dramatic moment. Riegl says of Rembrandt

that he loved dramatic conflict. Perhaps Riegl's account of his art carries such conviction because they shared this dialectical cast of mind.

The extremes of subordination in Rembrandt's art did, however, pose a problem for Riegl's acute sense of power relations enacted in depictions and between depictions and the spectator. In this respect, the leader of the Haarlem school, Frans Hals, was more congenial to his sensibility. The Haarlem school generally is said to have "a reserved attitude toward subordination" (p. 246), and for Riegl compositional subordination, unlike coordination, is a sign of unequal power relations. Hals's early work is typically Haarlemesque, but later he absorbs the influence of Rembrandt.

Riegl says of an early canvas, the *Banquet of the Officers of the St. George Civic Guard Company* (1616; fig. 15), that it conforms to Hals's practice of presenting several subgroups that are internally coherent and linking these with the spectator. In other words, there is no overriding subordination of the figures and only a "partial consideration" (p. 244) of the spectator. The conception of the painting is a banquet scene, complete with food, drink, and idle chat, which has been interrupted by a latecomer in the position of the spectator. Riegl argues that the bald-headed man is speaking to the colonel, overheard by others; at the same time, he gestures toward the new arrival. His dual function is mirrored by the man in the right foreground whose body faces us and who doffs his hat in greeting, but who turns his face toward the colonel. Near him, a seated man extends a hand in welcome. Riegl observes that the role of the colonel is not that of a "subordinating dominator" (p. 246) and that the bonds made with the spectator are "part passive (subordinate), part active (dominating)." In fact, Riegl has mis-identified the highest-ranking officer: the colonel sits in his rightful place at the head of the table and is the second from the left in the painting (Slive 1970, 1:43). Riegl also notes that the admixture of attention with camaraderie or fellow feeling links Hals with Rubens, except that here we see "a sense of humor, the slight self-denial of their lust for life for the benefit of others, in place of the Italianate

15
Frans Hals
The Banquet of the Officers of the St. George Civic Guard Company
1616
175 × 324 cm
Frans Halsmuseum, Haarlem
photo: Tom Haartsen

Flemish master's egotistical will to enjoy oneself" (Riegl 1931, p. 245). The party is interrupted, internal coherence diminished, for the sake of the new arrival.[26]

The change that takes place in Hals's work, according to Riegl, is shown in the way the depicted figures relate to the implied spectator. This is perfectly illustrated by a later Hals painting, *Officers and Sergeants of the St. Hadrian Civic Guard Company* (1633; fig. 16). Here the colonel and his flanking men seem to *demand* the spectator's attention. The colonel is immediately recognizable and there are now only two tightly bound groups. The implied spectator is without doubt subordinated to this impressive company, whereas in the earlier painting the relationships were reciprocal, part active and part passive.

Here and throughout *The Dutch Group Portrait,* Riegl thematizes power relations between spectator and depiction; he observes relations of domination and subordination, activity and passivity, the egotistical assertion of power and those subject to it. This is such an important and innovative aspect of Riegl's work that I devote a whole chapter to it and to contemporary contributions to the issue of the role of the spectator.

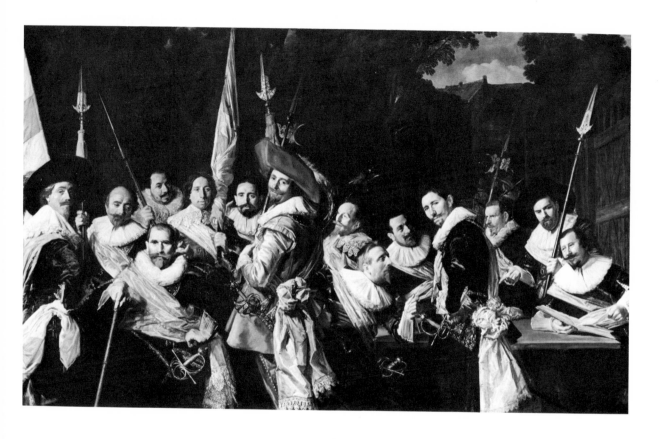

16
Frans Hals
Officers and Sergeants of the St. Hadrian Civic Guard Company
about 1633
207 × 337 cm
Frans Halsmuseum, Haarlem
photo: Tom Haartsen

Riegl and the Role of the Spectator

Riegl's historical architectonic is based on the idea of a gradual subjectivization of the objective. At the end of *The Dutch Group Portrait* he delineated the theory in the simplest of terms.

> The history of mankind up to the present is intelligible in this regard in terms of two extreme principles: in the beginning, the conception that every subject is at the same time an object—that is, only objects exist; today, the opposite whereby there are hardly any objects and only a single subject. (Riegl 1931, pp. 280–281)[1]

Dutch civilization of the sixteenth and seventeenth centuries has a crucial place in this history. For Riegl, the Dutch were the first people to regard objects as "representations" (*Vorstellungen*), that is, as appearances or mental images. For the Dutch *Kunstwollen,* the depiction of attention is central: when persons are represented they are shown entertaining representations in their minds; when still life or landscape is represented, then the objects of this "disinterested" form of contemplation are shown (p. 281). Riegl argued that this explains the persistent reluctance on the part of the Dutch artists to make history paintings, or more generally, paintings that adhere to the pictorial convention that makes the world of the painting discontinuous with that of the spectator. Instead they are inclined toward single and group portraits—"which only exist for the subject perceiving them" (*das nur für das vorstellende Subjekt existiert*) (p. 281).

This astonishing statement about portraiture, which implies that history painting is in some way independent of the spectator, would be difficult to understand if Hegel had not said almost exactly the same thing about the difference between sculpture and painting. The passage follows Hegel's remarks on the significance of the two-dimensionality of the medium of paint. While sculpture abstracts to some degree from "ordinary natural existence," painting cancels the real existent and transforms it into pure appearance addressed to vision alone. The pertinent section of the *Aesthetics* is worth quoting at some length.

Therefore painting *has to* renounce the totality of space and it is not required by any lack of human skill to sacrifice this completeness. Since the subject-matter of painting in its spatial existence is only a pure appearance of the spiritual inner life which art presents for the spirit's apprehension, the independence of the actual spatially present existent is dissolved and it acquires a far closer relation to the spectator than is the case with a work of sculpture. The statue is predominantly independent on its own account, unconcerned about the spectator who can place himself wherever he likes: where he stands, how he moves, how he walks round it, all this is a matter of indifference to this work of art. If this independence is to be preserved, the statue must give something to the spectator wherever he stands. But this independence the work of sculpture has to retain because its content is within and without, self-reposing, self-complete, and objective. Whereas in painting the content is subjectivity, more particularly the inner life inwardly particularized, and for this very reason the separation in the work of art between its subject and the spectator must emerge and yet must immediately be dissipated because, by displaying what is subjective, the work, in its whole mode of presentation, reveals its purpose as existing not independently on its own account but for subjective apprehension, for the spectator. The spectator is as it were in it from the beginning, is counted in with it, and the work exists only for this fixed point, i.e. for the individual apprehending it. (Hegel 1975, 2:805–806)

What Hegel seems to be suggesting is that painting's relinquishing of three-dimensionality, and the fact that a two-dimensional plane surface prescribes a fixed place for a spectator, both signal something about the content of painting. Since the representation is pure appearance, it only exists for a perceiving subject. Further, within the *milieu intérieur,* things are shot through with interconnections, unlike objects in the world which are extrinsic to one another. Of course, both paintings and statues are made to be seen and to that extent they bear exactly the

same relation to the spectator. Still, sculpture might be said to heighten our consciousness of the world as separate and self-contained, whereas painting appeals to our sense that whatever we behold is *our* vision of it.

Riegl appropriates Hegel's sense of the different ways sculpture and painting stand in relation to the spectator for his own account of the differences between history painting and portraiture. The former could be said to pretend to an independent existence both because of its compositional internal coherence and, one might add, because of the enduring importance of its subject matter. Portraiture, in contrast, addresses the spectator in the sense that it compositionally implies one, or sometimes implies a fictive character in the place of the spectator. Portraiture might also be thought to depend on the sympathetic interest of the spectator to grant the individual likenesses importance.

The most innovative aspect of *The Dutch Group Portrait* is undoubtedly the explicit theoretical formulation of a kind of composition that presents only part of what constitutes its totality and, so to speak, reaches out to the spectator to complete the scene. It might be thought to be an extension of the history of reflection on "the beholder's share" or "the faculty of projection" that Gombrich explores in *Art and Illusion*. But Riegl's conception is not at all concerned with the problem of image recognition. At its most radical, his understanding of the beholder's share involves imagining a person or persons in some dramatic confrontation with the depicted figures. Yet this is not an entirely original idea. Of course, Diderot imagined himself consoling Greuze's *Young Girl Who Mourns for Her Dead Bird* (1765), but he does not develop this idea in any systematic way (Diderot 1960, 2:145–148). Riegl actually names one source of inspiration for his interpretation of Dutch art, something he very rarely does. In his discussion of Rembrandt's *Syndics,* he notes: "Bürger-Thoré first saw the need to describe this dramatic content. He rightly recognized that in the place of the spectator, an invisible party must be substituted, conferring with the syndics" (Riegl 1931, p. 211).[2] Thoré-Bürger interprets the dramatic encounter as one of polemical opposition in which the chief syndic has just had the last word and the others look out at the inter-

locutor in triumph. "The speaker seems pleased with these arguments, and his neighbor's facial expression says: Well! What have you got to say to that?" (Bürger 1858, p. 26). Riegl confirms the idea of dramatic interplay, but emphatically disagrees with Thoré-Bürger's reading of it; for him the scene evokes an atmosphere of appeasement or agreement, not "spiteful satisfaction and gloating" (Riegl 1931, p. 211).

Théophile Thoré was important for Riegl not only for his suggestion of an implied presence in front of the picture space, but also for his high evaluation of Dutch art based on the belief that it embodies the values of political and religious liberty. He was an ardent republican who wrote his art criticism in exile after 1848 under the pseudonym William Bürger. He often contrasts Flemish art, particularly that of Rubens, and its domination by Spain with Dutch art and its political freedom. Riegl frequently makes the same contrast, although placing more emphasis on compositional differences. Thoré praises Dutch art for its representation of all classes, its record of everyday life, its spontaneity and sincerity. As exemplified in his criticism of Thoré's interpretation of *The Syndics,* Riegl stresses the equal power relations set up between the implied spectator and the depicted figures. For him, the syndics don't triumph over their interlocutor, rather they show interest and at the same time attend to the words of the chief syndic. One assumes that "the party" in front of the painting does as well, and its reactions are taken in by the syndics. Attentive and attended to, active and passive—these roles are swapped back and forth in a reciprocal circuit between "our" side of the composition and "theirs." This egalitarian reciprocity is central to Riegl's ideal of spectator/depiction relationships.

Riegl's interest for us owes in large part to the sophisticated dynamics he attributes to the spectator/depiction relationship. In recent years there has been an explosion of interest in the role of the reader in literary theory and a corresponding, if somewhat delayed, one in the role of the spectator in art theory. Some of the recent literature in art theory builds on the foundations provided by Riegl, some does not. In either case, however, comparing the recent work with Riegl's may

prove reciprocally illuminating. The shift toward interest in the role of the spectator has many quite independent determinants, but most probably relates to a general disillusionment with the formalism and scientism of New Criticism and structuralist literary theory. Both tended to treat the object of their enquiry as a fixed crystalline structure. Following the shift in interest, the once independent text has become wedded to the reader. There is an important strand of poststructuralist literary and film theory concerned with the role of the reader or spectator. There is also a body of reception aesthetics informed by phenomenology. A brief account of these theoretical positions will enable us better to situate the art historical literature that has enquired into the beholder's relation to visual art.

An important text for the reorientation of structuralist critical thought came from the very heartland of Saussurian linguistics. Émile Benveniste's *Problèmes de linguistique générale* (1966; trans. 1971) contains a chapter translated into English as "The Correlations of Tense in the French Verb." The chapter is fairly technical, but it contains a very fruitful distinction between two planes of utterance, *histoire* and *discours*. The "historical" plane is used for the narration of past events. It is marked by the use of certain tenses and also by the exclusive use of the third person and the avoidance of locutions like "here" and "now." In historical narrative, Benveniste says, "there is no longer a narrator. The events are set forth chronologically, as they occurred. No one speaks here: the events seem to narrate themselves" (Benveniste 1971, p. 208). "Discourse," in contrast, includes "every utterance assuming a speaker and a hearer. . . . Someone addresses himself to someone" (207). It uses the first and second persons, "I" and a complementary "you." The distinction is not equivalent to that between written and spoken language, because many written texts are discursive in character, though the French aorist tense, typical of *histoire,* is now only a written form.

Benveniste's linking of the ideas "past," "event," and "narration" and his connecting these with the effacement of any indication of narrator or narratee makes the notion of *histoire* an irresistible theoretical framework for rethinking the con-

ventions of history painting. Louis Marin attempts this in his essay "Toward a Theory of Reading in the Visual Arts: Poussin's *The Arcadian Shepherds*." For Marin, Poussin's painting is constructed in such a way that no one addresses us from within the painting as representative of the sender of the message. It effaces "its situation of emission and reception" (Marin 1980, p. 305) and so "posits representation in its 'objective' autonomy and independence" (p. 315).

The turn toward the reader or spectator inevitably problematized the idea of the viewing or reading subject, so it was not surprising that criticism within a post-structuralist paradigm turned to psychoanalysis, particularly that of Jacques Lacan whose work is informed by Saussurian linguistics. Also, the gender of the reading or beholding subject became an increasingly pressing question by the mid-seventies. Concern with the spectator, psychoanalysis, and gender converge in the work of the feminist film maker and theoretician Laura Mulvey. In her classic article "Visual Pleasure and Narrative Cinema," she investigates the kind of pleasures evoked for the presumed male spectator of classical Hollywood cinema. This cinema subscribes, she holds, to the regimes of looking that dominate patriarchal society. An active masculine gaze is directed at a feminine object of the gaze. Mulvey shows how this gaze is caught up in narcissistic identification with the hero as well as fetishistic and voyeuristic forms of fascination. Interestingly, she explains the inducement to voyeurism in cinema with an implied reference to Benveniste's "historical" form of narration. The "mass of mainstream film, and the conventions within which it has consciously evolved, portray a hermetically sealed world which unwinds magically, indifferent to the presence of the audience, producing for them a sense of separation and playing on voyeuristic phantasy" (Mulvey 1975, p. 10). She closes the article with a program for a radical cinema that might be able to counterpoint the voyeuristic fascination of classical narrative cinema. It would do so by taking explicit reference to the camera (narrator) and to the audience. In other words, the new form of cinema would be discursive in character (pp. 17–18).

The predominantly French poststructuralist critical tradition readily assimilated psychoanalysis in order to address the question of the subject. But there was also a predominantly German tradition, allied to phenomenology, that has always made the subject of aesthetic experience focal. This theory is concerned with how individuals experience or "realize" works of art. The term was proposed by Roman Ingarden in *The Literary Word of Art* (1965; trans. 1973) and refers to the way the text itself offers a sort of schema to which the reader responds and, in a sense, produces the work of art. The "realized" work of art is a merging of text and reader, painting and spectator. One prominent literary critic whose work is informed by Ingarden's theory is Wolfgang Iser, and his work has in turn been adapted by the art historian Wolfgang Kemp in his studies of nineteenth-century art. The art historian Michael Fried, who has also made an important contribution to the study of the role of the spectator, is loosely tied to the phenomenological tradition. One final text that ignited interest in spectator/depiction relationships was the dazzling analysis of Velázquez's *Las Meninas* with which Michel Foucault opened his book *Les mots et les choses* (1966; translated as *The Order of Things,* 1970). This text and others related to it are of special relevance in this context. Although neither Foucault nor his commentators really consider the work in terms of its genre, it is, of course, a group portrait.

Michael Fried on Absorption

Fried's work is a sustained meditation on the problematic of spectator/depiction relationships. The nature of his concern is most explicitly formulated in *Absorption and Theatricality: Painting and Beholder in the Age of Diderot* (1980), where it becomes apparent that Diderot's criticism of art and of the theater is the touchstone of Fried's entire critical project, whether it concerns eighteenth- or nineteenth-cen-

tury French painting or sculpture made in the United States in the 1960s. The early essay "Art and Objecthood" (1967) is a polemic directed against the minimalist sculpture of Robert Morris, Donald Judd, and others. His hostility to what he refers to as "literalist" sculpture turns on the kind of subject/object relationship that he says the works set up. The relationship, which Fried terms "theatrical," is prompted by the way the sculpture plays to its audience, becoming mannered and ingratiating and so alienating the spectator. To describe the impassive shapes of minimalist sculpture in this way seems somewhat eccentric. It is only really intelligible when read through Fried's account of Diderot's criticism.

In *Absorption and Theatricality,* Fried reads Diderot's art criticism as a reaction to the rococo and to the threat it posed, particularly for painting, of turning art into nothing more than decoration, an object hanging on the wall or, worse still, wallpaper. In order to counter that threat, Diderot championed a kind of painting that has the effect of stopping viewers in their tracks and engaging their rapt attention. "Absorption" is the term Fried uses to describe both the engrossment of the spectator and the attitude of the depicted figures in the paintings that elicit this response. The figures in Chardin and Greuze paintings are either quietly absorbed in their own thoughts or intently focused on some object.

It is tempting to read "absorption" as a version of Riegl's concept of attention, for both involve the relation of the spectator to a depiction and the attitude of depicted figures. The temptation is heightened by Fried's claim that the first efflorescence of "absorptive" paining in the seventeenth century included the work of Poussin, Velázquez, Zurburán, Vermeer, and "supremely, Rembrandt" (Fried 1980, p. 43). Yet Fried does not seem to know Riegl's work, and in any case, closer scrutiny proves that the two concepts are actually at odds with one another. What they do have in common is a delicate observation of exchanged glances and of the direction of gazes within the depiction. They also share a preoccupation with the problem of pictorial coherence, but Fried's ideal of coherence is com-

pletely *internal,* even hermetically sealed—the type of painting he admires is "self-sufficient, a closed system which in effect seals off the space or world of the painting from that of the beholder" (p. 64). Absorptive painting is, as Fried himself acknowledges, in the Albertian tradition. It does not, like Riegl's formulation of attentive painting, describe a kind of composition that includes the spectator. On the contrary, the spectator is emphatically excluded.

The key concepts of Riegl and Fried are also different in psychological character. Absorption is a total enthrallment to the point of self-forgetting. It is defined as an extreme state of mind, whereas Riegl's concept of attention is specifically defined as a state of equilibrium—a partial self-forgetting or diminishment of egotistical isolation that allows one to attend to another. To this important psychological difference corresponds a difference in artistic function. Absorption is a guarantee of plausible narrative; the figures are not guilty of posing for the spectator because they are so manifestly oblivious to being observed. This plausible narrative is in turn a powerful lure for the spectator: "only by establishing the non-existence of the beholder could his enthrallment by the picture be assured" (Fried 1980, p. 103). The similarity of Fried's ideal of the spectator/depiction relationship to the structure of voyeuristic fascination is striking. The spectator intently gazes at someone or a group of people who are not aware that they are being observed. Absorptive painting is, like Mulvey's description of Hollywood cinema, "a hermetically sealed world that unwinds magically, indifferent to the presence of the audience" (Mulvey 1975, p. 10). While Fried's ideal aims at sustaining the "supreme fiction that the beholder does not exist" (Fried 1980, p. 83), Riegl's ideal of attentive painting is structured in such a way that it acknowledges the beholder's presence, calling for reciprocal recognition.

If Fried's ideal of aesthetic perception mirrors aspects of voyeurism, it is an unintended consequence of what he set out to do, which was to describe a form of beholding that deproblematizes beholding. For Fried, a spectator's relation to an object of perception is likely to result in mutual self-consciousness that simul-

taneously isolates and alienates the spectator and renders the object of the gaze artificial, affected, and false. His acute sense of the corrupting potential of beholding has many resonances with Diderot's great contemporary Jean-Jacques Rousseau. In the *Discourse on the Origins of Inequality* (1754), Rousseau attacks display and competitive games as powerful sources of corruption in the original state of nature.

> They accustomed themselves to assemble before their huts round a large tree; singing and dancing, the true offspring of love and leisure, became the amusement, or rather the occupation, of men and women assembled together with nothing else to do. Each one began to consider the rest, and to wish to be considered in turn; and thus value came to be attached to public esteem. Whoever sang or danced best, whoever was the handsomest, the strongest, the most dexterous, or the most eloquent came to be of most consideration; and this was the first step toward inequality and at the same time toward vice. (Rousseau 1973, p. 90)

Because people win favor for how they appear in other people's eyes, semblance or the facade of superiority become sufficient tokens, desirable in themselves. By wearing a mask, by bearing emblems or symbols of superiority, one can command respect and admiration. Rousseau argues that men should not *seem* but *be* a certain way. In other words, they should be perfectly transparent to one another, instead of covered in an accretion of signs. Nor should they need or want to compare themselves to others. For Rousseau, masks are bound up with competition and discord, transparency with collective harmony. One commentator on Fried, Stephen Melville, is sensitive to this deep root of his concern. "Diderot's dream, Fried's dream, is finally of a world to which we can simply be present and in which we can be simply present to one another, undivided, unposed, graceful" (Melville 1981, p. 75). All this perhaps helps explain why Fried found minimalism so disconcerting. Its effect is to make the spectator conscious of him- or herself

as embodied, as in a room or space with certain contours. Fried's gloss on this effect is telling: it is as though "the work in question has been *waiting for* him. And in as much as the literalist work *depends on* the beholder, is *incomplete* without him, it *has* been waiting for him—confronting, distancing, isolating him" (Fried 1980, p. 140). Minimalist sculpture posits a spectator and, for Fried, this means it is caught up in the bad faith and corruption of theatricality.

Fried finds theatrical painting or sculpture ingratiating. The interest in depicted figures is bound up with their being *veiled,* inaccessible, reticent, and the paradigmatic cases of these alluring figures are female. Yet the question remains why this necessarily frustrating effort should be so alluring. Again Rousseau provides a clue. His *Lettre à d'Alembert sur les spectacles* (1758) may prove illuminating on the nature of the attraction to these reticent figures. In fact, Fried appends a discussion of the *Letter* to *Absorption and Theatricality. Sur les spectacles* and *Émile* (1762) are notorious for their advocacy of an extreme form of sexual differentiation in which women are encouraged to simulate modesty or the veil of *pudeur.* Sophie, Emile's companion, is taught to cultivate her "natural gift" of cunning so that she will know how to conceal her own feelings, for if she told the truth "she would no longer attract him" (Rousseau 1974, p. 348). This "productive illusion" of idealized femininity inspires sublime love and promotes the sort of self-mastery necessary for men to transcend "the baseness of our human nature." In the appended discussion of the *Letter,* Fried cites a passage where Rousseau recommends a manner of courtship that, as Fried points out, "rescues" women from their natural proclivity "to give themselves up to the tainted and debasing pleasures of self-exhibition" (Fried 1980, p. 168). If women are to remain modest, then men must cultivate the skill of deciphering tacit consent or be guilty of the audacity of a satyr: "To read it in the eyes, to see it in the manner, despite the mouth's refusal, is the art of one who knows how to love" (Fried 1980, p. 168). She becomes for him textual rather than theatrical—an interesting, desiring enigma behind a veil.

As Rousseau says elsewhere in the *Letter,* "The desires, veiled by shame, become only the more seductive" (Rousseau 1960, p. 84). What I am suggesting is that in Fried, abstracted states act as a kind of veil, a screen onto which the reverie of the spectator is projected. So what at first appeared to be an account of the spectator/depiction relationship, which valued the separateness or self-contained-ness of the depicted figure, turns out to be one in which the image capitulates entirely to the spectator's desire. It is this aspect of Fried's theory that contrasts sharply with Riegl's ideal of the attentive relation and its characteristic reciprocity.

Kemp's Constitutive Blanks

Wolfgang Kemp's contributions to the study of spectator/depiction relationships are largely in German, so they are less well known to readers of English. Perhaps because his work is so deeply rooted in a German tradition, it seems more in sympathy with Riegl's concerns than does Fried's. In the methodological first chapter to his book *Der Anteil des Betrachters: Rezeptionsästhetische Studien zur Malerei des 19. Jahrhunderts,* Kemp names Diderot, Hegel, and Riegl as the most important contributors to the study of the aesthetic reception of art. He criticizes the later Vienna school of art historians for cutting short the development of Riegl's work in reception theory by confining their interest in his work to formal and stylistic matters (Kemp 1983, p. 24). Kemp reads *The Dutch Group Portrait* through Hegel and makes an interesting critique of Riegl's concepts of internal and external coherence. Riegl tends to regard these as independent stylistic ty-pologies, whereas a close reading of Hegel reveals that if Riegl had followed Hegel properly he would have seen them as two functions at work in every work of art. Kemp cites some passages from the *Aesthetics* to make his point.

But however far a work of art may form a world inherently harmonious and complete, still, as an actual single object, it exists not for *itself,* but for *us,* for a public which sees and enjoys the work of art. The actors, for example, in the performance of a drama do not speak merely to one another, but to us, and they should be intelligible in both these respects. And so every work of art is a dialogue with everyone who confronts it. (Hegel 1975, 1:263–264)

Although Hegel says in the first sentence of the passage that the work does not exist for itself but rather for us, the rest makes clear that what he means to say is that every work of art involves both internal and external relations, albeit in varying proportions. He observes that the "severe" style is utterly simple and seemingly diffident in relation to the spectator, while the "pleasing" style "turns itself inside out and as it were makes an appeal to the spectator" (2:619). In Hegel's opinion, French artists aim to please; they "aim in their work at flattery, attraction and plenty of effect" (2:620). The "in itself" and "for others" have opposing weaknesses. Only the ideal manages a perfect balance: "Both, peace in itself and turning to the onlooker, must indeed be present in the work of art, but the two sides must be in complete equilibrium" (2:619). Hegel's analysis of different relations works of art bear to the spectator both constitutes an aesthetic norm and unfolds a history of stylistic development.

Although Kemp argues that Riegl followed Hegel's lead in stressing the work of art's relation to the beholder and in formulating a history of stylistic development that traces increasing spectator participation, Kemp also notes a divergence.

Riegl's conceptual framework is not far removed from Hegel's distinction between the "for itself" and "for us." Riegl spoke about "internal coherence" and "external coherence" and he meant, unlike Hegel, not two functions of one and the same work of art but two fundamentally different types of works of art. (Kemp 1983, p. 20)

He concludes that "the difference between 'internal' and 'external' coherence ought to consist in the differing means of structuring reception [*Rezeptionsvorgabe*], and not in the distinction between lack of consideration of the spectator and consideration of him or her" (p. 22). Kemp is right to suggest that we should think in terms of different functions in any work of art rather than typologies of style. However, as he himself points out, Riegl's own practice is to observe the interpenetration of the ideal types. His history of Dutch group portraiture is precisely a history of the integration of internal coherence into external coherence.

The analysis of how nineteenth-century paintings structure the spectator's reception is Kemp's field of study. He is aided in this not only by Riegl's work but also by literary theory in a phenomenological tradition, especially that of Roman Ingarden and Wolfgang Iser. Familiarity with the most theoretical of Iser's books, *The Act of Reading: A Theory of Aesthetic Response* (1976; trans. 1978), is helpful for understanding Kemp's project and especially his idea of "constitutive blanks." This idea is elaborated by Kemp in an article published in English as "Death at Work: A Case Study of Constitutive Blanks in Nineteenth-Century Painting" (1985). The article is especially interesting for us because it theorizes a form of open-textured composition.

Iser's theory of reading is basically that a text presents a certain structure but also a certain amount of indeterminacy and that this openness is what enables the text to "communicate" with the reader. The indeterminacies induce the reader to participate both in the production and in the comprehension of the work's intention (Iser 1978, p. 24). An individual's "realization" of the text has a degree of freedom, but it is not on that account arbitrary. For Iser, it is unannounced shifts in perspective or viewpoint within the text that open up gaps that require the reader's constitutive activity. Kemp adds an important element to this theory of reading by historicizing it. He contrasts a classicist painting by Prud'hon with a realist painting by Gérôme, showing how each sets up different relations to the spectator. He argues that the later nineteenth-century artist widens the field of

17

Pierre-Paul Prud'hon

Justice and Vengeance Pursuing Crime

1808

243 × 292 cm

Louvre, Paris

indeterminacy, apparently impeding intelligibility but in fact making the meaning something that has to be constructed by the spectator.

Kemp understands Pierre-Paul Prud'hon's *Justice and Vengeance Pursuing Crime* (1808; fig. 17) as an internally coherent composition that aims at a lucid exposition of the idea of justice. Prud'hon's own comments on a preliminary sketch, cited by Kemp, sum up his intention brilliantly: "It is appropriate for every age and belongs to every people, announces and explains itself, at the same time shows the cause and its effect" (Kemp 1985, p. 8). Despite the goal of self-sufficiency, Kemp shows how the painting relies on a gap that opens up between the limited point of view of the fleeing criminal, who does not see the looming figures of Justitia and Nemesis, and our comprehensive view. In other words, it is essential that we note the discrepancy between these two perspectives and provide the missing information, which is that the criminal, typically, does not foresee the consequences of his action.

The blank in this case functions as an aid to intelligibility. In Kemp's second example, Jean-Léon Gérôme's *The Death of Marshal Ney* (1868; fig. 18), the situation is quite different: "instead of manifest intelligibility, contingency; instead of sense, sensory data; instead of completeness on the part of the beholder, suspense" (Kemp 1985, p. 114). According to Kemp, the wall that dominates the painting indicates an absence, a space once filled by the now dead Ney lying in the street. Equally, the retreating soldiers and, more particularly, the man who looks back over his shoulder bring "into the picture a part of the *hors du champ,* a part of the space in front of the picture" (p. 112). The "blank" in front of the picture, which has also just been vacated, is thus invoked by the composition. The spectator is positioned in that space, perhaps taking the role of one who has accidentally witnessed the execution. In the case of the Prud'hon painting, that space has no relevance to the scene in the picture and so "Prud'hon integrates the function of the beholder, the all-seeing eye of Justice, into the picture" (p. 112).

One important implication of Kemp's paper is that the realist painting does not force a conclusive reading. He suggests that a "displacement of activities takes

18

Jean-Léon Gérôme

The Death of Marshal Ney

1868

Graves Art Gallery, Sheffield

Reproduced by permission of Sheffield City Art Galleries

place—the artist is no longer a fabricator of solid data and relations; instead he arranges spaces and surfaces, which are open to the projective activity of the beholder" (p. 114). "Indeterminacy" carries for Kemp some of the same values as "attention" did for Riegl. What is offered by Gérôme's painting is a *Vorstellung* of an event, presented without comment, rather than the lucid presentation of a significant action. You could say that since the spectator's response is not determined, he or she is not subordinated to it. They meet on level terms.

Foucault's *Las Meninas*

The famous canvas by Diego Velázquez, *Las Meninas* (1656; fig. 19), about which so much has been written in recent years, has an obvious relevance to the theme of this chapter. It is a wonder that Riegl did not mention it in his account of group portraiture, for it could be regarded as a demonstration piece of his principles of coordination and external coherence. To acknowledge that, however, would have wreaked havoc with Riegl's contention that these principles are characteristic of the Dutch *Kunstwollen* and related to the Netherlands' political emancipation from Spain. The impetus for much of the recent literature was given by Michel Foucault's analysis of the painting in *The Order of Things*. Yet the responses to it have not considered the painting in the context of the classical episteme. Rather, attention has been paid to puzzling paradoxes of self-reference and perspectival viewpoint—John Searle's "*Las Meninas* and the Paradoxes of Pictorial Representation" (1980) is a case in point. Foucault's sense of it as "the representation of classical representation" (Foucault 1970, p. 16) was lost, perhaps because it was rather difficult to grasp in the first place. After the brilliant description of the painting in his opening chapter, Foucault does not refer to it again until the very end in closing his discussion of the nineteenth-century episteme. There he

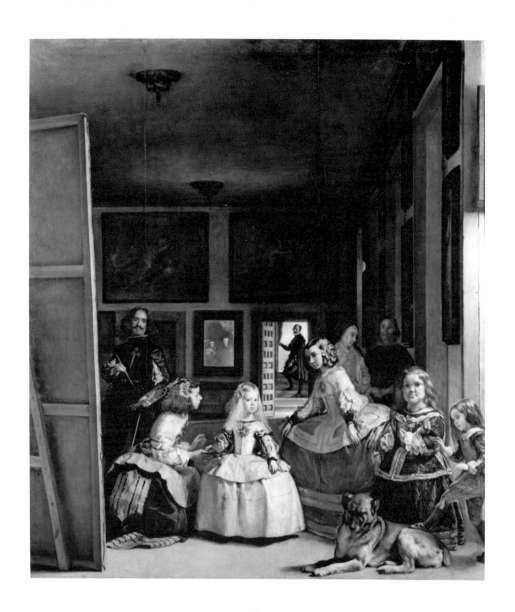

19
Diego Velázquez
Las Meninas
1665
318 × 276 cm
Prado, Madrid

introduces "at the last moment, rather like some *deus ex machina,* a character who has not yet appeared in the great Classical interplay of representations"—man (p. 307). Within the classical episteme, the subject who classifies and orders representations cannot himself be amongst the represented things: man is not a possible object of knowledge. For Foucault, *Las Meninas* allegorizes this situation. The painting is an enumeration or summation of the elements that add up to visual representation, all laid out in an ordered table: "In the great volute that runs around the perimeter of the studio, from the gaze of the painter, with his motionless hand and palette, right round to the finished paintings, representation came into being, reached completion, only to dissolve once more into light; the cycle was complete" (p. 15). But Velázquez's painting has another dimension: "The lines that run through the depth of the picture are not complete; they all lack a segment of their trajectories" (p. 15). The gap caused by the absence of the royal couple is "an artifice on the part of the painter" (p. 16), that is, a part of its composition. But, for Foucault, that gap "both conceals and indicates another vacancy," that of the artist and spectator. These absences are a structural part of the classical episteme. The composition of the painting artfully eclipses these positions by installing the King and Queen as models in that space. An "essential void" is created that is "the necessary disappearance of that which is its foundation—of the person it resembles and person in whose eyes it is only a resemblance. This very subject—which is the same—has been elided. And representation, freed finally from the relation that was impeding it, can offer itself as representation in its pure form" (p. 16). Far from being a painting that acknowledges the spectator/ artist's constitutive function, then, Foucault's *Las Meninas* actually short-circuits consideration of that position. It is painting's equivalent of Benveniste's "historical" utterance. Yet it must be significant that Foucault should have chosen this painting that poses so insistently the question of the viewing subject. He could, like Louis Marin, have chosen a Poussin painting. It can only have been because Foucault wanted to illustrate the impossibility of maintaining a view of knowledge or of representation that presents itself as *the* order of things, rather than as *our*

ordering of things. The eclipse of the constitutive subject of knowledge is the classical episteme conjuring trick. The eclipse of the viewer of *Las Meninas* as Foucault describes it is also a sleight of hand. Not to see the precariousness of both is like not getting the joke.

One of the most interesting and pertinent "responses" to Foucault's essay was in fact written prior to it, but published after, prompted by the wave of subsequent material: Leo Steinberg's "Velázquez' *Las Meninas*" (1981) offers an interpretation of the painting that shows the flip side of Foucault's teetering classical episteme. He first of all observes the many attempted and failed connections between the figures portrayed. The princess is offered a drink in which she takes no interest, a boy harasses a dog who fails to react, a woman talks to a man who appears not to listen—and the great canvas in the painting turns its back on us (Steinberg 1981, p. 48). Instead, all but three of the *dramatis personae* look in our direction. In Riegl's terminology, what Steinberg is noticing is the diminishment of internal coherence and the compensating shift toward connection with those in the imagined space in front of the picture. It is loosely strung together and the central motif is a nonevent. Why, then, does it maintain "such a steadfast grip on one's consciousness"?

> It must be a force, an energy issuing from the picture which arrests and invites and ends up drafting us into its orbit. Looking at *Las Meninas,* one is not excluded; one hardly feels oneself to be looking *at* it, as one would a thing over there—a painted surface, a stage set, or gathering of people. Rather, we enter upon *Las Meninas* as if we were part of the family, part of the event. (p. 48)

He speaks of the painting's "complementary hemisphere"—it shows "but one half of its own system" (p. 51). Very like Riegl's account of Dutch group portraiture, Steinberg stresses reciprocity. It does not behave like an object.

Rather, the picture conducts itself the way a vital presence behaves. It creates an encounter. And as in any vital exchange, the work of art becomes the alternate pole in a situation of reciprocal self-recognition. . . . The mirror within *Las Meninas* is merely its central emblem, a sign for the whole. *Las Meninas* in its entirety is a metaphor, a mirror of consciousness. (p. 54)

Although there is no reference to Riegl in the Velázquez essay, Steinberg was undoubtedly influenced by him. Steinberg's best-known essay, "The Philosophical Brothel" (1972), draws on *The Dutch Group Portrait* and Riegl's conception of external coherence to describe Picasso's *Les Demoiselles d'Avignon* (1907). Picasso, he argues, need not have had direct knowledge of Riegl nor much regard for the group portraits he discussed, "but he did know the supreme realization of this Northern intuition—Velázquez's *Las Meninas,*" a work that "presents itself not as internally organized, but as a summons to the integrative consciousness of the spectator" (Steinberg 1972, p. 22).

Conclusion

"Allegory of the classical episteme" or "mirror of consciousness"? It is hard to imagine two more radically incompatible interpretations. They face off on either side of the divide we have been calling internal and external coherence, or *histoire* and *discours,* or "in itself" and "for others." And the fact that both sides of the opposition can be made to adhere to the same painting suggests that they might be false distinctions. We are back to the problem broached in our discussion of Hegel. A statue can only *seem* "self-complete and objective" or "unconcerned about the spectator" (Hegel 1975, 2:805–806). Or, to put it the other way around,

there is no object of perception that does not imply a subject. But this is to argue that the distinctions we have been elaborating are without value. The history of art and of art theory have been caught up in a dialectic that runs between the claim that objects have an independent existence, and the view that no such object or external world exists because my thought and the object of my thought cannot be separated out in this way. In Riegl's art theory, the positions become the poles of an historical evolution. In his account of attention in Dutch group portraits, however, he seems to suggest the heuristic value of holding onto both positions. This is seen most clearly in his argument that "baroque dualism of object and subject" (Riegl 1931, p. 200) is the necessary epistemological assumption for portraiture. He argues that the immediate rapport of the portrait figure with the spectator is only possible given this dualism. "Classical antiquity had avoided this facing outward, for it recognized only objects. Modern art likewise is able to dispense with it, but on exactly opposite grounds: it knows only the subject, because in its view so-called objects are reducible to the sensation of the subject" (p. 200).[3] Baroque art is midway between these positions. It liberated the subject but, at he same time, preserved the existence of the object—or, in the case of portraiture, of another subject. Riegl's notion of attention tries to sustain this delicate equipoise. Although the historical trajectory of Riegl's system is toward ever increasing subjectivity, he seems to have been deeply concerned about the ultimate consequences of modern subjectivism.

Postscript on Panofsky: Three Early Essays

The most celebrated and penetrating commentator on Riegl was the young Erwin Panofsky. His early essays are highly theoretical engagements with questions of methodology in art history. After the 1915 critique of Wölfflin, he wrote three important essays that directly and indirectly engage Riegl's work. The 1920 paper "Der Begriff der Kunstwollens" ("The Concept of the *Kunstwollen*") is his attempt to interpret Riegl's *Kunstwollen* as an a priori principle that inheres in the individual work of art and constitutes its coherence. It is a use of transcendental idealism to overcome both inconsequential empiricist fact gathering and willful subjective interpretations in art history. Two subsequent essays make focal Riegl's notions of objectivity and subjectivity. In "Die Entwicklung der Proportionslehre als Abbild der Stilentwicklung" (1921; translated as "The History of the Theory of Human Proportions as a Reflection of the History of Styles"), different types of canon are taken to be indicative of a varying *Kunstwollen,* but one *Kunstwollen* is regarded as superior to the others: for Panofsky, the Renaissance achieved a perfect epistemological poise between attention to the objective world and recognition of the subjective conditions of perception. In the slightly later "Die Perspektive als 'symbolische Form'" (1924–1925, 1927; translated as "Perspective as Symbolic Form"), the Italian Renaissance again serves as a kind of norm. Perspective's transformation of the experience of space into a mathematical system is compared with Kantian epistemology, for both are said to achieve an "objectification of the subjective" (Panofsky 1964, p. 123).

Panofsky carried forward Riegl's project, but he did so with a somewhat different set of priorities. Chief among them was his effort to find an absolute viewpoint, an Archimedean point, in relation to which all the products of art could be authoritatively understood. He seems to have found too diffuse Riegl's multiple typology of styles equivalent in value. In Panofsky's hands, Riegl's sliding scale of possible relations to the world between a predominantly objective outlook and a subjective one got collapsed into the dual necessary conditions of knowledge as described by Kant. Because, in Panofsky's scheme, they constitute conditions of

knowledge, the question of the optimum relation between them is crucial. There must be a just balance between sensuous receptivity and active mental formulation. The proper balance of these two conditions as it appears in art was located by Panofsky in the Italian Renaissance, making it an obvious candidate for the absolute viewpoint his conception of *Kunstwissenschaft* required. This search for a unitary principle that would systematically elucidate works of art was, of course, part of Riegl's project too. But in Riegl, the totalizing nature of the project was mitigated by his concern to legitimate a wide range of different styles. The *Kunstwollen* was intended both to guarantee historical continuity and to rescue the art of the past from the imposition of our aesthetic values. Panofsky's appropriation of Riegl's concept, as we shall see, turned it into a gauge that measures other styles as lacking in relation to the ideal of Renaissance art.

The normative aesthetic implied by Panofsky's early essays owes something to Schiller's letters *On the Aesthetic Education of Man* in which he argued that the highest ideal of the beautiful is found in "the most perfect possible union and equilibrium of reality and form" (Schiller 1967, pp. 110, 111). Yet Panofsky's ideal goes beyond the notion of epistemological poise to include a notion of reflexivity. Panofsky adopted the Renaissance as a viewpoint because he thought that it included within its representations a reflexive awareness and acknowledgment of the relationship of mind to things. In this respect it is more akin to the achievement of Schiller's sentimental poet who, rather than immediately representing objects, "*reflects* on the impression that objects make upon him" (Schiller 1966, p. 166). As with Schiller, one can detect in Panofsky's work an ambivalence between an ideal of equilibrium of sense and thought and one in which the world of sense is thoroughly absorbed and transcended in thought.

This latter ideal is closer to the neo-Kantian position espoused by Ernst Cassirer. During the second decade of the century Cassirer and Panofsky were both professors at the University of Hamburg and Panofsky regularly attended the philosopher's lectures. In order to understand Panofsky's project for an objective art

history we must first come to terms with the broad outlines of Cassirer's *Philosophy of Symbolic Forms* (first published 1923–1929). Cassirer understood all cultural forms—language, myth, art, religion, and knowledge—as products of cognition. The ultimate project of philosophy for him was the elucidation of the basic formative principle of all symbolic forms, which would confirm the unity of the spirit's productive process within the multiplicity of its manifestations. Very much like Hegel, he thought that the spirit only develops and discloses itself in shaping material. Citing Shelley, he declared that "the authentic and essential life of the pure idea comes to us only when phenomena 'stain the white radiance of eternity'" (Cassirer 1972, 1:88). The products of culture are therefore neither wholly objective nor wholly subjective: "Art can no more be defined as a mere expression of inward life than as a reflection of the forms of outward reality" (1:93). Against Hegel, however, Cassirer was concerned to maintain the specificity of different symbolic forms.

Another aspect of Cassirer's philosophy, also related to the Hegelian inheritance, is the notion that the history of culture embodies the history of man's progressive self-revelation and self-liberation. He discerned in the history of cultural forms a development in which symbols that originally corresponded to sensory objects gradually became permeated with thought, until finally they display a free self-consistent significance above and beyond any sensory raw material. The completion of this project brings with it a reflexive awareness of man's own formative activity and his realization of freedom.

> Thus, with all their inner diversity, the various products of culture— language, scientific knowledge, myth, art, religion—become parts of a single great problem-complex: they become multiple efforts, all directed toward the one goal of transforming the passive world of mere *impressions,* in which the spirit seems at first imprisoned, into a world which is pure *expression* of the human spirit. (Cassirer 1972, 1:80)

We shall see how Panofsky adapts this idea of cultural progress in the papers on proportion and perspective. In so doing we shall uncover the difficulty internal to it—a difficulty especially acute for one engaged in the study of visual art: this notion of cultural history cannot fully shed its association with Hegel's aesthetics, in which art merely serves the higher accomplishment of philosophy. Placing such a high value on the intelligible or discursive register must imply a devaluation of the visible, the sensory, lived experience. Michael Podro picks out a telling passage, quoted from Goethe, from Panofsky's first book on Dürer's theory of art that underlines this ideal and goal of the systematic absorption of the world in thought: "The highest thing would be to grasp things in such a way that everything factual was already theory" (Panofsky 1915, p. 199).

Although Panofsky was indebted to Cassirer, he was no mere follower. While he does not comment directly on this matter, one can infer that Panofsky was more than a little skeptical of Cassirer's Olympian confidence in the logical unfolding of consciousness or the progressive determination of the symbols that culminate in modern science. His histories of symbolic forms have a rather fraught or perilous aspect foreign to Cassirer. Even early in his career Panofsky recognized that cultures can and do move in an antirational direction.

"The Concept of the *Kunstwollen*"

"Der Begriff des Kunstwollens" is not so much an interpretation of Riegl's concept as an appropriation and reformulation of it. Panofsky regarded the concept as the nearest art history had come to finding a general principle that would make art susceptible of systematic interpretation and render our critical judgments objectively valid. Such judgments are only possible, however, if the works themselves contain a concept or a principle of intelligibility that holds the various components

of the work together with *necessity*. Such a principle cannot be discovered if one stays on the level of historical phenomena. And art history, as opposed to history, must look further because it deals not with mere occurrences but with formed products (Panofsky 1964, p. 33). While history is satisfied with the connecting of events in a sequence, art history must seek a point of view outside of the historical complex; it must discover a "fixed Archimedean point":

> And so the demand emerges for the study of art—a demand that in the area of philosophy is filled by the theory of knowledge—to find a principle of elucidation on the basis of which one can not only grasp the artistic phenomenon in its existence, through an ever widening net of references to other phenomena, but can also know it in the conditions of its existence through reflection descending below the sphere of empirical being. (p. 33)[1]

The 1920 paper is essentially an attempt to make these analogies between art and knowledge and between systematic art history and epistemology work.

Although Panofsky acknowledged Riegl as "the most important exponent of this serious philosophy of art" (p. 34), he had grave reservations about the term *Kunstwollen*. As I have also suggested, Panofsky understood Riegl's main motivation for this reference to "will" or intention as a way of setting his ideas in clear opposition to those art theories that stressed material factors determining artistic production. Because of this background, Panofsky believed that the *Kunstwollen* left itself open to psychologistic notions of intention, either of an individual or a collectivity. Panofsky also objected in this context to psychologistic theories that held that the spectator could connect with the original intention of the artist by means of empathy with the work. By changing the terminology from "intention" to "a priori concept" he hoped "to secure the concept of the *Kunstwollen* against confused interpretation" (p. 41).

Panofsky's main objection to psychologistic forms of interpretation is that we simply do not have access to the intention of the artist. If we attempt to deduce that intention from the works themselves then our procedure is hopelessly circular. This circularity is not avoided by reference to artists' statements or other such documents because they too stand in need of interpretation. Interpretation in terms of period psychology runs into the same difficulties: constructs such as Worringer's Gothic Man are "only the hypostatizing of an impression we receive from just this artistic product" (p. 37). He concludes that

> the artistic intention achieved in a work of art must be strictly separated from the varying personal aims of the artist, as well as from the mirroring of the artistic phenomena in the contemporary consciousness [*Zeit-Bewußtsein*], or indeed from the content mediated by the experience of latter-day observers: that is, briefly, the *Kunstwollen* as the object of possible art historical knowledge is not a (psychological) reality. (p. 38)[2]

The other prevailing mode of art historical interpretation, apart from psychologistic ones, is interpretation based on empirical generalization over artistic phenomena. This method, ascribed to Wölfflin, also falls into circularity because it forms principles of elucidation by generalizing over just those works of art standing in need of interpretation. The only solution is to formulate a priori principles like Kant's categories of thought. Then and only then will the subjectivity and contingency of art historical enquiry be overcome: "The *Kunstwollen* cannot be anything but that which objectively (not just for us) 'lies' in the artistic phenomenon as the ultimate meaning, if this expression is to signify neither a psychological reality nor an abstract term of classification" (p. 39).

The transformation of the *Kunstwollen* into an a priori concept follows the epistemological position outlined in Kant's *Prolegomena*. In that text, Kant distinguished between "judgments of perception" which are only subjectively valid and

"judgments of experience" which claim objective validity (Kant 1922, 4:48). While the first sort of judgment involves the combination of perceptions or associations that pertain to the contingent experience of an individual thinking subject, the latter sort is determined by pure concepts of the understanding. Panofsky elaborates this distinction using Kant's own example. Kant argues that the statement "Air is expandable" might be understood as expressing a simple judgment of perception, that is, a perception of decreased pressure followed by a perception of increased volume. But if the judgment is understood as containing the concept of cause, then the sentence is implicitly hypothetical-categorical: "If I change the pressure on a quantity of air, this will bring about a change in its extension." The perceptions in this case do not simply follow one another in a temporal sequence; they are connected necessarily, not just psychologically, by our inclusion of the concept of cause (4:50–52). As Kant states, "the judgement becomes of necessity universally valid, consequently objective, and thus a perception is transformed into an experience" (4:48).

If objectively valid judgments of works of art are possible, then some concept, which functions like the a priori concept of cause in the case of scientific knowledge, must be available to the art historian. This is clearly spelled out:

> Just as the sentence "Air is expandable" takes on a certain epistemological character that reveals itself by a consideration *sub specie* the concept of cause (and only by such a consideration), so the objects of art historical discourse, delimited more or less broadly as epochal, regional, or individual artistic phenomena, can also disclose an immanent meaning—and thus a *Kunstwollen* will be disclosed, not merely in a psychological but also in a transcendental-philosophical sense, if they [the objects of art historical study] are to be considered not in relation to something lying outside them (historical circumstances, psychological history, stylistic analogies) but exclusively in their own being. (Panofsky 1964, p. 40)[3]

Panofsky suggested Riegl's objective/subjective pairing as possible art historical fundamental concepts equivalent to the concept of cause in scientific discourse. Since these a priori *Grundbegriffe* are so universal and abstract they require a schematism or some procedure of application. Concepts such a Wölfflin's linear/painterly, plane/recession, and so on might serve this purpose. Once set in relation to the a priori principle, certain formal characteristics and motifs would be seen not merely as coexisting in a work of art (a judgment of perception) but as necessarily bound together (a judgment of experience and therefore objectively valid). This indwelling guarantor of coherence Panofsky calls the immanent meaning (*immanenten Sinn*) of the work of art, stressing its inseparability from the individual work. As I understand it, the immanent sense is the schematized application of the a priori concepts to the particular work of art.

Although Panofsky proposes universal fundamental concepts constitutive of all works of art, the system he loosely adumbrates in this essay allows a great deal of scope for variability within the univocal conceptual framework. He suggests that Riegl's objective/subjective bipolar scheme was too restrictive and might be taken to define just one of two axes forming a graph onto which all styles and individual works could be plotted (p. 40). It should be noted that this model of a graph is completely ahistorical. History at this stage in his thinking seems to have been associated with a kind of temporal causal determination foreign to objective art history: "the 'necessity' that it ascertains in a particular historical process consists not in the fact that between several individual phenomena that follow one another temporally a causal relationship is noticed, but rather in the fact that a coherent sense is contained within them, as in a total artistic phenomenon" (p. 42).[4] In the two later essays under consideration here, this "coherent sense" is no longer plotted in relation to spatial coordinates but given a temporal dimension much like the project of culture as described by Cassirer.

"The History of the Theory of Human Proportions as a Reflection of the History of Styles"

The model for a systematic art history as elaborated in the *Kunstwollen* paper, although unified, does not privilege any one particular historical moment or position on the graph. Under the growing influence of Cassirer, Panofsky projected his synchronic and evaluatively neutral model onto a developmental history that involves man's growing reflexive self-awareness and freedom. Both the proportion paper and "Perspective as Symbolic Form" formulate histories in which the achievement of Italian Renaissance art constitutes an ideal in relation to which all other styles are organized.

In the 1921 paper different types of canon of proportion are taken to be indicative of differences in the underlying *Kunstwollen*. The major types of canon are classed by Panofsky as those that determine *objective* proportions of human beings independently of any special requirements of representation, and those that determine *technical* proportions or a system of relative dimensions that serves as a ready-made schema of representation. A problem is immediately posed by the case of Egyptian art. Its system of inscribing figures in grids clearly indicates a "technical" canon, but because the schema of representation is at the same time faithful to the objective dimensions of figures, Panofsky regarded it as a special case of an art in which technical and objective canons of proportion overlap. The types of canon only diverge when at least one of three conditions obtains: (1) when the artist takes into consideration organic movement, (2) when the artist makes adjustments and foreshortenings in accordance with the subjective conditions of perception,

and (3) when the artist departs from objectively correct proportion in order to compensate for the foreshortenings that occur when the spectator perceives the finished product (Panofsky 1970, p. 84). Each of these conditions is a recognition of subjectivity—of the figure, of the artist, and of the beholder, respectively—and none obtains in Egyptian art.

Panofsky's account of Egyptian art is negative: it is an art that fails to take account of subjectivity and, like all technical canons, imposes considerable constraint upon the freedom of the artist: "Without too much exaggeration one could maintain that, when an Egyptian artist familiar with this system of proportions was set the task of representing a standing, sitting or striding figure, the result was a foregone conclusion once the figure's absolute size was determined" (pp. 88–89). For Panofsky, objective canons are in this respect superior, for, while they determine the ideal or normal proportions of the human body, they do not then impinge on the artist's manner of execution. Greek artistic practice with its objective canon, for example, admits of "the irrationale of artistic freedom," unlike Egyptian which is "an art completely governed by a mechanical and mathematical code" (p. 100). Or, again, "classical Greece, then, opposed to the inflexible, mechanical, static and conventional craftman's code of the Egyptians, an elastic, dynamic, and aesthetically relevant system of relations" (p. 97).

One can almost hear Riegl objecting to this, as he did to the negative characterizations of late Roman art as lifeless and stiff: "we must understand that the *Kunstwollen* may be directed toward other perceptual forms of objects that according to our modern viewpoint are neither beautiful nor lively" (Riegl 1927, p. 11). In fact, Panofsky did concede, in one paragraph, to Riegl's insistence on the aesthetic legitimacy of all styles, noting that the Egyptian theory of proportion reflects a *Kunstwollen* directed "not toward the symbolization of the vital present, but toward the realization of a timeless eternity" (Panofsky 1970, p. 89). However, the overriding thrust of the essay is a celebration of objective canons of proportion

as practiced by the Italian Renaissance and a condemnation of the "passivity" of technical canons like the Byzantine and Gothic. Schematic art, which is not "held up to nature," suffers a similar fate in the hands of Gombrich, another theoretician concerned to give art the attributes of knowledge. For example, in *Art and Illusion* he suggests that the Byzantine conception of art "led to a concentration on distinctive features and came to restrict the free play of the imagination in artist and beholder alike" (Gombrich 1960, p. 145). One begins to harbor the suspicion that the analogy between knowledge and art carries with it some normative criteria of aesthetic "truth."

The objective canon of the Italian Renaissance, which measured the relative dimensions of humans independently of any technical procedures of representation, allowed artists to vary proportions when they took into account movement or foreshortenings. The scientific study of the objective world was complemented by an equally scientific recognition of the conditions of subjective experience, including a systematic theory of perspective. In short, the Renaissance satisfied the demand that constitutes Panofsky's implicit aesthetic norm: it evidences a reflexive awareness of those conditions that make experience (and art) possible, that is, receptivity to objective reality together with spontaneous mental formulation of that manifold.

The beauty of Renaissance art, for Panofsky, is that it simultaneously acknowledges the mind's contribution to experience while at the same time hanging onto an interest in things as self-contained objects independent of mind. Panofsky recognizes that the importance of objective canons was bound to diminish as artists began to emphasize the subjective conception of the object instead of the object itself (Panofsky 1970, p. 136). Panofsky greets this "victory of the subjective principle" in modern times with considerable skepticism. It also falls foul of his absolute viewpoint. While technical canons short-circuit subjective experience, "expressionist" art loses sight of the objectively constituted world of things.

"Perspective as Symbolic Form"

In "Perspective as Symbolic Form" the Italian Renaissance again serves as a kind of norm. Panofsky compares systematic perspective's transformation of the experience of space into a mathematical system with Kantian epistemology: both achieve an "objectification of the subjective" (Panofsky 1964, p. 123). The history of conceptions of space as they appear in works of art and in documents shows how the raw material of experience is systematically elaborated by thought and how space as we now understand it is a mental construction. This ambitious essay has great intrinsic interest, but it has particular pertinence in this context because the history of treatments of space is very close to Riegl's project in *Late Roman Art Industry*. The direction in which Panofsky developed Riegl's methodology is therefore clearly marked.

Cassirer's influence is very apparent in this essay and a tension present in the *Philosophy of Symbolic Forms* is repeated here. Cassirer would seem to have held two views on the relative status of symbolic forms. On the one hand, forms are relativized with respect to one other. For example, in the volume on language he declared that "in defining the distinctive character of any spiritual form, it is essential to measure it by its own standards" (Cassirer 1972, 1:177). On the other hand, he believed in a progressive teleology involving the spiritualization of forms. For example, we are told that the language of primitive peoples "is still entirely rooted in immediate sensory impressions" (1:202), while more advanced languages "display great freedom and abstract clarity in the expression of logical relations" (1:208). In her recent book *Cassirer, Panofsky and Warburg*, Silvia Ferretti also underlines this point.

> He does not contest the intrinsic validity of the mythical or religious
> world view; on the contrary, he attests to its total coherence in the
> conditions in which it came to the fore. On the other hand, he feels that
> those stages of man's relationship with the world are still too undevel-
> oped and not yet able to realize the logical self-consciousness that the
> modern age already possesses to the utmost. (Ferretti 1989, p. 105)

Clearly these two positions, a relativized typology and a teleology, are incom-
patible, yet we saw them both to some extent in Panofsky's proportion paper and
they are even more pronounced in "Perspective as Symbolic Form." By correlating
different artistic treatments of space with contemporaneous theoretical formula-
tions of it, Panofsky left open the possibility of maintaining a plurality of histor-
ically appropriate standards of evaluation. At the same time, however, he
understood each stylistic type as a stage of development leading up to the fully
rational space of Renaissance art.

The first section of the essay might at first be construed as an attack on central
perspective construction. Panofsky was at pains to show that it does not at all
accord with the way space is experienced: "for the structure of an infinite, un-
changing, and homogeneous space, in short, purely mathematical space, is directly
opposed to that of psycho-physiological space" (Panofsky 1964, p. 101). The
argument is supported by reference to Cassirer's second volume of *Philosophy of
Symbolic Forms,* on myth, in which he noted that perception is unacquainted with
infinity and that psychologically relevant spatial relations—in front/behind, above/
below, right/left—are not, like mathematical spatial relations, equivalent (Cassirer
1972, 2:83ff.). Panofsky concludes, with Cassirer, that infinite, homogeneous
space is not given in experience; it must be constructed, and perspective construc-
tion "abstracts fundamentally" from psychophysiological space (Panofsky 1964,
p. 101). All this, and more, is brought in evidence against a naive realist's view
of perspective construction, which might suppose that it represents the world

exactly as we experience it. It is a crucial stage in the argument, for, within Panofsky's teleological scheme, central perspective construction represents the final stage of the progressive spiritualization of a symbolic form and therefore must not be understood as corresponding to immediate sense experience. Perspective is the culmination of a long history in which perceived space is systematically modified, mathematically corrected, and thoroughly unified.

Given the trajectory of the teleology, all other artistic treatments of space must be seen as lacking such a high degree of systematic unity and abstraction. Panofsky described a dialectical progression that owes something to *Late Roman Art Industry* but also diverges interestingly from it. The art of classical antiquity he described as "an art of bodies only" that did not construct a painterly spatial unity (*malerisch Raumeinheit*). Instead, individual elements were bound together tectonically and plastically in a group (Panofsky 1964, p. 108). In Hellenistic art "the artistic representation still clings to separate objects to the extent that space is not experienced as something that transcends and reconciles the opposition between bodies and non-bodies, but rather as that which is left over between bodies" (pp. 108–109). There is a suggestion here that Panofsky thought of the confrontation of bodies and voids in a work of art as a contradiction that is later transcended in unified, perspectival space. Late Roman art is "still not a perfectly unified world" (p. 109). The space it represents "remains a spatial aggregate—it does not become what the modern world demands and realizes: a spatial system" (p. 109).

Panofsky's treatment of late Roman art directly contradicts Riegl's efforts in *Late Roman Art Industry* to formulate an alternative standard of judgment with which to evaluate it. In the chapter on painting, Riegl argues that linear perspective implies a *Kunstwollen* that is entirely foreign to this period: "The artists of antiquity could not have wanted perspectival spatial unity because it would not have offered them artistic unity. They still as always sought this in the rhythm of lines in the plane, to which was gradually added in imperial Rome the rhythm of light and shade" (Riegl 1927, p. 112).[5] While Riegl attempted to accustom our eyes to

different conceptions of coherence and different ideals of beauty, Panofsky was more concerned to make the art of the past disclose a Hegelian movement of the self-transcendence of the spirit.

In Panofsky's defense, it must be said that his account does include a view of the adequacy of artistic representations of space with respect to contemporaneous conceptions of space. Philosophical reflections on space from antiquity, such as Aristotle's, theorized space in relation to the body and lived experience: "The Aristotelian doctrine expresses with special clarity the fact that antique thought did not yet dare bring the concretely experienced properties of space, and especially the difference between bodies and non-bodies, to the common denominator of *substance étendue*" (Panofsky 1964, p. 110).[6] Antique art, then, is consistent with contemporaneous theoretical reflections, yet those theories themselves are laden with troublesome oppositions or contradictions that are later transcended in the purely mathematical conception of space elaborated by, for example, Descartes.

The dialectical history of this transcendence can be seen to move from the thesis of antiquity's "art of bodies only" to the antithesis of early Christian art, which represents space as an immaterial gold shimmer without measure or dimension. Before this fluid space can be perspectivized it must be turned into a more palpable substance: "Accordingly, the next step on the way to modern 'systematic space' had to lead first of all to making the world, now unified but ebbing and flowing like light, again into something substantial and measurable" (p. 112).[7] This step was taken by Romanesque art, which reduced both body and space to surface, thereby establishing the homogeneity of the two (p. 113). Gothic art liberated the body from the plane and with it a surrounding body of continuous space. The art of the Renaissance rationalizes this space, and "from now on there could be a spatial construction, univocal, free from contradiction, and—in the direction of sight—of infinite extent, within which bodies and their interstices were bound together in accordance with the rule of 'body in the generic sense'" (p. 122).[8] The period from the Renaissance to the present is the final stage of development in

Panofsky's history. Systematic perspective opens up the possibility for post-Renaissance styles to take advantage of its two-sided significance. Because perspective both recognizes the distance between mind and things and overcomes that distance "by drawing into the eye, as it were, the independently existing world of things" (p. 123), artists can move with great flexibility between one possibility and the other.

> So the history of perspective may be understood with equal right as a triumph of the distancing and objectivizing feeling for reality and as a triumph for the distance-denying human struggle for power; equally well as a fixing and systematizing of the external world and as an extension of the ego's sphere. (p. 123)[9]

Art is now free to choose either attention to the objective world or subjective expression. Yet the fundamental underlying conception of modern art is a new reflexive awareness of the relation between the ordering mind and the material of experience.

I have indicated in the course of my exposition some of the criticisms I would bring to bear against Panofsky's "improvement" of Riegl's methodology. One of them would target precisely what Panofsky no doubt regarded as his great contribution, that is, his positing of an absolute viewpoint. While it may strengthen the systematic coherence of art historical discourse, it does so at the expense of Riegl's efforts to study past styles in a way that granted them a certain autonomy and legitimacy even within the context of his sweeping historical architectonic. Just as central perspective construction negates differences in a homogeneous space, so Panofsky's early theoretical papers systematically abolish difference in a one-point historical construction whose vantage point is the Renaissance. Earlier and later period styles are strictly subordinated to it. As a result, one has a strong sense in reading these essays of the particular works of art serving the end of the

theory. His close association with philosophy probably accounts for this and for his refusal to regard his own discourse as historically determined. Although he was very conscious of the historical situatedness of art, in his own practice as an art historian he seemed to feel immune from such constraints and capable of interpretations and evaluations that would be universally and permanently valid.[10] He did not, as did Riegl, abandon the idea of an absolute standard of art (Riegl 1929, p. 187; trans. 1982, p. 47).

In the preceding chapter on the role of the spectator, I made it clear that Riegl also believed in an optimum relationship between objectivity and subjectivity in our understanding of the world. The difference is that he saw this balance in terms of what might be called an ethics of vision or representation. His assessments of art coalesce around a moral concern to preserve the separateness or otherness of others in our personal relationships. This dimension is lacking in Panofsky's early essays, where objectivity and subjectivity are more narrowly confined to their epistemological significance. Riegl's history of psychological attitudes provides categories for thinking about power relations acted out within a depiction and, more importantly, between the spectator and the depiction. Do certain forms of representation subordinate the viewer? Do other kinds invite a look that objectifies? Is a mode of representation possible that allows us to engage the other in an intersubjective exchange? These are the pressing questions Riegl asked, particularly in his last book, and which still need to be answered.

Riegl also asked questions about the position and attitudes of the art historian that are related to his questions concerning spectatorship. He was conscious that certain forms of art historical discourse subordinate the art of the past to our interests and values. And he acknowledged that the art historian necessarily participates in the contemporary *Kunstwollen,* and so, to some extent, he thought the imposition of our values was inevitable. These considerations are most clearly expressed in the 1901 paper "Naturwerk und Kunstwerk. I"

Why did the work of art please at the time of its origination and why does it not today? What, in those days, did people want from art and what do they want from it now? These are questions that monuments are capable of answering and, therefore, they must in future be answered. I see this as the most pressing task of art historical enquiry in the near future. (Riegl 1929, p. 63)[11]

This is the level of reflexivity sacrificed by Panofsky in the interest of establishing a single-point perspective for art history.[12]

Notes and German Texts

I

Introduction: The Concept of the *Kunstwollen*

I

An authoritative English translation of Riegl's book on Dutch group portraiture, *Das holländische Gruppenporträt,* has recently been commissioned by The Getty Center Publications Programs, to be edited and introduced by Wolfgang Kemp. An unfortunate accident of timing meant that Margaret Olin's monograph on Riegl (1992) appeared just as mine was going to press. I am therefore unable to comment on her book except to note that her emphasis differs widely from mine owing, I think, to the weight she gives to Riegl's early work.

2

Early and powerful voices in this debate included Martin Heidegger (see especially "The Question Concerning Technology," 1954, in Heidegger 1977) and Theodor Adorno and Max Horkheimer, *Dialectic of Enlightenment* (1944) 1979. Michel Foucault's work is dedicated to exploring the ways in which techniques of knowledge are imbricated with techniques of power; see especially *Power/Knowledge,* 1980. Many feminist voices have also been influential; a useful volume of essays on the subject is Sandra Harding and Merrill B. Hintikka (eds.), *Discovering Reality: Feminist Perspectives on Epistemology, Metaphysics, Methodology and Philosophy of Science,* 1983. See also Jean-François Lyotard, *The Postmodern Condition: A Report on Knowledge,* 1984.

3

"Wir müssen nicht mehr die einzelnen Kunstwerke für sich ins Auge fassen, sondern die Elemente, mit deren klarer Scheidung und Erkenntnis sich eine wahre einheitliche Krönung des Lehrgebäudes der Kunstgeschichte aufbauen lassen wird" (Riegl 1966, p. 210).

4

"Es kommt aber alles darauf an, zur Einsicht zu gelangen, daß weder mit demjenigen, was wir Schönheit, noch mit demjenigen, was wir Lebendigkeit nennen, das Ziel der bildenden Kunst völlig erschöpft ist, sondern daß das Kunstwollen auch noch auf die Wahrnehmung anderer (nach modernen Begriffen weder schöner noch lebendiger) Erscheinungsformen der Dinge gerichtet sein kann" (Riegl 1927, p. 11; trans. 1985, p. 11).

5

"It is the consciousness that his discourse is historically determined which makes Riegl one of the founders of art history as a discipline; it is also this consciousness which makes this discourse such a useful tool today, when we want to confront the apocalyptic defeatism of 'post-modernism'. It is this consciousness that made Walter Benjamin hail Riegl as one of his peers" (Bois 1991, p. 121). Kurt W. Forster makes a similar point in his introduction to the English translation of Riegl's "The Modern Cult of Monuments": "When Riegl argued for the historical contingency of all aesthetic values, he did not by the same token advocate eclecticism. On the contrary, he recognized that contemporary concerns, the *Kunstwollen* of our epoch, profoundly determine our perception of the past: there is no objective past, constant over time, but only a continual refraction of the absent in the memory of the present" (Forster 1982, p. 15).

6

"Es offenbart sich darin die nicht mehr zu übersehende Tatsache, daß selbst die Wissenschaft trotz aller anscheinenden Selbständigkeit und Objektivität ihrer Richtung im letzten Grunde doch von der jeweilig führenden geistigen Eigenart des Kunstbegehrens seiner Zeitgenossen nicht wesentlich hinauskann" (Riegl 1927, p. 3, trans. 1985, p. 6).

7

I am referring particularly to Kant, Hegel, Schopenhauer, and Nietzsche as well as to neo-Kantian psychologists such as Wilhelm Wundt and J. F. Herbart. For helpful overviews of the notion of style see Schapiro 1953, Gombrich 1960, Alpers 1979, and Sauerländer 1983.

8

In an article of 1902, Riegl explained why he changed his terminology from "tactile" to "haptic." The concern seems to have been that one would take the connotation of a "tactile" mode of vision too literally as "touching." "It has been objected that this designation could lead to misunderstandings, since one could be inclined to comprehend it as a borrowed word from the Greek, quite like the word 'optical' which is used as its opposite; and my intention has been drawn to the fact that physiology has long since introduced the more fitting designation 'haptic' (from *haptein—to fasten*). This observation seems to me justified and I intend henceforth to use this proposed term." (Riegl 1988, p. 190, footnote 1.)

9

"Das moderne Problem ist vielmehr ein Raumproblem wie jedes frühere: eine Auseinandersetzung zwischen dem Subjekt einerseits und dem Dinge (d.i. Ausdehnung, Raum) anderseits und keineswegs ein völliges Aufgehen des Objekts im Subjekt, das überhaupt das Ende der bildenden Kunst bedeuten würde" (Riegl 1931, p. 189).

10

See especially Said 1978.

11

"Der Mensch ist aber nicht allein ein mit Sinnen aufnehmendes (passives), sondern auch ein begehrendes (aktives) Wesen, das daher die Welt so ausdeuten will, wie sie sich seinem (nach Volk, Ort und Zeit wechselnden) Begehren am offensten und willfährigsten erweist" (Riegl 1927, p. 401; trans. 1985, p. 231).

12

In "Albrecht Dürer and Classical Antiquity" (1921/2), Panofsky is even more vitriolic. In a section concerning the advance of Renaissance "focused perspective" and the observation of reality he appended a note (17) that includes the following (with his subsequent comment): "It is no accident that the present age, which in art opposes nothing so passionately as focused perspective (even where it is handled as unmathematically as in Impressionism), questions the value of 'exact' science and 'rationalistic' scholarship—two forms of intellectual knowledge analogous to a perspective form of artistic perception. [This note was written in the heyday of German Expressionism and anti-intellectualism, whether Marxist or proto-Nazi.]" (Panofsky 1970, p. 322).

13

For more information on Sedlmayer see Schneider 1990.

14

"Riegl's masterly command of the transition from the individual object to its cultural and intellectual (*geistig*) function can be seen especially in his study *The Dutch Group Portrait*. One could just as well refer to Riegl's *Late Roman Art Industry,* particularly since this book demonstrates in exemplary fashion the fact that sober and simultaneously undaunted research never misses the vital concerns of the time. The reader who reads Riegl's major

work today . . . will recognize retrospectively how forces are already stirring subterraneously in *Late Roman Art Industry* that will surface a decade later in expressionism" (Benjamin 1988, pp. 87–88). For further discussion of this issue, see Kemp 1973.

15

This point is stressed by W. Kemp in his essay on Riegl (Kemp 1990, p. 38). See also Levin 1988.

16

For biographical sketches of Riegl see Dvořák 1929, Schlosser 1934, Tietze 1935, Kemp 1990.

II

Modernity in the Making

1

Among the secondary literature on Vienna and the Secession, I have found most helpful Vergo 1975, Janik and Toulmin 1973, Schorske 1980, and Varnadoe 1986.

2

"Wenn Semper sagte: Beim Werden einer Kunstform kämen auch Stoff und Technik in Betracht, so meinten die Semperianer sofort schlechtweg: die Kunstform wäre ein Produkt aus Stoff und Technik" (Riegl 1893, p. vii).

3

"Die 'Technik' wurde rasch zum beliebtesten Schlagwort; im Sprachgebrauch erschien es bald gleichwertig mit 'Kunst' und schließlich hörte man es sogar öfter als das Wort Kunst. Von 'Kunst' sprach der Naive, der Laie; fachmännischer klang es, von 'Technik' zu sprechen" (Riegl 1893, p. vii).

4

For a useful discussion of the history of the debates surrounding style, technology, and architecture see Mallgrave's introduction to Wagner's *Modern Architecture* (Wagner 1988, pp. 14ff.).

5

In the introduction to his translation of Wagner's *Modern Architecture,* Mallgrave notes that the pamphlet on polychromy is an early work of Semper and does not represent his mature view: "Semper in this instance reveals more of what Alois Riegl referred to in 1893 as the 'Semperians' of the day, rather than the genuine influence of Semper" (Wagner 1988, pp. 49–50, footnote 70).

6

For further information on Semper and elucidation of his theories see Quitzsch 1962, Ettlinger 1964, Podro 1972, Pevsner 1972, Rykwert 1976, Gombrich 1979, Herrmann 1984, Middleton and Watkin 1980, and Mallgrave's introduction to Semper 1989. For a good review of Semper 1989 and Wagner 1988, see Whyte 1990.

7

On Wagner see Lux 1914, Geretsegger and Peintner 1970, Schorske 1980, Vergo 1975, Mallgrave introduction to Wagner 1988.

III

The Aesthetics of Disintegration

1

"Das für diese Wandlung charakteristische, unablässig gesteigerte Bestreben, alles physische und psychische Erleben nicht in seiner objektiven Wesenheit, wie im allgemeinen die früheren Kulturperioden taten, sondern in seiner subjektiven Erscheinung, das heißt in den Wirkungen, die es auf das (sinnlich wahrnehmende oder sich geistig bewußt werdende) Subjekt ausübt, zu erfassen . . ." (Riegl 1929, p. 156).

2

"Das Denkmal bleibt nur mehr ein unvermeidliches sinnfälliges Substrat, um in seinem Beschauer jene Stimmungswirkung hervorzubringen, die in modernen Menschen die Vorstellung des gesetzlichen Kreislaufes vom Werden und Vergehen, des Auftauchens des

Einzelnen aus dem Allgemeinen und seines naturnotwendigen allmählichen Wiederaufge-
hens im Allgemeinen erzeugt" (Riegl 1929, p. 150).

3

"Das auf dem Alterswert beruhende ästhetische Grundgesetz unserer Zeit läßt sich sonach
folgendermaßen formulieren: von der Menschenhand verlangen wir die Herstellung ge-
schlossener Werke als Sinnbilder des notwendigen und gesetzlichen Werdens, von der in
der Zeit wirkenden Natur hingegen die Auflösung des Geschlossenen als Sinnbild des
ebenso notwendigen und gesetzlichen Vergehens" (Riegl 1929, p. 162). For further discus-
sion of this interesting essay see K. Forster 1982 and other articles in the same volume of
Oppositions, which also contains an English translation of Riegl's essay.

4

I am thinking particularly of those defenses of the modern within the German idealist
tradition, especially by Schiller and Hegel, both discussed in this chapter.

5

". . . sie hat nicht das Individuum, das ja gar nicht existiert oder genauer gesagt, als
Molekül zu klein ist, um Darstellung finden zu können, sondern den Universalzusammen-
hang aller Naturerscheinungen zu schildern. Die Kunst stellt ihn nicht als ein körperliches
Individuum, sondern als einen Komplex von optischen Erscheinungen dar, die zu gleicher
Zeit das Auge des Beschauers treffen" (Riegl 1966, p. 261).

6

For further discussion of the Klimt affair see Bahr 1903, Vergo 1975, Schorske 1980. For
a discussion of the tactile/optical distinction in relation to Klimt and Kandinsky, see Olin
1989b.

7

"Es war die kunstgewerbliche Reform mit ihrem Ruf einerseits nach Abkehr von der
Verbildung wie sie sich in den europäischen Kunstzuständen herausgestaltet hatte, ander-
seits nach Rückkehr zur Einfachheit, wodurch man auf das orientalische Dekorationssystem
geführt werden mußte. Wie wußten Semper, Redgrave, Owen [sic] die Vorzüge der
orientalischen Teppiche zu preisen: die anspruchlosen Blumenranken in den Bordüren,

die neutrale Musterung des Mittelgrunds in stilisierten Blüten und zierlich bewegtem Linienspiel" (Riegl 1891, pp. iv–v).

8

"Daraus ergab sich den Altchristen das zwingende Postulat: hinweg mit der körperlichen Verbesserung, d.i. mit der äusseren Verschönerung, Idealisierung der Natur! Das an sich Unvollkommene wird künstlich noch unvollkommener gemacht als es sich in der Natur offenbart, und so zum kostbaren Gefäß der Kunst erhoben!" (Riegl 1966, p. 37).

9

"Die Aufgabe lag also folgendermaßen: ein Motiv zu verwenden und dabei seinen Habitus als Motiv zu unterdrücken. Dies geschah hauptsächlich dadurch, daß mit allen Mitteln dem Grunde, von dem sich die Motive abheben sollten, eine selbständige Bedeutung gegeben wurde" (Riegl 1966, p. 102).

10

". . . denn innerhalb der koloristischen Harmonie gibt es keinen Stärkeren, dem das Schwächere nur zur Folie zu dienen hätte: das Auge sieht bloß eine vielfältige Gesamtheit, aus der sich kein Einzelnes beherrschend hervordrängt" (Riegl 1966, p. 102).

11

"Alles Leben ist eine unablässige Auseinandersetzung des einzelnen Ich mit der umgebenden Welt, des Subjekts mit dem Objekt. Der Kulturmensch findet eine rein passive Rolle gegenüber der Welt der Objekte, durch die er in jeder Weise bedingt ist, unerträglich und trachtet sein Verhältnis zu ihr selbständig und eigenwillig dadurch zu regeln, daß er hinter ihr eine andere Welt sucht, die er dann mittelst der Kunst (im weitesten Sinne des Wortes) als seine freie Schöpfung neben die ohne seine Zutun bewirkte natürliche Welt setzt" (Riegl 1931, p. 280).

12

"Nur das Vollkommene hat ein Anrecht auf künstlerische Existenz. In der Kunst gilt wie im Leben des antiken Menschen bloß das Recht des Stärkeren" (Riegl 1966, p. 25).

IV

The Articulation of Ornament

1

For introductions to the literature on these nineteenth-century debates in the fields of applied arts and design see Pevsner 1960 and Gombrich 1979.

2

Riegl wrote a review of Goodyear's book in *Mitteilungen der Anthropologischen Gesellschaft in Wien,* 22 (1892), p. 121.

3

"Man braucht dabei gar nicht an jene Radikalen zu denken, die überhaupt alles ornamentale Kunstschaffen für originell erklären, eine jede Erscheinung auf dem Gebiete der dekorativen Künste als unmittelbares Produkt aus dem jeweilig gegebenen Stoff und Zweck ansehen möchten" (Riegl 1893, p. v).

4

I have found references to followers of Semper in Bandmann 1971. The author cites several books indebted to Semper's theory and complains that these leave out of account Semper's sense of the symbolic import of the quality of materials. Among those mentioned is Jakob von Falke, *Aesthetik des Kunstgewerbes* (Stuttgart, 1883). Interestingly, von Falke was director of the Österreichische Museum für Kunst und Industrie during Riegl's tenure there and died in the year of Riegl's resignation. This prompts speculation about the reason for Riegl's resignation. Schlosser's oblique comment on the issue only aggravates the question: "With a heavy heart [he] had to give up his old position at the Austrian Museum. The situation there became intolerable for him" (". . . seine alte Arbeitsstätte im Österreichischen Museum schwersten Herzens aufgeben müssen; die Verhältnisse dort waren für ihn unleidlich geworden"; Schlosser 1934, p. 184).

5

"Wo der Mensch augenscheinlich einem immanenten künstlerischen Schaffungstreibe gefolgt ist, dort läßt Goodyear den Symbolismus walten, ebenso wie die Kunstmaterialisten

in dem gleichen Falle die Technik, den zufälligen todten Zweck in's Feld führen" (Riegl 1893, p. xii).

6

"Dann haben wir eine ganze Stufenleiter von Entwicklungsphasen, in denen sich der plastische Charakter allmälig verflüchtigt: zunächst ein flach gehaltenes Rundwerk, dann ein mehr oder minder hohes Relief, ein Flachrelief, und endlich die bloße Gravierung, die häufig mit dem Flachrelief zusammen entgegentritt, indem eines in das andere übergeht" (Riegl 1893, p. 20).

7

"Von diesem Augenblicke an gewann die Kunst erst recht ihre unendliche Darstellungsfähigkeit; indem man die Körperlichkeit preisgab und sich mit dem Schein begnügte, tat man den wesentlichsten Schritt, die Phantasie von dem Zwange der strengen Beobachtung der realen Naturformen zu befreien und sie zu einer freieren Behandlung und Kombinierung dieser Naturformen hinzuleiten" (Riegl 1893, p. 2).

8

"Auch die Sprache hat ihre Elemente, und die Entwicklungsgeschichte dieser Elemente nennen wir die historische Grammatik der betreffenden Sprache. Wer eine Sprache bloß sprechen will, bedarf der Grammatik nicht; und ebensowenig derjenige, der sie bloß verstehen will. . . . Wer aber wissen will, warum eine Sprache diese und keine andere Entwicklung genommen hat, wer die Stellung einer Sprache innerhalb der Gesamtkultur der Menschheit begreifen will, wer mit einem Worte die betreffende Sprache wissenschaftlich erfassen will, der bedarf der historischen Grammatik" (Riegl 1966, pp. 210–211).

9

"Nach beiden Richtungen wird sich ein zusammenhängender historischer Faden von der ältesten ägyptischen bis auf die hellenistische Zeit verfolgen lassen, d.h. bis zu dem Punkte, da die Griechen die Entwicklung zur Reife gebracht haben: indem sie einerseits den einzelnen Theilmotiven den Charakter vollkommener formaler Schönheit zu verleihen gewußt, anderseits—und das ist ihr besonderes Verdienst—die gefälligste Art der Verbindung geschaffen haben, nämlich die *line of beauty,* die rhythmisch bewegte *Ranke*" (Riegl 1893, p. 47).

10

"Es kommt alles darauf an, wie die verschiedenen Reproduktionsgesetze, welche aus den einzelnen Zügen der Zeichnung entstehen, zusammen passen. Je nachdem sie einander im Ablaufen der Reihen begünstigen oder widerstehen, ist der Gegenstand schön oder häßlich" (Herbart 1850, 2:133).

11

"Es spielt sich hier in fast typischer Reinheit ein Vorgang ab, der in aller architektonischer Entwicklung sich wiederholt: an Stelle der Koordination die Subordination, an Stelle eines lockeren Zusammenhanges ein Ganzes, wo jeder Teil integrierender Teil ist" (Wölfflin 1946, p. 53).

12

"Die geometrischen Kunstformen verhalten sich eben zu den übrigen Kunstformen genau so, wie die Gesetze der Mathematik zu den lebendigen Naturgesetzen. Ebensowenig wie im sittlichen Verhalten der Menschen, scheint es im Gange der Naturkräfte eine absolute Vollkommenheit zu geben: das Abweichen von den abstrakten Gesetzen schafft da und dort die Geschichte, fesselt da und dort die Langeweile des ewigen Einerlei" (Riegl 1893, p. 3).

V

Late Roman Art and the Emancipation of Space

1

"Im Gegensatze zu dieser mechanistischen Auffassung vom Wesen des Kunstwerkes habe ich—soviel ich sehe, als erster—in den *Stilfragen* eine teleologische vertreten, indem ich im Kunstwerke das Resultat eines bestimmten und zweckbewußten Kunstwollens erblickte, das sich im Kampfe mit Gebrauchszweck, Rohstoff, und Technik durchsetzt" (Riegl 1927, p. 9; trans. 1985, p. 9). I do not necessarily follow the English translation by Rolf Winkes published in Riegl 1985, but for longer passages I additionally cite page numbers to the corresponding passages in that edition.

2

"Es verrät sich darin die, wie es scheint, unausrottbare Verwechslung der Geschichte der bildenden Kunst mit der Ikonographie, während doch die bildende Kunst es nicht mit dem 'Was', sondern mit dem 'Wie' der Erscheinung zu tun hat und sich das 'Was' namentlich durch Dichtung und Religion fertig liefern läßt. Die Ikonographie enthüllt uns daher nicht so sehr die Geschichte des bildkünstlerischen Wollens als diejenige des poetischen und religiösen Wollens" (Riegl 1927, p. 394; trans. 1985, p. 227).

3

See for example H. L. F. von Helmholtz, *Handbuch der physiologischen Optik* (Leipzig, 1867), trans. Helmholtz's *Treatise on Physiological Optics,* ed. James P. C. Southall, 3 vols. (Madison, Wisconsin, 1924, 1925); and "Optisches über Malerei" in *Populäre wissenschaftliche Vorträge,* 3rd series (Brunswick, 1876), trans. "On the Relation of Optics to Painting" in *Popular Lectures on Scientific Subjects* (London, 1881), pp. 73–138.

4

There is a considerable literature on this topic. See, for example, J. M. Nash (1980) where he argues that Kahnweiler's neo-Kantian idealist explanation of cubism lacks authority and explanatory power. Ernst Gombrich was struck by the similarities between Hildebrand's ideas and those in Kahnweiler's "Der Weg zum Kubismus" and took the trouble to write to the latter in 1959 and ask if there was a connection. Kahnweiler replied that he did not know the book when he wrote his account of cubism (1915, published 1920) and that this kind of theorizing was not important in the genesis of cubism (Gombrich 1987). Yve-Alain Bois underlines this by arguing that Hildebrand's aesthetics was attacked by Kahnweiler in his "Das Wesen der Bildhauerei" (1919) as the symptom of a deep fear in the blurring of the boundaries between sculpture and objects (Bois 1987, p. 41).

5

"An Stelle der Gesamterscheinung treten verschiedene Einzelerscheinungen, welche durch Augenbewegung verbunden werden" (Hildebrand 1961, p. 10).

6

"Ein einheitliches Bild für den dreidimensionalen Komplex besitzen wir also allein im Fernbild, dieses stellt die einzige Einheitsauffassung der Form dar, im Sinne des Wahrnehmungs- und Vorstellungsaktes" (Hildebrand 1961, p. 12).

7

"Das Fernbild von etwas Dreidimensionalem gibt uns einen reinen Gesichtseindruck, welcher aber durch bestimmte Merkmale der Erscheinung zu Bewegungsvorstellungen anregt, diese also sozusagen latent in sich enthält" (Hildebrand 1961, p. 11).

8

"Wächst die Entfernung zwischen Auge und Ding über die Normalsicht hinaus, so tritt wieder der umgekehrte Prozeß ein: die Modellierung verschwindet immer mehr hinter der zunehmenden Dicke der zwischenliegenden Luftmauer, bis endlich nur mehr eine einheitliche Licht- oder Farbenfläche die Netzhaut des Auges trifft, was wir mit Fernsicht bezeichen wollen" (Riegl 1966, p. 130).

9

"Die Kulturvölker des Altertums erblickten in den Außendingen nach Analogie der ihnen (vermeintlich) bekannten eigenen menschlichen Natur (Anthropismus) stoffliche Individuen, zwar von verschiedener Grösse, aber jedes aus fest zusammenhängenden Teilen zu einer untrennbaren Einheit abgeschlossen. Ihre sinnliche Wahrnehmung zeigte ihnen die Außendinge verworren und unklar untereinander vermengt; mittels der bildenden Kunst griffen sie einzelne Individuen heraus und stellten sie in ihrer klaren abgeschlossenen Einheit hin" (Riegl 1927, p. 26; trans. 1985, p. 21).

10

"Es ergibt sich hieraus, daß schon die Überzeugung von der tastbaren Undurchdring-lichkeit als wesentlichste Voraussetzung der stofflichen Individualität nicht mehr allein auf Grund sinnlicher Wahrnehmung, sondern unter ergänzender Zuhilfenahme des Denkpro-zesses zustande kommt" (Riegl 1927, p. 28; trans. 1985, p. 22).

11

"Damit war die Notwendigkeit einer bestimmten Anerkennung auch der Tiefendimension von Anbeginn gegeben, und auf diesem latenten Gegensatze beruht nicht allein die Relief-auffassung der antiken Kunst, sondern auch zur einen Hälfte die Entwicklung, die sich innerhalb der bildenden Kunst des Altertums vollzogen hat. Zur anderen Hälfte ist diese Entwicklung . . . durch das allmähliche Eindringen der subjektiven Anschauung in die rein sinnliche Wahrnehmung von der stofflichen Individualität der Dinge bewirkt worden" (Riegl 1927, p. 31; trans. 1985, p. 24).

12

On Riegl's use of the term "haptic" see note 8 of my chapter 1.

13

"Die Auffassung von den Dingen, die dieses zweite Stadium der antiken Kunst kennzeichnet, ist somit eine taktisch-optische und in optischer Hinsicht genauer eine normalsichtige; sie ist verhältnismäßig am reinsten in der klassischen Kunst der Griechen zum Ausdrucke gelangt" (Riegl 1927, p. 33; trans. 1985, p. 25).

14

"Diese Ebene ist keineswegs mehr die taktische, denn sie enthält Unterbrechungen mittels tiefer Schatten; sie ist vielmehr die optisch-farbige, in welcher sie auch mit ihrer Umgebung verschwimmen" (Riegl 1927, p. 35; trans. 1985, p. 26).

15

"Die Auffassung von den Dingen, die diese dritte Phase der antiken Kunst kennzeichnet, ist somit eine wesentlich optische, und zwar eine fernsichtige, und tritt uns verhältnismäßig am reinsten in der Kunst der späteren römischen Kaiserzeit entgegen" (Riegl 1927, p. 35; trans. 1985, p. 26).

16

"In den Säulenportiken, die gleich den Faltenhöhlen der klassischen Draperie den Schatten sammeln, gelangt eine weitere Anerkennung der Tiefe und des Raumes an den Dingen zum beschränkten Ausdruck, wobei aber das Auge sofort an der geschlossenen Zellawand seinen Halt findet, wie an der ebenen Grundfläche eines Reliefs" (Riegl 1927, p. 39; trans. 1985, p. 29).

17

"Das tiefere Kunstziel aber, das man mit der Anbringung von begleitenden Seitenräumen verfolgt hat, lag in der wirksameren Abschließung des individualisierten zentralen Innenraumes nach der Tiefe und in seiner augenfälligeren Isolierung gegenüber der Grundebene" (Riegl, 1927, p. 45; trans. 1985, p. 32).

18

"Erinnert man sich, daß die Schaffung klar begrenzter, zentralisierter Einheiten das grundsätzliche Ziel der antiken Baukunst (und bildenden Kunst überhaupt) ausgemacht hatte, so

ergibt sich, daß mit dem Auftreten der Massenkomposition das architektonische Kunst-wollen in einem nicht minder grundwichtigen Punkte durchbrochen und außer Kraft gesetzt erscheint wie mit der Emanzipation des Raumes" (Riegl, 1927, p. 48; trans. 1985, p. 32).

19

"Die Voraussetzung für die Zulassung des Fensters in die Monumentalkunst war somit eine fernsichtige Aufnahme, welche die schattenden Höhlungen in ihrem rhythmischen Wechsel (Symmetrie der Reihung) mit den hellen Wandpartien dazwischen in einer Ebene als zusammenhängende optische Einheit erscheinen ließ" (Riegl, 1927, p. 49; trans. 1985, pp. 33–34).

20

"Die von der antiken Kunst begehrte klare und geschlossene Einheit des stofflichen Indi-viduums fand, soweit die Architektur in Betracht kommt, offenbar ihre höchste Befriedi-gung im Zentralbau; aber das eigentlich treibende Element ist doch der Langbau gewesen und dies aus leicht ersichtlichen Gründen. Der Langbau ist für die Bewegung von Menschen in seinem Innern geschaffen; Bewegung bedingt aber Verlassen der Ebene, Berücksichti-gung des Tiefraumes, Hinaustreten der Individualität aus sich selbst im Verkehr mit dem Raume" (Riegl, 1927, p. 51; trans. 1985, pp. 34–35).

21

"Eine nähere Betrachtung lehrt aber, daß ein solcher unnatürlicher Riss in der gleichmäs-sigen Entwicklung nicht existiert und dass die römischen Altchristen mit dem Mittelschiffe der Basilika gar keinen geschlossenen Innenraum und somit auch keinen perspektivischen Raumausschnitt schaffen wollten, den vielmehr bloß der moderne Beschauer hineindeutet" (Riegl, 1927, p. 58; trans. 1985, p. 37).

22

"Die geflissentliche Aufhebung aller taktischen Verbindungen zwischen den Teilen eines Baukörpers an der altchristlichen Basilika hat zur Folge gehabt, daß jener Eindruck der Notwendigkeit und des innigen organischen Zusammenhanges aller Teile, den die klas-sische und auch neuere Kunst von der Komposition verlangt, in der altchristlichen Basilika

(und auch im Zentralbau, an diesem aber in minderem Grade) so gut wie verlorengegangen ist" (Riegl, 1927, p. 59; trans. 1985, p. 38).

23

"Die antiken Künstler konnten die perspektivische Raumeinheit nicht wollen, denn sie hätte ihnen keine künstlerische Einheit geboten. Diese suchten sie nach wie vor im Rhythmus der Linien in der Ebene, wozu sich in der römischen Kaiserzeit allmählich der Rhythmus von Licht und Schatten gesellte" (Riegl, 1927, p. 112; trans. 1985, pp. 68–69).

VI

Dutch Group Portraits and the Art of Attention

1

The relative neglect is soon to be remedied by an English translation of the book (see note 1 of my chapter 1). For other critical commentaries see Podro 1982, Olin 1992, Kemp 1990.

2

"Die Kunstgeschichte unterscheidet zwei Erscheinungsformen des dreidimensionalen Raumes: den kubischen, der an den Körpern haftet, und den Freiraum, der zwischen den Figuren ist. Eine Kunst, die, wie die antike, die geformten Einzeldinge als das objektiv Gegebene ansah, konnte nie dazu gelangen, den Freiraum darzustellen. Erst die werdende christliche Kunst in der römischen Kaiserzeit hat den Freiraum emanzipiert, aber auch nur in einer sehr geringen, der Ebene noch sehr nahebleibenden Tiefe zwischen je zwei Figuren, nicht aber als unendlichen Freiraum. Diese physische Brücke von Figur zu Figur wurde bezeichnenderweise zur gleichen Zeit geschlagen wie jene psychische von Mensch zu Mensch, die wir als Aufmerksamkeit in christlichem Sinne bezeichnet haben" (Riegl 1931, pp. 22–23).

3

Margaret Olin argues persuasively that Wilhelm Wundt's psychology was important in Riegl's formulation of the concept of attention (Olin 1989a, p. 290). But, as she herself

points out, Riegl was critical of Wundt. In "Naturwerk und Kunstwerk. I" (1901), he criticized art historical writing of the second half of the nineteenth century, particularly that of Emanuel Löwy, which was modeled on the physiological psychology of Wundt and Fechner: "In the domain of art history, there corresponded to this tendency a theory according to which the figures that present themselves in the work of art were nothing other than material reproductions of memory images of real natural objects" (Riegl 1929, p. 54). Riegl objected to the mechanistic character of this theory. Predictably, perhaps, Gombrich is much more positive in his assessment of Löwy's *The Rendering of Nature in Early Greek Art* (1900), which, he says, "contains most of what is worth preserving in evolutionism" (Gombrich 1960, p. 19), that is, "the priority of conceptual modes and their gradual adjustment to natural appearances" (p. 100).

4

"Handlung ist aber siegreiche Überwindung der als Gegensatz empfundenen Umgebung des Menschen; der Wille trachtet somit das handelndne Individuum gegenüber seiner Umgebung zu isolieren" (Riegl 1931, p. 13).

5

"Das psychisch Isolierende ist der Wille, der immer egoistisch ist: Erhaltung des Individuums in irgendeiner Form. Das Verbindende ist Empfindung, Gefühl, das stets auf Vereinigung mit dem Universum, Aufhebung des Individuums strebt" (Riegl 1908, p. 50).

6

"Die Aufmerksamkeit ist passiv, denn sie läßt die Aussendinge auf sich wirken und sucht sie nicht zu überwinden; sie ist zugleich aktiv, denn sie sucht die Dinge auf, ohne sie gleichwohl der selbstischen Lust dienstbar machen zu wollen" (Riegl 1931, p. 14).

7

"Sucht man darin eine Handlung als Willensakt nach italienischer Weise, so bleibt sie unverständlich; an ihrer Stelle ist vielmehr ein psychischer Wechselverkehr getreten, in dem Gefühl und Aufmerksamkeit eine wichtigere Rolle spielen als der Wille und die sich erst einer intimeren Betrachtung, wie sie eben bloß den Nordländern eigen ist, erschließen" (Riegl 1931, p. 13).

8

The translation is Michael Podro's. For more on Schnaase see Podro (1982), chapter 3.

9

"Das holländische Gruppenporträt ist also weder ein erweitertes Einzelporträt noch eine sozusagen mechanische Zusammenstellung von Einzelporträts in ein Tableau: es ist vielmehr die Darstellung einer freiwilligen Korporation aus selbständigen, unabhängigen Individuen" (Riegl 1931, p. 2).

10

"Die Italiener arbeiteten im ganzen Quattrocento an der Lösung der Aufgabe, die Glieder der einzelnen Figur sämtlich einem Willensimpulse folgend, alle Figuren einer Historie an einer Handlung beteiligt darzustellen. . . . Wille, Handlung und Subordination beherrschen anscheinend wiederum die Auffassung, wie einst in der Antike, und die rückschauenden Italiener hatten im XVI Jahrhundert nicht so unrecht, wenn sie das verflossene Zeitalter als ein Rinascimento der antiken Kunst bezeichneten" (Riegl 1931, pp. 16–17).

11

"Es ist also geradezu der moderne Subjektivismus, der sich hierin ausspricht, dem aber ein Wesentliches fehlt: die Individualität des Subjektes; denn, wie wiederholt betont wurde, sind die Blicke der Schützen nicht auf einen einzigen Punkt (ein Augenpaar) gerichtet, sondern ihre Zielpunkte sind über einen größeren Kreis verteilt, innerhalb dessen zahllose Zuschauer Platz haben" (Riegl 1931, p. 44).

12

"Es handelt sich allerdings noch nicht um ein ausgesprochenes Raumdunkel, wie es das Helldunkel des XVII Jahrhunderts gewesen ist; aber es ist hier bereits in einem mehr oder minder klar bewußten Drange die Richtung eingeschlagen, den freien Luftraum durch eine bestimmte Färbung als ein zusammenhängendes Ding zu behandeln und auf solche Weise zwischen den individuellen geschlossenen Figuren eine auch ihrerseits ununterbrochene Verbindung herzustellen" (Riegl 1931, p. 49).

13

"Die naturgemäße Folge davon war die Beseitigung jeder Kultkunst, die dem Subjekt nur als ein fremdes Objektives entgegentreten kann, und ihre Ersetzung durch eine profane

Kunst, die das subjektive Erleben des einzelnen zur Darstellung zu bringen hatte" (Riegl 1931, p. 104).

14

"Nur hüte man sich vor der Meinung, daß diese Neuerung durch die erwähnte militärische Umgestaltung des Schützenwesens herbeigeführt worden ist: beide sind vielmehr parallele Wirkungserscheinungen einer und derselben oberen Triebkraft, die den Holländern jener Zeit auf allen Gebieten des Lebens, des sozialen wie des künstlerischen, eine straffere Unterordnung der Teile unter ein beherrschendes Element als begehrenswerten Ausdruck der Einheit des Ganzen erscheinen ließ" (Riegl 1931, p. 110).

15

"Zum ersten Male begegnet also eine gemeinsame Handlung zur Versinnlichung der Einheit der dargestellten Gruppe von Schützen, und zwar keine 'historische' Handlung, die sich einmal vollzogen hat, sondern eine öfter wiederholte, deren Bedeutung eben bloß in dieser häufigen, typischen Wiederholung lag: mit einem Worte: eine genremäßige Handlung" (Riegl 1931, p. 85).

16

"Natürlich war es nicht künstlerische Kaprize, was die holländischen Meister dafür eingenommen hat, sondern eine zwingende Notwendigkeit, die der Gang der Kunstentwicklung im Norden gezeitigt hatte" (Riegl 1931, pp. 116–117).

17

"Es ist also eine doppelte Einheit durch Subordination in diesem Bilde: einmal zwischen Tulp und den sieben Chirurgen, die sich sämtlich ihm als dem Vortragenden subordinieren, zweitens zwischen dem krönenden Chirurgen und dem Beschauer, welch letzterer dem ersteren und durch diesen mittelbar wieder dem Dr. Tulp subordiniert wird" (Riegl 1931, p. 183).

18

"Und endlich gewahrt man, daß das Helldunkel des Freiraumes mit demjenigen an den Figuren in keinem Punkte zusammenfällt oder ineinander überfließt; die Figurengruppe hebt sich vielmehr, gleichwie ein Muster vom Grunde" (Riegl 1931, p. 191).

19

For more on de Piles see Puttfarken (1985).

20

"Rembrandt hat hiermit aus dem von ihm einmal adoptierten Prinzipe der Subordination die äußersten Konzequenzen gezogen. Es ist auch nicht zu leugnen, daß die Entwicklung, wenn jenes Prinzip einmal zugelassen war, unwiderstehlich nach einer extremen Richtung hindrängen mußte" (Riegl 1931, p. 195).

21

"Rembrandt dagegen malte als Holländer grundsätzlich nicht sowohl die Aktion selbst als das Anfangsstadium dazu: es ist mehr die psychische Absicht, die intellektuelle Konzeption, die Aufmerksamkeit auf dasjenige, was zu geschehen hat, was er dargestellt hat" (Riegl 1931, p. 197).

22

"Diese Verlegung der Handlung in ihre Anfangsstadien ist im Grunde nichts anderes als jener echt holländische einseitige Verkehr in den älteren Gruppenporträten, der auf halbem Wege steckenbleibt und der Ergänzug durch den Beschauer aus dessen Erfahrungsbewußtsein bedarf" (Riegl 1931, p. 197).

23

"Jede Responsion von Linien wirkt zwar in der Ebene; aber es gibt zwei Arten von Erscheinungen der Ebene: die haptische, in welcher die aus der Nähe gesehenen Dinge tastbar in Höhe und Breite nebeneinander stehen, und die optische, in welcher die aus der Ferne gesehenen Dinge sich dem Auge darbieten, wenngleich sie tastbar in verschiedenen Raumtiefen hintereinander zerstreut sind" (Riegl 1931, p. 208). For further commentary on Riegl's "optical plane" see Schöne 1954, pp. 247, 432.

24

"Durch die geschilderte Behandlung des Sprechers, durch die er die Aufmerksamkeit der Beisitzer herausfordert, ist also unzweideutig gesagt, daß die letztere wenigstens zum Teile seinen Worten gilt. Die Beisitzer haben aber sämtlich den Blick nach der Seite des Beschauers, d.h. einer Partei, gerichtet (die auch diesmal nach dem zerstreuten Verlaufe der Blickstrahlen nicht auf einen einzigen beschränkt gedacht werden darf) und beobachten

dieselbe mit größter Spannung, unter leichter Beimischung von Selbstgefühl" (Riegl 1931, p. 210).

25

"Das Ideal der holländischen Gruppenporträtmalerei erscheint hiermit schon darin erreicht, daß die Träger der inneren und der äußeren Einheit im Bilde nicht mehr auseinanderfallen, sondern miteinander identisch sind, so daß nun in der Tat die vollkommenste Individualisierung der äußeren Einheit in Raum und Zeit hergestellt erscheint" (Riegl 1931, p. 211).

26

Richard Wollheim comments on Riegl's reading of Hals's 1616 group portrait in his *Painting as an Art*. He observes that this connection with the spectator "relies solely upon the small intimate details of social exchange. Rank is not pulled" (Wollheim 1987, p. 180).

VII

Riegl and the Role of the Spectator

1

"Die bisherige Geschichte der Meschheit läßt in dieser Hinsicht zwei extreme Grundsätze erkennen: am Anfange die Auffassung, daß jedes Subjekt zugleich ein Objekt sei und daß hiernach im Grunde bloß Objekte existieren; heute die entgegengesetzte, wonach es gar kein Objekte und nur ein einziges Subjekt gebe" (Riegl 1931, pp. 280–281).

2

"Bürger-Thoré hat sich als erster veranlaßt gesehen, jenen dramatischen Inhalt zu skizzieren. Er hat vor allem richtig erkannt, daß an Stelle des Beschauers eine unsichtbare Partei vorausgesetzt werden muß, mit der die Staalmeesters verhandeln" (Riegl 1931, p. 211).

3

"Die klassische Antike hatte diese Wendung vermieden, denn sie kannte nichts als Objekte. Die moderne Kunst kann ihrer ebenfalls entraten, aber aus genau entgegengesetztem

Grunde: sie kennt nicht als das Subjekt, denn nach ihrer Anschauung reduzieren sich die sogenannten Objekte durchwegs auf Empfindung des Subjekts" (Riegl 1931, p. 200).

VIII

Postscript on Panofsky: Three Early Essays

1

"Und damit erhebt sich vor der Kunstbetrachtung die Forderung—die auf philosophischem Gebiete durch die Erkenntnistheorie befriedigt wird—, ein Erklärungsprinzip zu finden, auf Grund dessen das künstlerische Phänomen nicht nur durch immer weitere Verweisungen an andere Phänomene in seiner Existenz begriffen, sondern auch durch eine unter die Sphäre des empirischen Daseins hinabtauchende Besinnung in den Bedingungen seiner Existenz erkannt werden kann" (Panofsky 1964, p. 33).

2

". . . daß die in einem Kunstwerk verwirklichten künstlerischen Absichten von den gemützuständlichen Absichten des Künstlers ebenso streng geschieden werden müssen, wie von der Spiegelung der Kunsterscheinungen im Zeit-Bewußtsein oder gar von den Inhalten der Eindruckserlebnisse, die das Kunstwerk einem heutigen Betrachter vermittelt: daß, kurz gesagt, das Kunstwollen als Gegenstand möglicher kunstwissenschaftlicher Erkenntnisse keine (psychologische) Wirklichkeit ist" (Panofsky 1964, p. 38).

3

"Ganz wie dem Satz 'die Luft ist elastisch' ein bestimmtes erkenntnistheoretisches Wesen zukommt, das sich der Betrachtung *sub specie* des Kausalitätsbegriffes (und nur dieser Betrachtung) entschleierte, so kann auch in den Objekten der Kunstwissenschaft, in den weiter oder enger, epochal, regional oder individuell begrenzten künstlerischen Erscheinungen, ein immanenter Sinn—und damit ein Kunstwollen in nicht mehr psychologischer, sondern gleichsam auch transzendental-philosophischer Bedeutung—erschlossen werden, wenn sie nicht durch Beziehung auf etwas außerhalb ihrer Liegendes (historische Umstände, psychologische Vorgeschichte, stilistische Analogien), sondern ausschließlich in ihrem eigenen Sein betrachtet werden" (Panofsky 1964, p. 40).

4

".. . die 'Notwendigkeit', die auch sie in einem bestimmten historischen Prozesse feststellt, besteht ja . . . nicht darin, daß zwischen mehreren zeitlich aufeinander folgenden Einzelerscheinungen ein kausales Abhängigkeitsverhältnis konstatiert würde, sondern darin, daß innerhalb ihrer, als in einem künstlerischen Gesamtphänomen, ein einheitlicher Sinn erschlossen wird" (Panofsky 1964, p. 42).

5

"Die antiken Künstler konnten die perspektivische Raumeinheit nicht wollen, denn sie hätte ihnen keine künstlerische Einheit geboten. Diese suchten sie nach wie vor im Rhythmus der Linien in der Ebene, wozu sich in der römischen Kaiserzeit allmählich der Rhythmus von Licht und Schatten gesellte" (Riegl 1927, p. 112).

6

"Vielleicht drückt diese aristotelische Raumlehre mit besonderer Deutlichkeit die Tatsache aus, daß das antike Denken noch nicht vermochte, die konkret erlebbaren 'Eigenschaften' des Raumes, und namentlich den Unterschied zwischen 'Körper' und 'Nichtkörper' auf den Generalnenner einer 'substance étendue' zu bringen" (Panofsky 1964, p. 110).

7

"So mußte der nächste Schritt auf dem Wege zum modernen 'Systemraum' zunächst einmal dazu führen, die nunmehr vereinheitlichte, aber luministisch fluktuierende Welt aufs neue zu einer substantiellen und meßbaren zu machen, freilich durchaus nicht im Sinn antiker, sondern eben mittelalterlicher Substantialität und Meßbarkeit" (Panofsky 1964, p. 112).

8

".. . daß nunmehr ein eindeutiges und widerspruchsfreies Raumgebilde von (im Rahmen der 'Blickrichtung') unendlicher Ausdehnung konstruiert werden konnte, innerhalb dessen die Körper und ihre freiräumlichen Intervalle gesetzmäßig zum *corpus generaliter sumptum* verbunden waren" (Panofsky 1964, p. 122).

9

"So läßt sich die Geschichte der Perspektive mit gleichem Recht als ein Triumph des distanzierenden und objektivierenden Wirklichkeitssinns, und als ein Triumph des distanzverneinenden menschlichen Machtstrebens, ebensowohl als Befestigung und Systemati-

sierung der Außenwelt, wie als Erweiterung der Ichsphäre begreifen" (Panofsky 1964, p. 123).

10

See Michael Ann Holly's remarks on this issue (Holly 1984, p. 89).

11

"Warum hat das Kunstwerk zur Zeit seiner Entstehung gefallen und warum gefällt es heute nicht? Was wollte man dazumal von der bildenden Kunst und was will man von ihr heute? Das sind Fragen, die sich aus den Denkmälern heraus beantworten lassen und darum einmal beantwortet werden müssen. Hierin erblicke ich überhaupt die brennendste Aufgabe der Kunstgeschichtforschung in der nächsten Zukunft" (Riegl 1929, p. 63).

12

Further discussion of Panofsky's work is found in Heckscher 1969, Podro 1982, Bonnet 1983, Holly 1984, Ferretti 1989, Preziosi 1989, Didi-Huberman 1990.

Bibliography

Ackerman, J. S.

1960

"Art History and the Problem of Criticism." *Daedalus,* 89, no. 1 (Winter), 253ff.

1963

"Western Art History." In Ackerman and R. Carpenter, eds., *Art and Archaeology,* 123–232. Englewood Cliffs, N.J.

1973

"Toward a New Social Theory of Art." *New Literary History,* 4 (Winter), 315–330.

Alpers, S.

1977

"Is Art History?" *Daedalus,* 106, 1–13.

1979

"Style Is What You Make It: The Visual Arts Once Again." In Berel Lang, ed., *The Concept of Style,* 137–162. Ithaca.

1982

"Art History and Its Exclusions: The Example of Dutch Art." In N. Broude and M. Garrard, *Feminism and Art History: Questioning the Litany.* New York.

1983

The Art of Describing: Dutch Art in the Seventeenth Century. Chicago.

Alpers, S., and P. Alpers

1972

"Ut Pictura Noesis? Criticism in Literary Studies and Art History." *New Literary History,* 3, no. 3 (Spring), 437–459.

Bahr, H.

1903

Gegen Klimt. Vienna.

Bandmann, Günter

1971

"Der Wandel der Materialbewertung in der Kunsttheorie der Künste im 19. Jahrhundert." In *Beiträge zur Theorie der Künste im 19. Jahrhundert.* Frankfurt am Main.

Banham, Reyner

1960

Theory and Design in the First Machine Age. London.

Baxandall, M.

1980

The Limewood Sculptors of Renaissance Germany. New Haven and London.

Benjamin, W.

1973a

"Art in the Age of Mechanical Reproduction." In *Illuminations,* ed. Hannah Arendt, trans. Harry Zohn, 219–254. New York.

1973b

Charles Baudelaire: A Lyric Poet in the Era of High Capitalism. Trans. Harry Zohn. London.

1977

The Origin of German Tragic Drama. Trans. John Osborne. London.

1988

"Strenge Kunstwissenschaft: Zum ersten Bande der Kunstwissenschaftlichen Forschungen." In *Gesammelte Schriften,* 3:363–374. English translation as "Rigorous Study of Art: On the First Volume of the Kunstwissenschaftliche Forschungen," trans. Thomas Y. Levin, *October,* no. 47 (Winter 1988), 84–90.

Benveniste, E.

1971

Problems of General Linguistics. Coral Gables, Florida. First published as *Problèmes de linguistique générale,* Paris, 1966.

Boe, Alf

1957

From Gothic Revival to Functional Form. Oslo and Oxford.

Bogner, Dieter

1984

"Empirisme et Spéculation: Aloïs Riegl et l'école viennoise d'histoire de l'art."
"Fin-de-siècle et modernité," special issue of *Cahiers du musée national
d'art moderne,* 14, 44–55.

Bois, Yve-Alain

1987

"Kahnweiler's Lesson." *Representations,* 18 (Spring), 33–68.

1991

"Susan Smith's Archeology." In *Interpreting Contemporary Art,* ed. S. Bann and
W. Allen, 102–123. London and New York.

Bonnet, J., ed.

1983

Erwin Panofsky: Cahiers pour un temps. Paris.

Brendel, Otto J.

1979

Prolegomena to the Study of Roman Art. New Haven and London.

Brown, J.

1979

"The Meaning of *Las Meninas.*" In *Images and Ideas in Seventeenth Century
Spanish Painting,* 87–110. Princeton.

Bungay, Stephen

1984

Beauty and Truth. Oxford.

Burckhardt, J.

1949

The Age of Constantine the Great. Trans. M. Hadas. London. First published as
Die Zeit Constantins des Grossen, 1853.

1950

Recollections of Rubens. Trans. M. Hottinger. London. First published as
Erinnerungen aus Rubens, 1898.

1988

The Altarpiece in Renaissance Italy. Ed. and trans. Peter Humfrey. Oxford.
First published as "Das Altarbild," 1894.

Bürger, W.

1858

Musées de la Hollande: Amsterdam et La Haye. Vol. I. Paris.

Cassirer, E.

1972

The Philosophy of Symbolic Forms. 3 vols. New Haven and London.
First English edition 1955.

Clark, Kenneth

1966

Rembrandt and the Italian Renaissance. London.

Conze, A.

1870

Anfänge der griechischen Kunst. Vienna.

Damisch, Hubert

1972

Théorie du nuage: Pour une histoire de la peinture. Paris.

Diderot, Denis

1960

Salons. Ed. J. Seznec and J. Adhémar. Vol. 2. Oxford. First published 1765.

Didi-Huberman, G.

1990

Devant l'image: Question posée aux fins d'une histoire de l'art. Paris.

Dilly, H.

1979

Kunstgeschichte als Institution: Studien zur Geschichte einer Disziplin. Frankfurt am Main.

1990 (ed.)

Altmeister moderner Kunstgeschichte. Berlin. Contains an essay by W. Kemp on Riegl.

Dittmann, L.

1967

Stil, Symbol, Struktur: Studien zu Kategorien der Kunstgeschichte. Munich.

1985

Kategorien und Methoden der deutschen Kunstgeschichte, 1900–1930. Stuttgart.

Dvořák, M.

1924

Kunstgeschichte als Geistesgeschichte. Munich. Trans. as *The History of Art as the History of Ideas,* trans. John Hardy, London, 1984.

1929

"Alois Riegl." In *Gesammelte Aufsätze zur Kunstgeschichte,* ed. J. Wilde and K. M. Swoboda, 279–299. Munich. First published 1905.

Eco, U.

1979

The Role of the Reader: Explorations in the Semiotics of Texts. London.

Ettlinger, L. D.

1964

"On Science, Industry and Art: Some Theories of Gottfried Semper."
Architectural Review (July), 57–60.

Ferretti, S.

1989

Cassirer, Panofsky and Warburg: Symbol, Art and History. Trans. Richard Pierce.
New Haven and London.

Forster, K.

1972

"Critical History of Art, or Transfiguration of Values?"
New Literary History, 3, no. 3 (Spring), 465ff.

1982

"Monument/Memory and the Morality of Architecture."
Oppositions, 25 (Fall), 5–16.

Foster, H., ed.

1988

Vision and Visuality. Seattle.

Foucault, M.

1970

The Order of Things: An Archaeology of the Human Sciences. Ed. R. D. Laing.
New York. First published as *Les mots et les choses,* Paris, 1966.

Frampton, K.

1980

Modern Architecture. London.

Fried, M.

1968

"Art and Objecthood." In G. Battcock, ed., *Minimal Art: A Critical Anthology,* 116–147. New York. First published in *Artforum,* June 1967.

1969

"Manet's Sources: Aspects of his Art 1859–1865." *Artforum,* 7, no. 7 (March), 28–82.

1980

Absorption and Theatricality: Painting and Beholder in the Age of Diderot. Berkeley and Los Angeles.

Fromentin, E.

1960

The Masters of Past Time. London. First published as *Les maîtres d'autrefois,* 1876.

Geretsegger, H., and M. Peintner

1970

Otto Wagner 1841–1918. London.

Gombrich, E.

1960

Art and Illusion: A Study in the Psychology of Pictorial Representation. Princeton.

1969

In Search of Cultural History. Oxford.

1979

The Sense of Order: A Study in the Psychology of Decorative Art. London.

1987

"From Careggi to Montmartre: A Footnote to Erwin Panofsky's Idea." In *"Il se rendit en Italie . . .": Etudes offertes à André Chastel.* Paris.

Goodyear, W.

1891

The Grammar of the Lotus: A New History of Classic Ornament as a Development of Sun Worship. London.

Hart, Joan

1982

"Reinterpreting Wölfflin: Neo-Kantianism and Hermeneutics." *Art Journal*, 42 (Winter), 292–300.

Hauser, A.

1959

The Philosophy of Art History. London.

Haverkamp-Begemann, E.

1982

Rembrandt: The Nightwatch. Princeton.

Heckscher, William S.

1958

Rembrandt's Anatomy of Dr. Nicolaas Tulp: An Iconographical Study. New York.

1969

Erwin Panofsky: A Curriculum Vitae. Princeton.

Hegel, G. W. F.

1905

The Introduction to Hegel's Philosophy of Fine Art. Trans. B. Bosenquet. London.

1944

The Philosophy of History. Trans. J. Sibree. New York.

1975

Aesthetics: Lectures on Fine Art. 2 vols. Trans. T. M. Knox. Oxford.

1979
Phenomenology of Spirit. Trans. A. V. Miller. Oxford.

Heidegger, Martin
1977
The Question Concerning Technology and Other Essays. Trans. William Lovitt.
New York.

Heidrich, E.
1917
Beiträge zur Geschichte und Methode der Kunstgeschichte. Basel.

Helmholtz, H. L. F.
1876
"Optisches über Malerei." In *Populäre wissenschaftliche Vorträge.* Brunswick.
Translated as "On the Relation of Optics to Painting," in *Popular Lectures on
Scientific Subjects,* second series, trans. E. Atkinson, London, 1881, 1963.

Herbart, J. F.
1834
Lehrbuch zur Einleitung in die Philosophie. Königsberg. First published 1813.

1850
*Psychologie als Wissenschaft neu gegründet auf Erfahrung, Metaphysik und
Mathematik.* 2 vols. Leipzig. First published 1824–1825.

1883
Lehrbuch zur Psychologie. Hamburg and Leipzig. First published 1816.

Herrmann, W.
1984
Gottfried Semper: In Search of Architecture. Cambridge, Mass., and London.

Hildebrand, A.

1961

Das Problem der Form in der bildenden Kunst. First published Baden–Baden, 1893.
English translation as *The Problem of Form in Painting and Sculpture,* trans.
M. Meyer and R. O. Ogden, New York, 1932; rpt.
New York and London, 1978.

Hofmann, W.

1971

Gustav Klimt and Vienna at the Turn of the Century.
Trans. Inge Goodwin. Greenwich, Conn.

Holly, M. A.

1984

Panofsky and the Foundations of Art History. Ithaca.

Ingarden, Roman

1973

*The Literary Work of Art: An Investigation on the Borderlines of Ontology, Logic,
and the Theory of Literature.* Trans. G. Grabowicz. Evanston.
First German edition 1965.

Iser, Wolfgang

1978

The Act of Reading: A Theory of Aesthetic Response. London.
First German edition 1976.

Iversen, M.

1979

"Style as Structure: Alois Riegl's Historiography."
Art History, 2, no. 1 (March), 62–71.

1980

"Alois Riegl's Historiography." Ph.D. thesis, University of Essex, England.

1981

"Politics and the Historiography of Art History: Wölfflin's Classic Art."
Oxford Art Journal (July), 31–34.

1991a

"Aby Warburg and the New Art History." In *Aby Warburg: Akten des
internationalen Aby Warburg-Symposiums, Hamburg 1990,* ed. H. Bredekamp,
M. Diers, and C. Schoell-Glass, 281–292. Weinheim.

1991b

"Alois Riegl and the Aesthetics of Disintegration." *Kunst und Kunsttheorie.*
Herzog August Bibliothek, Wolfenbüttel.

Janik, A., and S. Toulmin.

1973

Wittgenstein's Vienna. New York.

Jones, O.

1886

Grammar of Ornament. London. First published 1856.

Jowell, S. F.

1977

Thoré-Bürger and the Art of the Past. New York and London.

Kandinsky, W., and F. Marc, eds.

1974

The Blaue Reiter Almanach. Ed. Klaus Lankheit. London.

Kant, Immanuel

1922

"Prolegomena zu einer jeden künftigen Metaphysik die als Wissenschaft wird
auftreten können." In *Immanuel Kants Werke,* ed. A. Buchenau and E. Cassirer.
Vol. 4, *Schriften von 1783–1788.* Berlin.

1952

Critique of Judgement. Trans. J. C. Meredith. Oxford.

Kemp, Wolfgang

1973

"Walter Benjamin und die Kunstgeschichte. Part I. Benjamins Beziehung zur Wiener Schule." *Kritische Berichte*, 1, no. 3, 30–50.

1983

Der Anteil des Betrachters: Rezeptionsästhetische Studien zur Malerei des 19. Jahrhunderts. Munich.

1985

"Death at Work: A Case Study of Constitutive Blanks in Nineteenth-Century Painting." *Representations*, 10 (Spring), 102–123.

1990

"Alois Riegl." In Dilly 1990.

Kleinbauer, W. E.

1971

Modern Perspectives in Western Art History. New York.

Kulturmann, U.

1966

Geschichte der Kunstgeschichte: Der Weg einer Wissenschaft. Vienna.

Levin, T. Y.

1988

"Walter Benjamin and the Theory of Art History"
October, no. 47 (Winter), 77–83.

von Loh, D.

1983

"Alois Riegl und die Hegelsche Geschichtsphilosophie."
Ph.D. dissertation, University of Berlin.

Loos, A.

1982

Spoken into the Void: Collected Essays 1897–1900. Trans. J. O. Newman and
J. H. Smith. Cambridge, Mass., and London.

Lübke, W.

1876

"Zur Geschichte der holländischen Schützen- und Regentsbilder."
In *Repertorium für Kunstwissenschaft,* 1:1–27. Stuttgart.

Lux, J. A.

1914

Otto Wagner. Munich.

Mandelbaum, M.

1971

History, Man and Reason: A History of Nineteenth Century Thought. Baltimore.

McCorkel, C.

1975

"Sense and Sensibility: An Epistemological Approach to the Philosophy of Art
History." *Journal of Aesthetics and Art Criticism,* 34 (Fall), 35–50.

Marin, L.

1980

"Toward a Theory of Reading in the Visual Arts: Poussin's *The Arcadian
Shepherds.*" In S. Suleiman and I. Crosman, eds., *The Reader in the Text:
Essays on Audience and Interpretation,* 293–324. Princeton.

Melville, Stephen

1981

"Notes on the Reemergence of Allegory . . ." *October,* no. 19, 55–92.

1990

"The Temptation of New Perspectives." *October,* no. 52 (Spring), 3–15.

Metz, C.

1982

Psychoanalysis and Cinema: The Imaginary Signifier. London.

Middleton, R., and D. Watkin.

1980

Neoclassical and Nineteenth Century Architecture. New York.

Mulvey, L.

1975

"Visual Pleasure and Narrative Cinema." *Screen,* 16, no. 3. (Autumn).
Reprinted in *Visual and other Pleasures,* London, 1989.

Nash, J. M.

1980

"The Nature of Cubism: A Study of Conflicting Explanations."
Art History, 3 (December), 435–447.

Nodelman, S.

1966

"Structural Analysis in Art and Anthropology."
Yale French Studies, nos. 36–37 (October), 89–103.

Olin, M. R.

1982

"Alois Riegl and the Crisis of Representation in Art Theory, 1880–1905."
Ph.D. dissertation, University of Chicago, Illinois.

1989a

"Forms of Respect: Alois Riegl's Concept of Attentiveness."
Art Bulletin, 71 (June), 285–299.

1989b

"Validation by Touch in Kandinsky's Early Abstract Art."
Critical Inquiry, 16, 144–172.

1992

Forms of Representation in Alois Riegl's Theory of Art.
University Park, Pa.

Pächt, O.
1963
"Art Historians and Critics, IV: Alois Riegl."
Burlington Magazine, 105 (May), 188–193.

Panofsky, E.
1915
*Dürers Kunsttheorie, vornehmlich in ihrem Verhältnis zur Kunsttheorie der
Italiener.* Berlin.

1964

Aufsätze zu Grundfragen der Kunstwissenschaft. Berlin. Includes the essays
"Das Problem des Stils in der bildenden Kunst" (1915); "Der Begriff des
Kunstwollens" (1920; English translation as "The Concept of Artistic Volition,"
trans. Kenneth J. Northcott and Joel Snyder, *Critical Inquiry,* 8 [Autumn 1981],
17–33); and "Die Perspektive als 'symbolische Form'" (1924–1925, 1927;
English translation as *Perspective as Symbolic Form,* trans. Christopher Wood
[New York, 1991]).

1970

Meaning in the Visual Arts. Harmondsworth. Includes the essays "The History
of the Theory of Human Proportions as a Reflection of the History of Style"
("Die Entwicklung der Proportionslehre als Abbild der Stilentwicklung,"

Monatshefte für Kunstwissenschaft, 14 [1921], 188–219) and "Albrecht Dürer and
Classical Antiquity" ("Dürers Stellung zur Antike,"
Jahrbuch für Kunstgeschichte, 1 [1921/2], 43–92).

Pevsner, N.
1960
Pioneers of Modern Design, from William Morris to Walter Gropius.
Harmondsworth. First published 1936.

1972
Some Architectural Writers of the Nineteenth Century. Oxford.

de Piles, Roger
1969
Cours de peinture par principe. Geneva. Reimpression of Paris edition, 1708.

Podro, M.
1972
The Manifold in Perception: Theories of Art from Kant to Hildebrand. Oxford.

1982
The Critical Historians of Art. New Haven and London.

Popper, K. R.
1945
The Open Society and Its Enemies. 2 vols. London.

1961
The Poverty of Historicism. London. First published 1957.

Preziosi, D.
1989
Rethinking Art History: Meditations on a Coy Science. New Haven and London.

Puttfarken, T.

1985

Roger de Piles' Theory of Art. New Haven and London.

Quitzsch, H.

1962

Die aesthetischen Anschauungen Gottfried Sempers. Berlin.

Redgrave, R.

1852

"Supplementary Report on Design." In *Report by the Juries,* 708–749. London.

Riegl, A.

1891

Altorientalische Teppiche. Leipzig. Reprint Mittenwald, 1969.

1893

Stilfragen: Grundlegungen zu einer Geschichte der Ornamentik. Berlin. Reprint
Mittenwald, 1977. Spanish translation as *Problemas de estilo: fundamentos para una
historia de la ornamentaci,* Barcelona, 1980.

1894

Volkskunst, Hausfleiß und Hausindustrie. Berlin. Reprint Mittenwald 1968.

1908

Die Entstehung der Barockkunst in Rom. Lectures from the years 1901–1902.
Edited by A. Burda and M. Dvořák. Vienna. Reprint Mittenwald, 1977.

1912

Baldinuccis Vita des Bernini. From seminars given in 1901.
Edited by A. Burda and O. Pollak. Vienna.

1927

Die spätrömische Kunstindustrie nach den Funden in Österreich-Ungarn, Part I. New
edition. Vienna. Reprint Darmstadt, 1973. First published 1901. Italian

translation as *Arte tardoromano,* trans. L. C. Ragghianti, Turin, 1959, 1968. New translation as *Industria artistica tardoromano,* trans. B. Forlati Tamaro and M. T. Ronga Leoni, Florence, 1981. English translation: see Riegl 1985.

1929

Gesammelte Aufsätze. Edited by K. M. Swoboda, with an introduction by H. Sedlmayr and a bibliography of Riegl's publications. Augsburg and Vienna.

1931

Das holländische Gruppenporträt. New edition. Vienna. First published in *Jahrbuch des allerhöchsten Kaiserhauses,* 22 (Vienna, 1902).

1966

Historische Grammatik der bildenden Künste. Edited by K. M. Swoboda and O. Pächt. Graz. French translation as *Grammaire historique des arts plastiques,* trans. E. Kaufholz, Paris, 1978.

1982

"The Modern Cult of Monuments: Its Character and Its Origin." Trans. Kurt W. Forster and Diane Ghirardo. *Oppositions,* no. 25, pp. 21–50. Translation of "Der moderne Denkmalkultus, sein Wesen, seine Entstehung," in Riegl 1929, pp. 144–194 (first published 1903). French translation as *Le culte moderne des monuments, sa nature, son origine,* trans. Jacques Boulet, Paris, 1984.

1985

Late Roman Art Industry. Trans. Rolf Winkes. Rome.

1988

"Late Roman or Oriental?" Trans. Peter Wortsman. In Gert Schiff, ed., *German Essays on Art History,* pp. 173–190. New York, 1988. Translation of "Spätrömisch oder Orientalisch?," *Münchner Allgemeine Zeitung,* no. 93–94 (1902).

Rosen, C.

1988

"The Ruins of Walter Benjamin." In *On Walter Benjamin: Critical Essays and Recollections,* ed. Gary Smith. Cambridge, Mass., and London.

Rousseau, J.-J.

1960

Politics and the Arts: Letter to M. d'Alembert on the Theatre.
Trans. Allan Bloom. Glencoe, Ill.

1973

The Social Contract and Discourses. Trans. G. D. H. Cole, J. H. Brumfitt, and
J. C. Hall. London.

1974

Emile. Trans. Barbara Foxley. London.

Rykwert, J.

1976

"Semper and the Conception of Style." In *Gottfried Semper und die Mitte des
19. Jahrhunderts.* Basel and Stuttgart.

Said, E. W.

1978

Orientalism. London.

Sauerländer, W.

1977

"Alois Riegl und die Entstehung der autonomen Kunstgeschichte am Fin de
siècle." In *Fin de siècle: Zur Literatur und Kunst der Jahrhundertwende,* ed. Roger
Bauer et al., 125–139. Frankfurt am Main.

1983

"From Stilus to Style: Reflections on the Fate of a Notion."
Art History, 6 (Sept.), 253–270.

Saussure, F. de

1974

Course in General Linguistics. Ed. C. Bally, A. Sechehaye, and A. Reidlinger, trans. Wade Baskin. London. First French edition 1916.

Schapiro, M.

1936

"The New Viennese School." *Art Bulletin,* 18, 258–266.

1953

"Style." In A. L. Kroeber, ed., *Anthropology Today.* Chicago. Reprinted in *Aesthetics Today,* ed. Morris Philipson (New York, 1961), 137–171.

Schiff, Gert, ed.

1988

German Essays on Art History. New York.

Schiller, J. C. F.

1966

Naive and Sentimental Poetry. Trans. J. A. Elias. New York.

1967

On the Aesthetic Education of Man. Trans. E. Wilkinson and L. Willoughby. Oxford.

Schlosser, J. von

1934

"Die Wiener Schule der Kunstgeschichte." *Mitteilungen des österreichischen Instituts für Geschichtsforschung,* suppl. vol. 13. Innsbruck.

1935

"Stilgeschichte und Sprachgeschichte der bildenden Kunst." *Sitzungsberichte der philosophisch-historischen Abteilung der Bayerischen Akademie der Wissenschaften.*

Schmarsow, A.

1905

Grundbegriffe der Kunstgeschichte. Leipzig and Berlin.

Schnaase, K.

1834

Niederländische Briefe. Stuttgart.

Schneider, N.

1990

"Hans Sedlmayer." In Dilly 1990.

Schöne, W.

1954

Über das Licht in der Malerei. Berlin.

Schopenhauer, A.

1969

The World as Will and Representation. Trans. E. F. J. Payne. 2 vols. New York.

Schorske, K.

1980

Fin-de-Siècle Vienna. New York.

Schupbach, W.

1982

The Paradox of Rembrandt's "Anatomy of Dr. Tulp." London.

Searle, J. R.

1980

"*Las Meninas* and the Paradoxes of Pictorial Representation."
Critical Inquiry, 6 (Spring), 477–488.

Sedlmayer, H.

1929

"Die Quintessenz der Lehren Riegls." Introduction to Riegl 1929, xii–xxxiv.

1958

Art in Crisis: The Lost Center. Chicago.

Semper, Gottfried

1834

Vorläufige Bemerkungen über bemalte Architektur und Plastik bei den Alten. Altona.

1851

Die vier Elemente der Baukunst. Brunswick.

1878

Der Stil in den technischen und tektonischen Künsten. 2 vols. 2d ed.
Frankfurt am Main. First published 1860, 1863.

1884

Kleine Schriften. Ed. Hans and Manfred Semper. Berlin and Stuttgart.
Reprint Mittenwald 1979.

1989

Gottfried Semper: The Four Elements of Architecture and Other Writings.
Trans. H. F. Mallgrave and Wolfgang Herrmann. Cambridge, England.

Shedel, J.

1981

Art and Society: The New Art Movement in Vienna, 1897–1914. Palo Alto.

Slive, S.

1970

Frans Hals. 3 vols. London.

Stadler, I.

1967

"Perception and Perfection in Kant's Aesthetics." In *Kant: A Collection of Critical Essays,* ed. R. P. Wolff. London.

Steinberg, Leo

1972

"The Philosophical Brothel." *Art News,* no. 5 (September), 20–41; no. 6 (October), 38–47.

1981

"Velázquez' *Las Meninas.*" *October,* no. 19 (Winter), 45–54.

Stieglitz, Ann

1989

"The Reproduction of Agony: Toward a Reception-History of Grünewald's Isenheim Altar after the First World War." *Oxford Art Journal,* 12, no. 2, 87–103.

Thausing, M.

1884

Albrecht Dürer: Geschichte seines Lebens und seiner Kunst. Leipzig. First published 1875.

Tietze, H.

1913

Die Methode der Kunstgeschichte. Leipzig.

1935

"Alois Riegl." In *Neue österreichische Biographie, 1815–1919,* 8:142ff.

Timms, E.

1986

Karl Kraus: Apocalyptic Satirist. New Haven and London.

Varnadoe, K.

1986

Vienna 1900. New York.

Vergo, P.

1975

Art in Vienna 1898–1918. London.

Waetzoldt, W.

1921, 1924

Deutsche Kunsthistoriker. 2 vols. Leipzig.

Wagner, O.

1979

"The Development of a Great City." *Oppositions,* no. 17 (Summer 1979),
103–106. Translation of part of Wagner's book
Die Großstadt: Eine Studie über diese (Vienna, 1911).

1988

Modern Architecture. Trans. Harry Francis Mallgrave. Santa Monica.
First published as *Moderne Architektur,* 1896.

Whyte, I. B.

1990

"Semper Fidelis." *Art History,* 13 (March), 122–126.

Wickhoff, F.

1912

Römische Kunst, Die Wiener Genesis. Berlin. First published in 1895 as
"Die Wiener Genesis" as a supplement to the *Jahrbuch der kunsthistorischen
Sammlungen des Allerhöchsten Kaiserhauses.* English translation,
Roman Art: Some of Its Principles and Their Application to Early Christian Painting,
trans. and ed. Mrs. S. A. Strong (London, 1900).

Wind, E.

1925

"Zur Systematik der künstlerischen Probleme."
In *Zeitschrift für Ästhetik und allgemeine Kunstwissenschaft*, 18, 438–486.

1963

Art and Anarchy. London.

Wölfflin, H.

1909

Review of Hans Cornelius, *Elementargesetze der bildenden Kunst*.
In *Repertorium für Kunstwissenschaft*, 32, 335–336.

1946

"Die antiken Triumphbogen in Italien: Eine Studie zur Entwicklungsgeschichte
der römischen Architektur und ihr Verhältnis zur Renaissance." In *Kleine
Schriften (1886–1933)*, ed. Joseph Gantner, 51–74. Basel. First published 1893.

1950

The Principles of Art History. Trans. M. D. Hottinger. New York.
First published as *Kunstgeschichtliche Grundbegriffe*, 1915, 5th ed. Munich, 1943.

1964a

Classic Art: An Introduction to the Italian Renaissance. Trans. Peter and Linda
Murray. New York. First published as *Die klassische Kunst: Eine Einführung in
die italienische Renaissance*, 1899, 5th ed. Munich, 1921.

1964b

Renaissance and Baroque. Trans. K. Simon. London. First published as
*Renaissance und Barock: Eine Untersuchung über Wesen und Entstehung des Barockstils
in Italien* (Munich, 1888).

Wollheim, R.

1987

Painting as an Art. London.

Worringer, W.

1911

Formprobleme der Gotik. Munich. English translation as *Form in Gothic,*
trans. H. Read (London, 1927).

1953

Abstraction and Empathy: A Contribution to the Psychology of Style.
Trans. M. Bullock. London. First German edition 1908.

Zerner, H.

1976

"Alois Riegl: Art, Value and Historicism." *Daedelus,* 105 (Winter), 177–188.

Index